Double Happiness!

工.

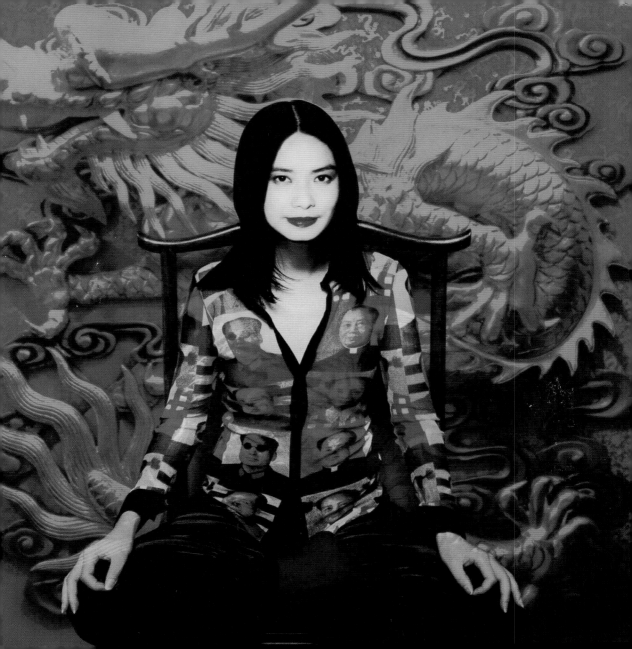

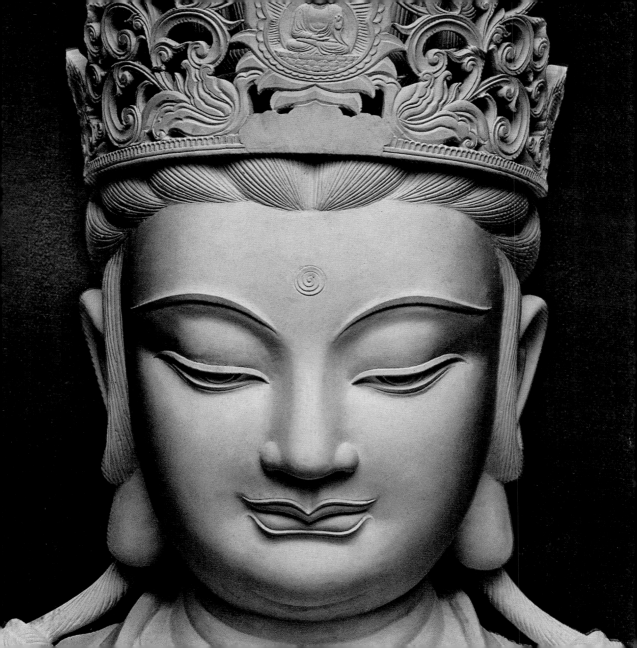

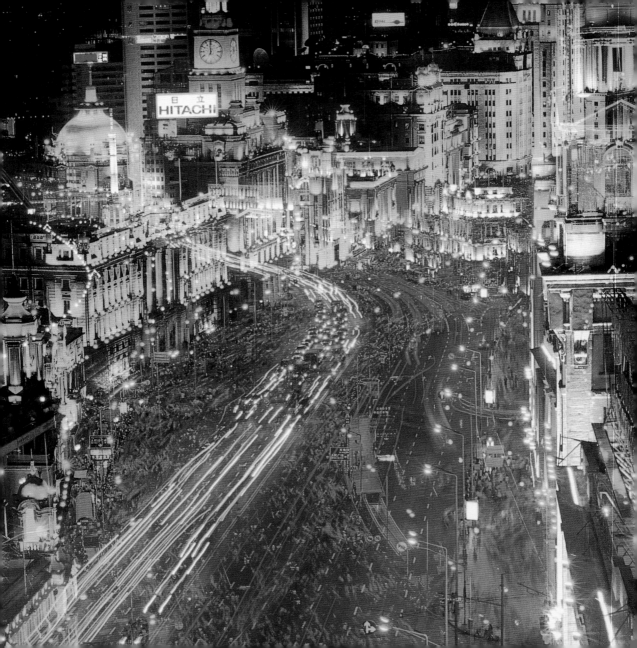

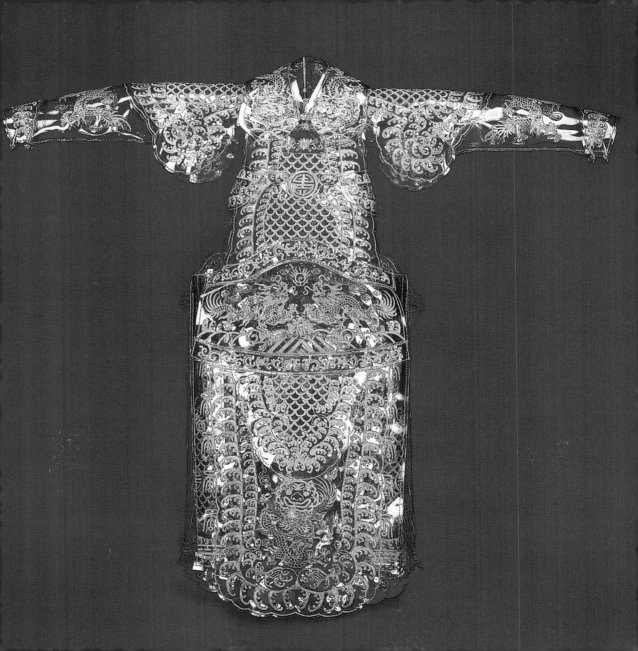

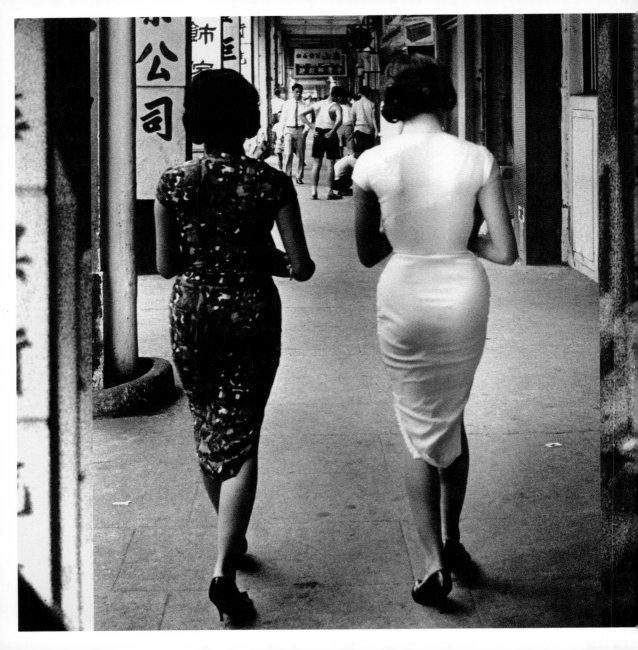

CHINA CHIC

VIVIENNE TAM

WITH MARTHA HUANG

ReganBooks
An Imprint of HarperCollinsPublishers

ART DIRECTION BY WING SHYA
DESIGN AND ILLUSTRATION BY ELAINE KWONG of shya-la-la workshop
PROJECT MANAGEMENT BY ROBERT LOH of baboon and broccoli
COVER CONCEPT AND PHOTOGRAPH BY FOREIGN DEVIL
EDITED BY CHARLES RUE WOODS AND CASSIE JONES
PRODUCTION MANAGEMENT BY RONI AXELROD

Permissions, constituting an extension of the copyright page, appear on pages 312–313.

A large-format edition of this book was published in 2000 by ReganBooks, an imprint of HarperCollins Publishers.

HarperCollins books may be purchased for educational, business, or sales promotional use. For information please write: Special Markets Department, HarperCollins Publishers Inc., 10 East 53rd Street, New York, NY 10022.

The Library of Congress has cataloged the large-format edition as follows:

Tam, Vivienne.
 China chic : a visual memoir of Chinese style and culture / Vivienne Tam.—1st ed.
 p. cm.
 ISBN 0-06-039268-1
 1. Art—Chinese influences. 2. Decorative arts—Chinese influences. 3. Art, Chinese—Western
 influences. 4. Tam, Vivienne—Sources. I. Title.

 N7429 .T359 2000
 709—dc21 00-039046

ISBN 0-06-079663-4

06 07 08 09 10 TP 10 9 8 7 6 5 4 3 2 1

To my mother

She is my greatest inspiration. She taught me to use my hands—to touch, to feel, and to create.
Her presence has been a gentle and loving constant—both in this book and in my life.

CONTENTS

PREFACE by Tama Janowitz

Vivienne Tam weaves delicate and complex webs, in which later she will wrap people and objects—webs of ideas, webs in time, webs of her own unique place and vision, webs in which the viewer—the wearer, the reader—is hopelessly, irrevocably, and deliciously entwined.

When I first met her, some years ago, her will and determination were readily apparent. Though I found her—and her clothes—to be beautiful, this book, with its stunning and exotic imagery and its insights into Chinese culture and life, gave me a new perspective on Vivienne.

She is someone who can pay equal attention to thermoses lined up on a shelf and to the meaning of color in the garb of the emperor while expanding the horizons of the reader. Her thoughts and observations range from the minute and physical—"a woman . . . nicely dressed in a skirt and blouse . . . would put on a pair of crocheted gloves . . . to go off on her bike"—to the historic and factual, always written in a style that is vivid, crisp, and poetic. Whether she writes about koi fish in a pond—"the tails and fins flowed . . . like the long white sleeves of Chinese opera heroines or the silk strands of the ribbon dance, graceful and ethereal"—or street clothing in China—"It might be a woolen jacket with a strangely colored plaid, or a see-through blouse with a burned-out wave design. The transparent pattern would be sexy in the West, but when worn on the street next to Mao jackets it could be a bit jarring"—she makes the reader see things in a new way.

I'm deeply envious of her ability to transcend and understand these two worlds, East and West; also her gentle yet strong personality. To read her stories and view the carefully selected surreal, remarkable pictures is to dip into a landscape of the unconscious. It's an unusual combination of autobiography; cultural and philosophical observations; poetry; mini biographies and interviews with figures of Chinese background in the arts, not necessarily well known in this country—interviews as notable for Vivienne's ability to ask thoughtful and provocative questions as for being concise portraits of interesting subjects.

The book manages to be simultaneously a celebration of modern twentieth-century Chinese design and an explanation of it. Vivienne's evocative writing is more of a cross-cultural explo-

ration than anything I have come across previously. And along the way is an entertaining, vivid memoir as well as Vivienne's thoughts and observations on Chinese philosophy, music, food, politics, art, theater, and other topics.

Vivienne has transcended the category of fashion designer with this book, although previously her clothes and shops conveyed a statement that encompassed a realm larger than simply fashion—to walk into her store, to view her clothing, one felt instantly at peace with oneself and excited, stimulated. She does everything with a kind of ease and perfection that ultimately seems totally natural, perhaps most closely aligned to the Japanese concept of *shibui*.

Some years back I visited China, where I was amazed, entertained, enthralled, but missed so much; images and thoughts in Vivienne's book have made me rethink my own trip there. We are living in a time when the globe is shrinking and cultural differences are diminishing, yet at the same time people seem to have less understanding of one another.

In this book Vivienne not only clarifies what is different in Western and Eastern existence, but brings a new understanding to it. I greatly admire Vivienne's duality, her ability to understand and be a part of both China and the West, and I'm not alone in realizing that she has become something akin to an icon. I remember going to dinner with her in a restaurant where the Chinese owner/hostess was so excited to have Vivienne in her restaurant, she immediately offered the party complimentary drinks—it was a bit like the old days, going out to a restaurant with Andy Warhol, when the response to him had been similar. Not long ago I returned to Brooklyn from an evening out to be told with great excitement by the sixteen-year-old baby-sitter, "Vivienne Tam called! I can't believe she called and I spoke to her! I love her!" My esteem had risen so considerably in the baby-sitter's eyes, it was hard to imagine that I was the same person who had left her with my child earlier that night. It's exciting to know Vivienne and, ultimately, somehow innately satisfying to hold and read this book.

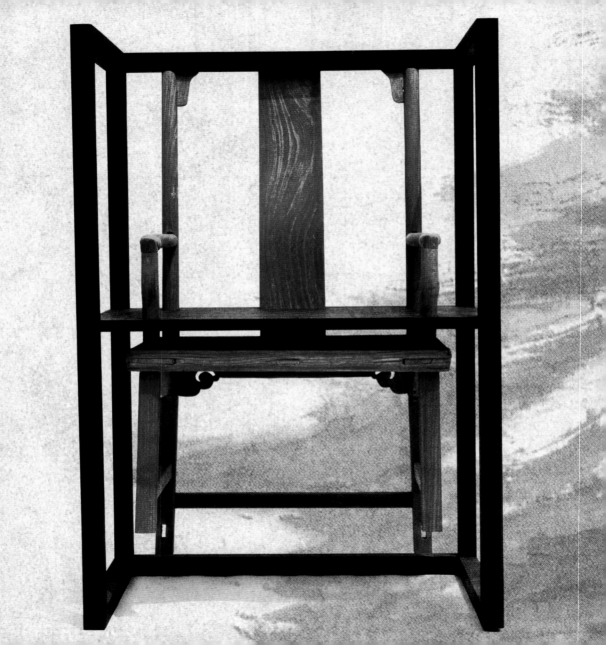

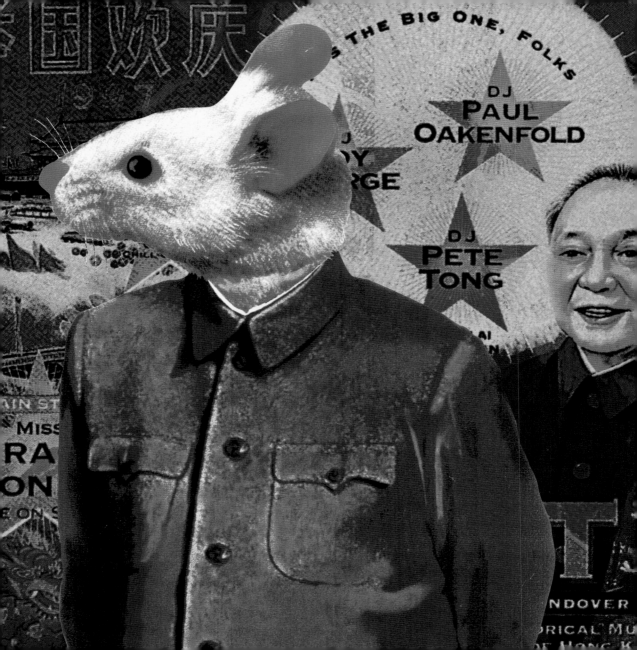

CULTURAL CROSS-DRESSING by Geremie R. Barmé

All of us have a cross-dressing closet of memories, styles, and ideas. It is a labyrinthine abode similar to the memory palaces of the past, mental structures of the imagination that were used by monks and scholars to help bring order to a lifetime of knowledge.

China Chic, Vivienne Tam's memory palace, is not a multiroomed baroque mansion but more like a traditional Chinese garden. Dotted with pavilions, terraces, and towers, it is not structured along the strict lines of a grid or according to some immutable geometry. And it does not declare itself with a showy facade covering a redoubt of cramped and cluttered rooms. Vivienne's realm of style and memory is a meandering space of languid hillocks and fast-flowing streams, serpentine paths that wend through miniature vistas and hidden delights. It is a sensibility that has evolved as Vivienne has moved constantly, even restlessly, between cultures, from Hong Kong to mainland China, from Europe to America.

Like the traditional Chinese garden, Vivienne's world constantly changes and engages its audience. In *China Chic*, words and images constantly play on one another, creating a perspective that is both deceptively familiar and engagingly other. Vivienne's journey through Chinese style is both inquisitive and acquisitive, an energetic appropriation, an innocent and playful look that reveals the workings beneath the empire of Chinese signs that enliven her life and work.

The former British colony of Hong Kong where Vivienne grew up has been home to the best and worst of twentieth-century China. From the late 1940s much that was lost to revolution and violence on the mainland continued to grow and develop in Hong Kong. The colony port inherited many of the talents, people, styles, and energy that had inspired the metropolitan modernism of China before the communist victory in 1949.

Then, after Mao Zedong's death in 1976, new political and economic policies inspired revivals and interest in everything from popular music to TV soaps, advertising to publishing, fashion to kung fu, Hong Kong "Chineseness" to export-quality chinoiserie. All of this was at the center of China's reinvention of itself.

When Vivienne traveled to China in the late seventies and early eighties, she discovered

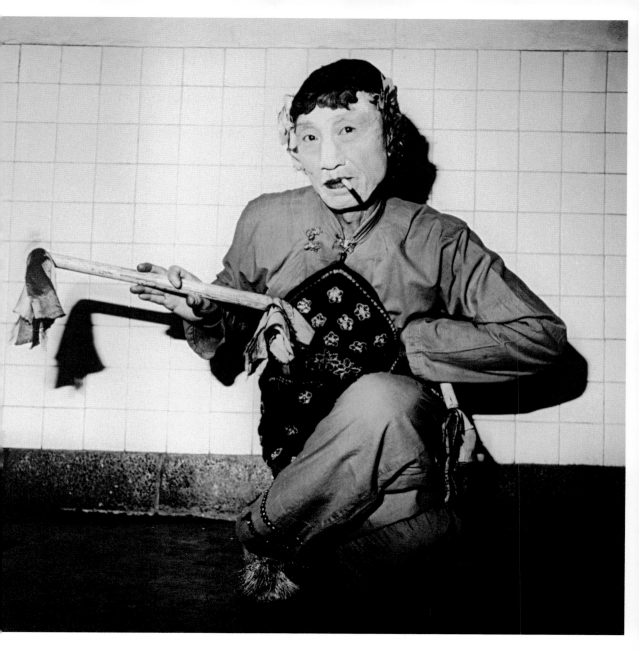

a sense of style in the permanently retro fashion of the place. She called it "edgy—on the borderline between bad taste and hip." This reinforced her own sense and sensibility. Her exposure to the revolutionary retro of China at a time when Hong Kong was inspiring the first shifts to postrevolutionary fashion had an impact that has worked as a basic riff throughout Vivienne's career. It is hybrid by nature—diasporic and cosmopolitan.

The retro delights that Vivienne shows us in *China Chic* are a fifties style frozen by a revolution. China seemed to be in a time warp that moved according to its own calendar; retro wasn't about a revival of a past style, because retro still hadn't happened. It was a take on the past that lay in the future.

The plastic sandals and green army sneakers she recalls were not merely a fashion statement but rather part of the limited wardrobe of mainland life. The colors, fabrics, and layering of clothes were part of a carefully coded aesthetic that took time to see and appreciate. Many saw these hues and styles as limited and lifeless, but Vivienne picked up on their unspoken message as soon as she traveled across the border. She understood the language of a coquettish flash of a bright hue at the sleeve or trouser leg. She noticed the sexy look of young men in striped T-shirts with bright colors of cotton peeking from around the ankle. It was an insouciant style that often slipped into the openly erotic.

The past that Vivienne draws from is not limited to Maoist China. She explores traditional Chinese style with this same fresh sense of wonder, and her consideration of the Qing dynasty helps place Chinese style in a new perspective.

The Manchus conquered the Ming dynasty in the seventeenth century and founded the Qing dynasty (1644–1911). It is their legacy from which the China of today has evolved. They emulated the Ming dynasty, its fashions and palaces, its arts and artifice but added an opulent twist of the baroque, creating a mix of cultures that has left China cross-dressing creatively for more than a century. The modern cheongsam, or *qipao*, and the Beijing opera—as well as the imperial court's adventures into Europeanoiserie—are all part of the Qing tradition.

Vivienne is confident skirting around the world of modern Manchu chinoiserie. She understands that in everything from kung fu cinema to the melancholy of traditional music, from the postimperial pomp of the People's Republic's Great Hall of the People to the ethnic kitsch decor of a pagoda-topped phone booth in Chinatown and the red-flocked wallpaper of your local Chinese restaurant—all have a touch of the hybrid high culture created by the Manchus.

At the same time, Vivienne's affinity for Ming dynasty style and her eloquent exploration of Chinese Buddhism provide an elegant, minimalist counterpoint to the question "What is Chinese?"

China is enlivened by many calendars—the Western time of international business, the ancient agricultural calendar that determines annual festivals and celebrations, the agendas of the ruling Communist Party, the demands of international trade, and the many private calendars and time zones in which Chinese people function. In Vivienne Tam's vision these different times and modes of being are brought into a clear and beguiling focus.

China Chic is about hybrid worlds and cultures. Vivienne is from a China that has been on the cutting edge of change and turbulence for over half a century, and her assuredness amid the clamor of growing internationalism has allowed her to pick and choose from the past as her vision has evolved. She is a designer for all seasons and all geographies.

In *China Chic* she has created a rare personal history, a personal path that wends its way between the Ming and the Qing, between the eclipsed authority of British colonialism and Maoist revolution. She wears the changing habits of her multifaceted culture lightly, confidently weaving a future from its past.

I was born in China. The first child in my family was a boy, and my mother always considered herself lucky in this respect. A son to carry on the family name is important, so the pressure was off. Even so, when I was an infant my grandparents dressed me as a boy—maybe they saw that I had a strong spirit, or maybe they wanted to give me one. They also cut my hair really short.

My father was from a landlord family, which means that they had owned land with peasants living and farming on it. After the establishment of the People's Republic of China in 1949, the government began to eliminate private property ownership and to create farming communes in which everyone worked the land together. But people still remembered who the landlords had been. Every time there was political unrest, these families were accused again of exploiting people for their own profit.

Since we were vulnerable to that, my mother decided it was time to leave. My parents were just starting out, with two kids, and they didn't want the shadow of the past over all of us. They went to Hong Kong, which was still a colony under the British, and brought us out to join them one by one as they became more settled.

Since I was second-born, I stayed behind with my grandparents at first. When my parents returned for me, they took me out of the mainland through Macau, then a Portuguese colony, because the border with Hong Kong had been closed. They went through first, and I followed with their close friends, a couple who could pretend to be my parents because they were already Macau residents. My mother still talks about what it was like to wait for me on the other side of the immigration booth. I was only three, and they were so worried that I would point at them, or say the wrong thing and talk about my real parents. Actually it was okay; you learn how to survive when you have to.

I have a picture of myself then, with a crew cut and wearing a fancy party dress with a Peter Pan collar. The look was a little strange, but I really love this image—half little boy, half little girl. It's very strong. This is where my life started—a life in China, and then a life in Hong Kong; a life in the East, and then one in the West. A party dress and a crew cut, always crossing borders.

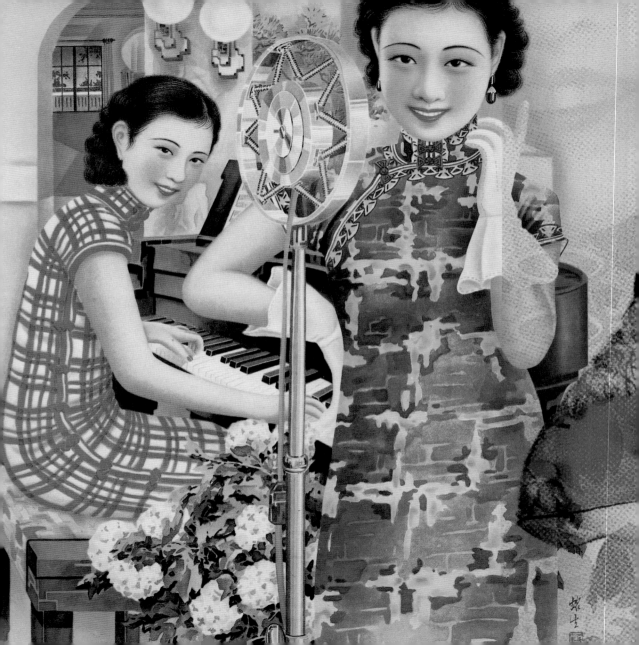

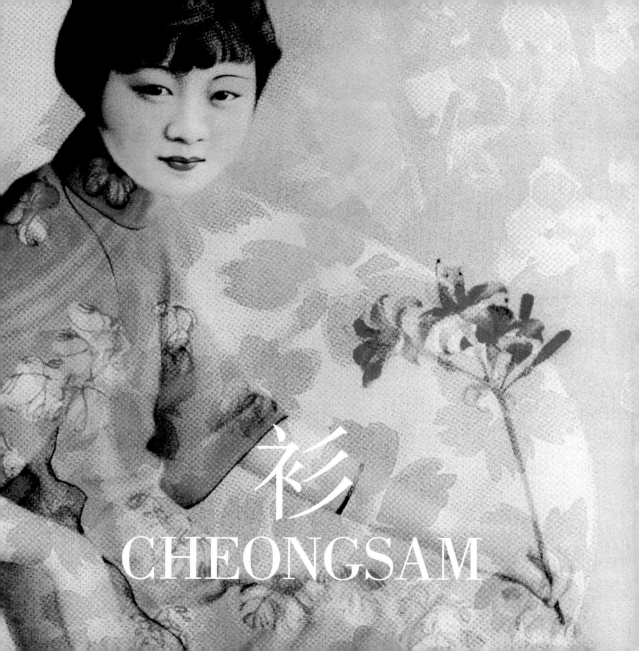

衫
CHEONGSAM

CHEONGSAM衫 *(shan)*

Shirt, clothing, or topwear. It's a term with a range of meanings, from the loose and accommodating to the svelte and fashionable. The **shan** doesn't simply cover, it caresses, concealing and revealing to perfection. Cheongsam is Cantonese for long shirt; in Mandarin the term most often used is **qipao**, literally banner gown, **qi** being the term for a Manchu military division.

MY MOTHER'S DRESS

I remember when I first noticed my mother in a cheongsam. She was dressed up to go out to dinner, and didn't really look like my ordinary mother anymore: suddenly she was so refined, her body seemed slimmer, straighter, and really noble. Her head was held up high, and she moved more slowly because of the slits and the cut of the dress. You have to be disciplined in your movements when wearing a cheongsam, and of course you need a good figure. But when a woman puts it on, like my mother, a metamorphosis takes place—she's taller, more elegant, in a state of grace.

To me, the cheongsam is really a homemade dress, because we made most of our own clothes. I remember my mother taking me to the tailor to see the huge bolts of cheongsam fabric in his shop—silk brocades, jacquards, and great prints—a flood of color and texture. Then we'd go to the street market and find a stall that sold fabric remnants. My mother said we could make better combinations with the pieces we bought there, because remnants were unique.

I would watch my mother make her own cheongsams. She knew her body, and never had to use patterns—she just drew straight onto the fabric, picked up the scissors, and began cutting. She even made her own fastenings by twisting ribbons of fabric into all sorts of shapes—flowers, butterflies, or geometric patterns. The neck could be lower for everyday, or really high for formal wear. The dresses always fit her perfectly.

She made Western clothes for me, everything from party dresses to school uniforms. She

taught me how to work with my hands; I learned how to knit and crochet, and to do needlepoint and embroidery. She would say, Don't dress like everybody else, it's better to be different.

I've been collecting cheongsams since high school. I love the beautiful embroidery and dragon beading, the lined lace from the sixties, the crochetwork from the seventies. Good friends know I love old clothes. I remember once walking down a street in Wanchai and hearing someone call my name. It was a friend who said, "Hey, I found a cheongsam for you, I think it'll fit!" He was right—it was a red printed satin jacquard number that he'd found in the rubbish on the sidewalk, and I still have it in my collection!

When I first tried them on, the best way to describe the way I felt is to say that the cheongsams made me feel like a young woman. It was like playing dress-up, partly because I'd always connected the cheongsam with my mother. I felt more mature, and the structure of the dress immediately forced me to be more disciplined. I still remember my embarrassment when I ripped the side slit climbing on a bus too quickly.

The problems with wearing the cheongsam were obvious: the collar was so restricting—too stiff and impossibly hot in the summer. The shape of the torso was also confining—you can't really eat much in a cheongsam! The wearer becomes very body-conscious, in both good and bad ways. She might worry about her figure, but she also becomes more aware of how her body feels when she moves, stands, or sits.

As I got more used to the cheongsam, I started to experiment. The essence of the cheongsam is in a few basic details: the cross opening, the high neck, the close fit to the body, and the side slits. These elements make up a kind of grid—you can change the variables but not the basic form. Nothing else really matters. The sleeves don't matter at all; the tailoring can be nipped with darts or fall straight from the shoulder. The cross opening is unique to Asian dressing, and I find it very inspiring. I like to wear the collar unbuttoned, creating a new slit from neck to armpit. Even if no skin is exposed, it's very sexy. It might be suggestive of a Chinese bordello, but it's also very liberating.

The way the cheongsam shapes the body is unique. The collar makes the wearer hold her head up high, totally realigning her posture and separating the head from the body; she looks proud, and a little bit up in the clouds. The narrow cut holds the body in, but the slits at the hem liberate the legs. The body is revealed, every movement means more.

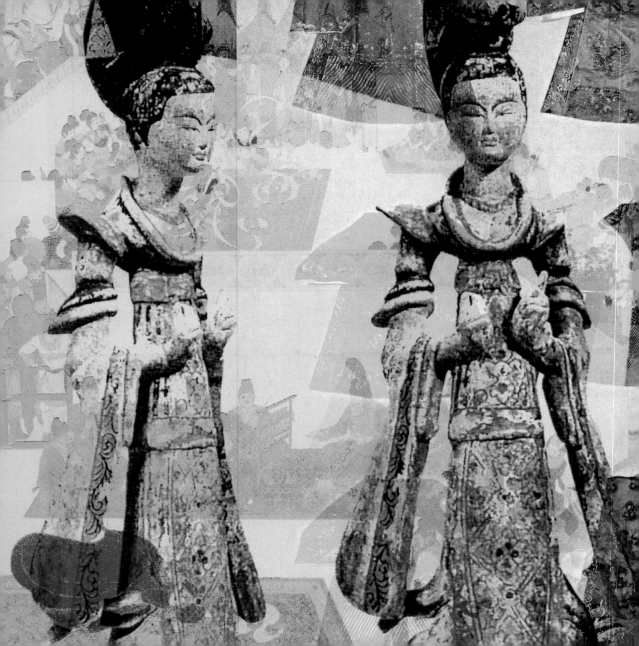

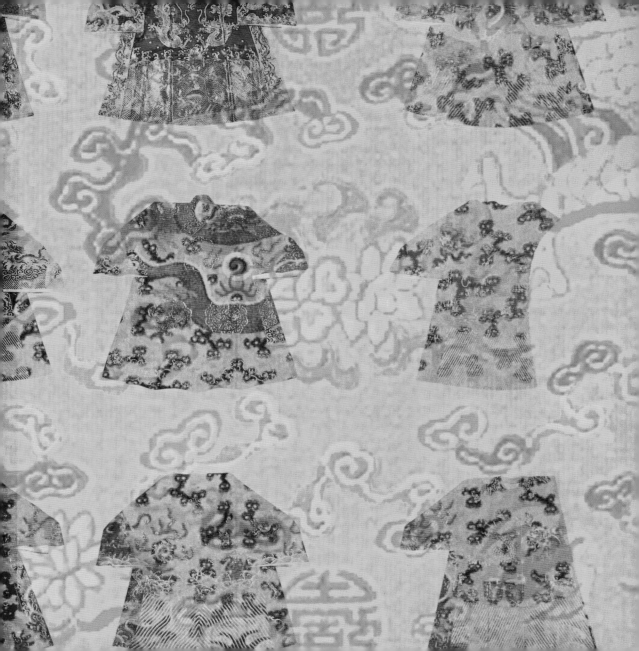

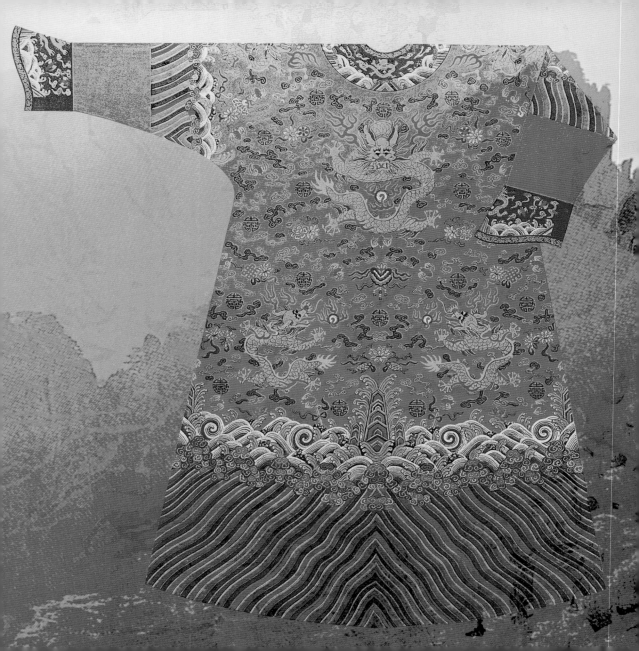

SPACE ROBE

In 1644 the new Manchu rulers brought their horseback fashion from the steppes into the palace. They made their long gowns or cheongsams in rich silk and fur. This was the basis for the dragon robe—the uniform for the emperor. It was clear from the very beginning that the new rulers had their own ideas about fashion and style. The Qing ordered all Chinese men to shave the front half of their heads and to wear the rest in a long braid, or queue, and decreed that they dress in Manchu style instead of the loose comfortable robes of the Ming. When the emperor Yongzheng heard that a Ming loyalist had refused to be buried in Manchu clothes, he had the style rebel's body dug up and broken into pieces—one of the world's earliest fashion victims.

Today, I think the dragon robe makes a wonderful party dress. When I dance in one, it feels like flying, with the embroidered waves at my feet and the dragons perched right over my chest. Once I put one on I understood immediately why the gown was called a dragon robe. You feel invincible, and you can see a grand vision—not of the past, but of the future.

The dragon robe protected the emperor with talismans and symbols, and assigned him enormous power. The decoration is all about the sky and the heavens—starting with the cosmic waves at the hem, and rising up through the clouds, topped with flying dragons racing across the chest and shoulders. The dragon motif is space age, representing the universe's highest power, a mythical creature that issues from water, creates clouds, and dwells in the heavens. The waves represent earth, but they also have the meaning of unending happiness and long life.

I would love to know who designed these robes with such cosmic imagination. Was it a gifted imperial tailor, or maybe a visitor from the future to the imperial court? I'd like to think so. Every detail has been so carefully thought out. The lines of the robe are very futuristic: the A-shape is firmly grounded at the base, and then rises up like a pyramid to a power point. The sleeves are cut straight across the shoulder, without a seam, and when you spread them out, they look like wings ready to fly; the wearer is ready for takeoff. In the Chinese tradition, when a person reaches immortality after years of meditation and practice, he's said to have gained wings. So I like to think of the dragon robe as clothing for space angels. Of course the gown is ceremonial, but the powerful symbols represent a man of action, an explorer. The emperor was supposed to intercede between heaven and humanity; he was the original space traveler. Everything on the robe points upward; the design is unconscious and reflects our deepest myths and dreams.

SHANGHAI LADIES

The end of the Qing dynasty in 1911 didn't mean the end of Qing style. The dragon robe was slimmed down to the sleek lines of an Art Deco abstract, but richly decorated with the elaborate designs and colors of the Qing. The robe's shape was the basis for the uniform worn by the emperor's imperial Manchu troops, and was known as the *qipao,* or banner gown in Mandarin. This became the long gown worn by civilian men too—the cheongsam, or long gown in Cantonese. In the early twenties, young Chinese intellectuals argued that if women were equal to men, they should dress like men too, and modern girl students began wearing the cheongsam.

Through the twenties and thirties, you can see the woman's cheongsam growing narrower and closer to the body. In the mid-twenties, socialite Hui-lan Koo, the wife of the Chinese foreign minister Wellington Koo, took credit for getting rid of the trousers and wearing silk stockings beneath the slitted gown instead. In the forties the Shanghai writer Zhang Ailing wrote that the really tight cheongsam is an expression of pressure; in uncertain times, it's a way of holding yourself together. In any case, what started out as unisex dressing turned into the most feminine dress of all. I love that twist. For me, the best way to see that transformation is to look at the calendar art of the period. The calendars and the girls in them—the Shanghai ladies—bring that time alive.

I grew up with Shanghai lady images. My mother used to buy a brand of cosmetics called Two Girls—white face powder, scented soaps, hair oil, and a Florida water perfumed with peppermint and lavender that could be used for disinfecting and mosquito bites. I loved the packaging—the colors and patterns were all from a different time, and they made me conscious of how Western and Chinese aesthetics could be combined.

The Two Girls brand was founded by a young Chinese chemist at the turn of the century. The story is that he was walking through central Hong Kong, thinking about starting a new soap-making business, when he encountered two beautiful young women dressed in white. "Are you angels?" he asked them. "No," they replied, "we are just two girls."

When I saw my first Chinese calendar art, there was an immediate connection with these bathroom-cabinet memories. In fact, some of the most famous calendar art in Hong Kong is from the Two Girls campaign. A new calendar featuring two beautiful girls in matching clothing was

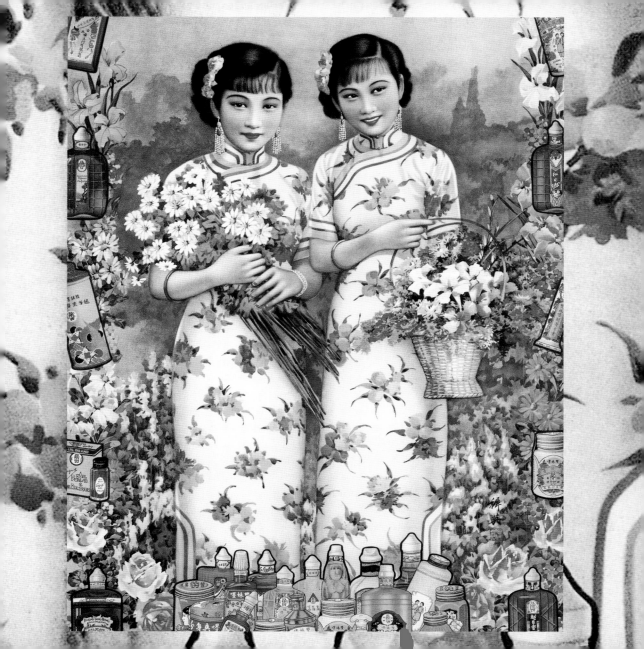

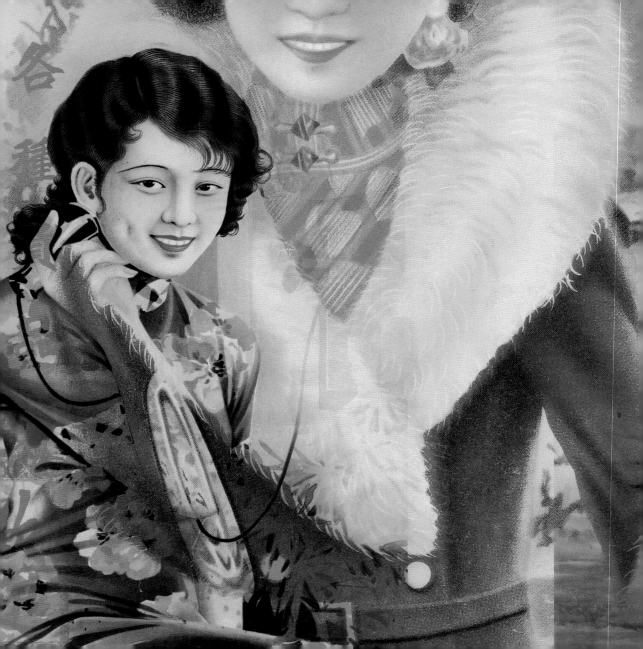

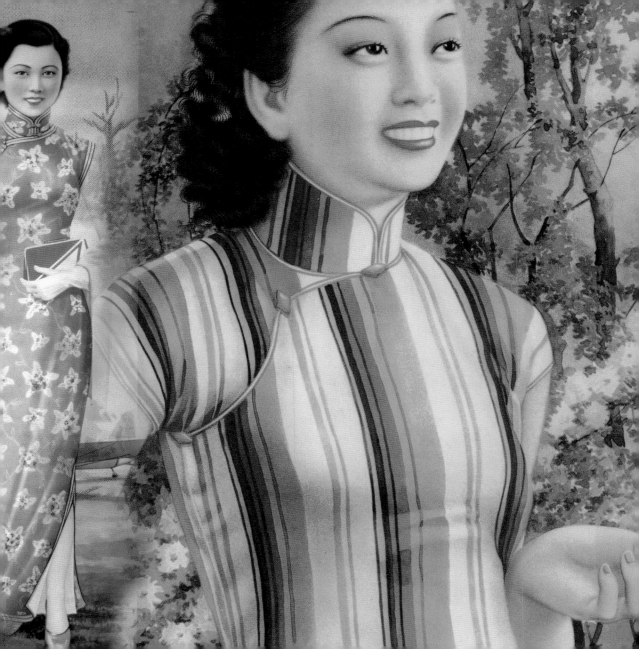

issued every year. They were like a historical record of fashion from the twenties through the forties. As a teenager, I loved visiting the flea markets off Hollywood Road on Cat Street in Hong Kong, and rummaging around for this kind of old advertising art.

These posters symbolized a romantic time when Shanghai was the Paris of the East. Shanghai started out as a small harbor town, but after the end of the Opium War in the mid-nineteenth century, the Western powers moved in, and the city became the most Westernized in China. By the twenties and thirties, there were great banks and office buildings hugging the harbor promenade, known as the Bund. Grand international hotels, nightclubs, and department stores lined the great Nanjing Road shopping district. Shanghai was the business and cultural center where East met West, and it's here that you can find the beginnings of both high finance and Chinese pop culture—including a dynamic movie, recording, and fashion industry.

The posters were an idealized, exotic take on a Chinese modern metropolis, but they show how the cheongsam fit into its original time, and how women wanted to see themselves, with their combination of permed hair and Chinese-style makeup. Those high thin eyebrows could be from Garbo, or they might be from Yang Guifei, a famous concubine in the Tang emperor's court.

And then there were the poster cheongsams, in all sorts of new prints and fabrics. No more dragons, but lots of stripes and abstract flower patterns. Instead of the wave pattern there were Art Deco curves, or solid colors set off by contrast piping and frog closures in all shapes and sizes, including modern geometric forms. There was also a mix of different textures—European lace trims at the neck and sleeves, and of course lace-lined petticoats peeking out from the side slits, thick tweeds contrasting with smooth satin, and the ultimate luxuries—crystal or pearl beading, metallic embroidery, or a bit of fur trim. Women wore different-colored stockings or anklets, with every kind of shoe, from sandals and high heels to two-toned oxfords. They combined trench coats and crocheted shawls with high-necked cheongsams, creating a hybrid fashion that was unique to cosmopolitan Shanghai. The clothes were the opposite of the dragon robe—light, streamlined. It was liberation, but the dress also produced a new kind of vulnerability—suddenly there was only a thin layer of silk between a woman's skin and the air and eyes around her.

The women in the posters come to life in the movies from that period. I saw my first film

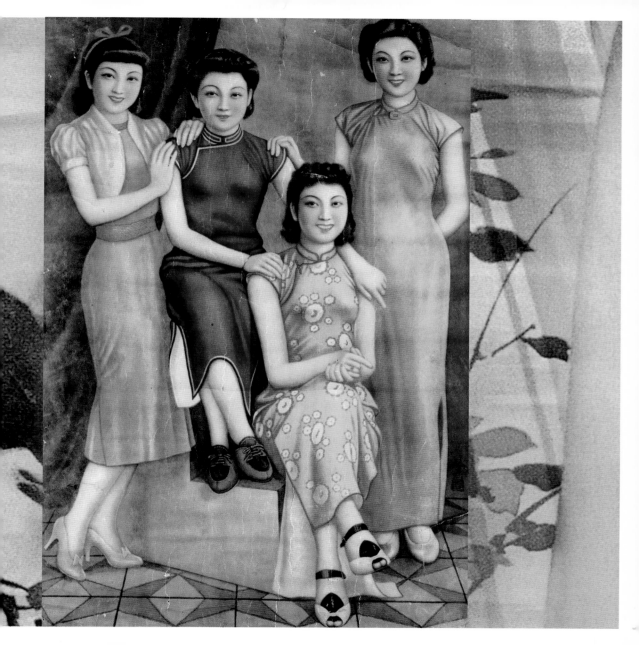

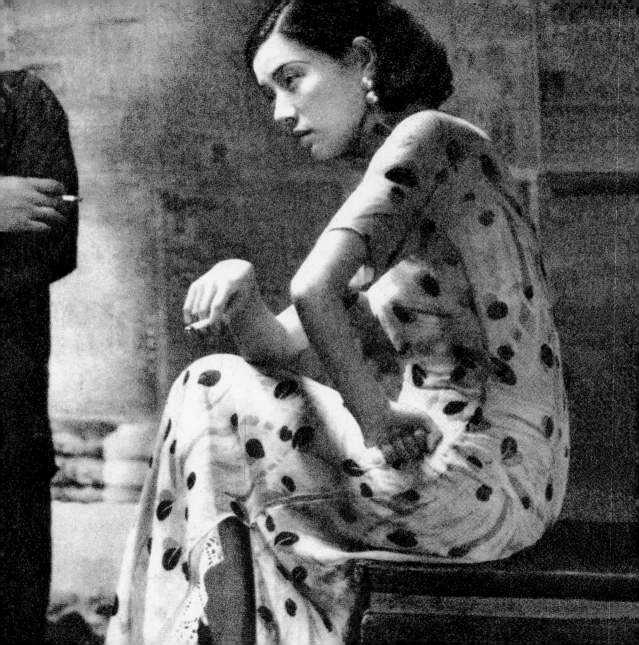

from the thirties while I was at the university: it was *The Goddess*, starring Ruan Lingyu, about a young single mother forced to work as a prostitute to pay her child's tuition. She was tough and modern but still trapped inside Chinese society. The way she crumpled when the school authorities refused to take her money was heartbreaking. I loved the feverish way she pulled a handkerchief out from the bosom of her cheongsam. Ruan was known as the Chinese Greta Garbo, but she had a sadder end. She committed suicide at age twenty-five when the gossip columns attacked her over a love affair, one writer commented that she had been applauded to death.

When I look back to that time, I'm fascinated by the new look on the street. You can see it best in the cities—especially Shanghai. Men strolling down the avenue in long Chinese gowns and fedoras; women in furs, high heels, and silk stockings, sitting in a rickshaw pulled by a puffing runner.

For the first time, people were free to pursue the best of East and West, and that meant combining rich layers of Qing palace style with the most streamlined shapes of European and American designs. Not just the cheongsam, but also the architecture. The sleek skyscraper of the Bank of China on the Shanghai Bund, with its pagoda roof and its palace balustrade treatments; the great dining room of the Peace Hotel, with the latest Art Deco light fixtures, a hall of mirrors lined with Lalique glass, and heavy dark Qing tables and chairs. At night the sky was lit with neon advertising—nightclubs like Ciro's or the Empress or Western trademarks like Johnnie Walker whiskey or Camel cigarettes framed with Chinese characters.

I still remember the first time I saw the words *Shanghai* or *Beijing* written in white on a black plastic travel bag, streamlined, with the wind speeding off the strokes, so modern and new. The bags were seventies era, but the stylization of the characters was pure Shanghai Art Deco.

Even fifty years later I could still see the 1920s Europeanoiserie of the Bund. To walk down the avenue was to experience China as a totally different world—one filled with gleaming white marble banks and department stores. Shanghai is heaven, said one writer, with twenty-four layers of hell underneath.

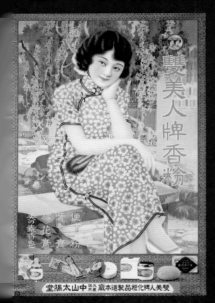

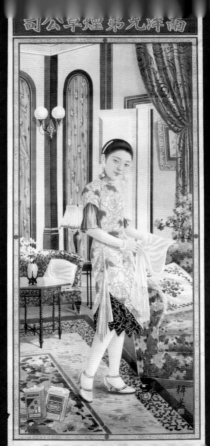

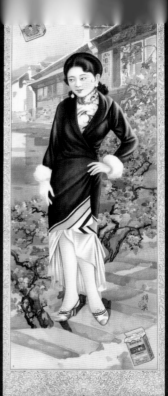

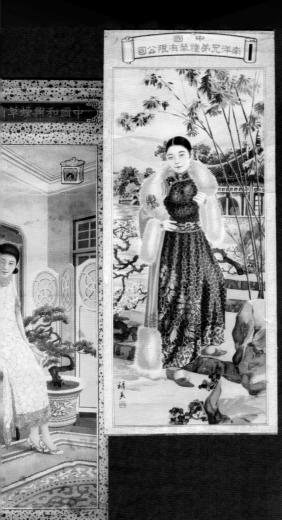

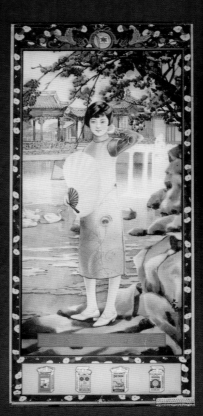

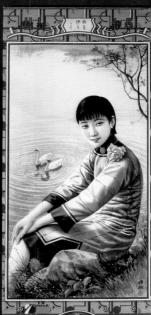

CALENDAR GIRLS Interview with Martha Huang

For me, Shanghai style was a new direction, with a street edge and a sense of humor. It can be kitsch, or camp, but it's always creative and energetic. I wanted to learn more about Shanghai calendar art, so I met with Martha Huang, a writer who has been studying these posters.

Martha's parents come from China, and she was born in the States. She holds a doctorate in modern Chinese literature and is working on a project about Shanghai literature and fashion.

VT: How did you get interested in calendar girls?

MH: It was a very emotional thing. I remember I was just poking around antique stores in the backstreets of Macau, and I came across a poster of a young woman in a white cheongsam embroidered with red chrysanthemums, standing under a willow tree. She looked so much like my mom, I was really taken aback. It took me another trip or two before I went back to get her, because normally I'm not a collector of anything. But that was the beginning.

VT: Did you ever show the poster to your mother?

MH: Yes, but her reaction was funny. My father was intrigued. "Look at this," he said to my mother. Then he squinted at the fine print and said, "Look, it was printed on Si Malu!" That's old Foochow Street in Shanghai, which was full of printers and old bookstores—and brothels at night—back in the thirties. My mother just looked at it and shrugged. "Not a very good street," she said. And that's when I realized that these calendar posters, which speak to us so romantically of old Shanghai and a glamorous past, were originally just pinups. Imagine a decade or two from now, your niece coming back from the flea market with a supermodel calendar and saying, "Hey, look what I found!"

VT: I love the Chinglish flavor of these calendar girls. They look so exotic, but you can't tell why—is it their Chinese style or their Western style, or the mix? Who were they? Who painted them?

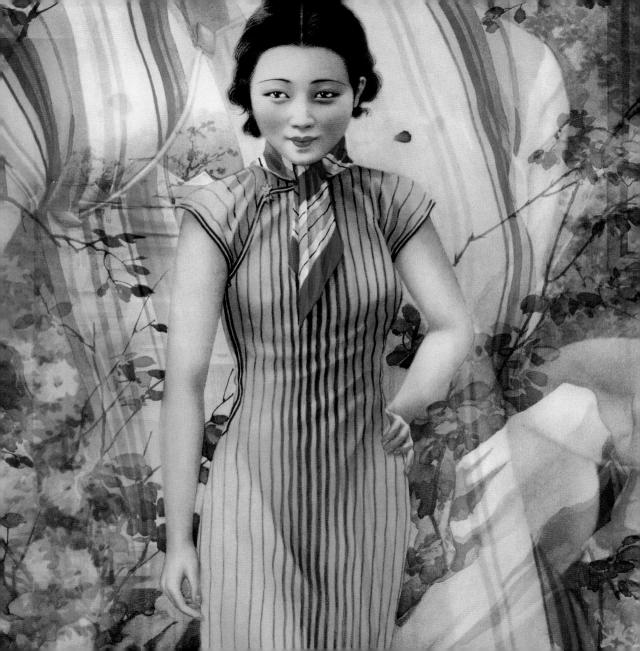

MH: Who were the girls? It's a good question. Of course, some of them were well-known movie stars or famous actresses and singers. But the rest are a mystery. When the first posters were done in the 1910s, no respectable woman would ever pose for such a thing, and no respectable person would buy it. So the artists used men, usually male opera performers who played female roles, dressed as women. It's astounding that the first modern images of Chinese women were embodied by men, because it opens up the whole idea of cross-dressing—cross-sex, but also cross-culture.

VT: That was acceptable?

MH: Yes. By the early twenties women gradually became more liberated, and began to pose. Sometimes they were teahouse singers or actresses. Sometimes they were starlets; the movie industry was just beginning, and they were always looking for pretty girls. Sometimes the artist made up a face, or started with a picture of a Hollywood star, like Jean Harlow or Joan Crawford, and made her face look a little more Chinese.

VT: How did fashion relate to these posters?

MH: These artists were very creative about clothing. They noticed what fashionable women were wearing in the street, in the dance halls, and in the theaters, and they just used their imagination. Shanghai was a cosmopolitan city in those days, so the artists also had access to Western fashion, and they would mix things up. But it worked both ways. Sometimes women would take these posters to their tailors and ask them to copy the clothes.

VT: I love that mix of Eastern and Western fashion.

MH: And not just the fashion: the painting style was a mix too. You'd have a starlet dressed in a Hollywood-style evening gown, but she'd be standing next to a Chinese vase with flowers that could have come straight out of a traditional watercolor. The form itself was a hybrid—traditional calendar art consisted of good luck prints exchanged as gifts at the New Year, dating as far back as the Tang dynasty. Then American companies co-opted the calendars at the end of the 1800s. Cigarette com-

panies were big players in the poster industry—they always produced advertising posters in the West. In China they did the same thing and gave them away for the New Year. The posters were a mix advertising all the accessories of modern life—cigarettes, face powder, electric batteries, life insurance, durable machine-dyed fabric—but the artwork was still very Chinese—very flat, almost no shadows.

VT: Is it easy to get calendar girl posters now?

MH: It's getting more difficult. Collectors from Taiwan and Hong Kong began buying them up in the late eighties and early nineties. They have also produced the best books and publications on the subject. But now the market is flooded with counterfeit posters—some are very obvious, but others are quite good, and even have gilding. A few years ago in Shanghai an antiques dealer showed me how to tell a fake one by smelling them. Since acid is used to age the metal hangers on the fakes, the paper smelled vinegary. Other dealers say you can tell by running your hand over the paper, because it's really difficult to imitate the fine wrinkles that come with time. The printing methods were fairly modern by the thirties and forties, so unless you really know what you're doing it's hard to tell, even with a magnifying glass.

It's a poster, you know, so thousands were printed. I personally think you should invest only if you really love the image. The girl has to say something to you.

VT: But they just stopped when the People's Republic of China was established; suddenly everybody was in the Mao suit.

MH: Well, almost. The interesting thing is that the calendar artists kept working. Some were recruited to work in the propaganda units painting propaganda posters, especially posters of Mao. When I first read this, I thought it was great, because you get a kind of continuity. These artists were skilled at advertising, a really close cousin of propaganda. In a way, you could even call Mao the new calendar girl of the post-1949 period. I love it when I find a poster of Mao painted by one of the calendar girl painters. They make him look like such a nice guy.

VT: Mao as calendar girl—I love it—just like my T-shirts.

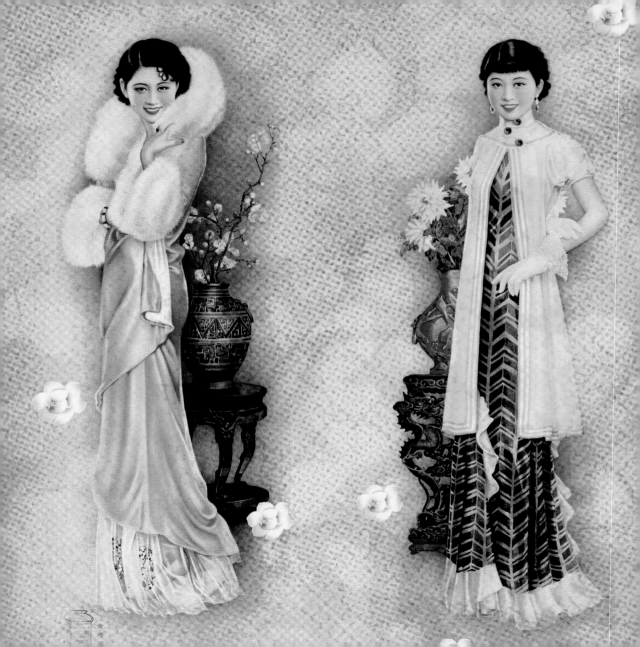

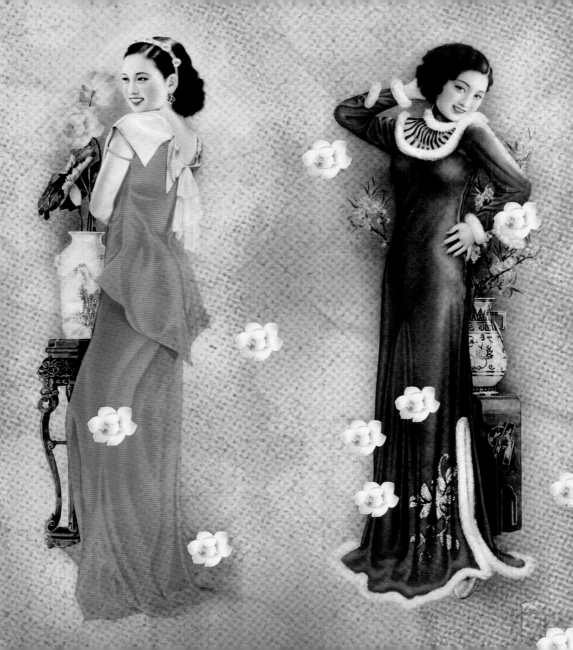

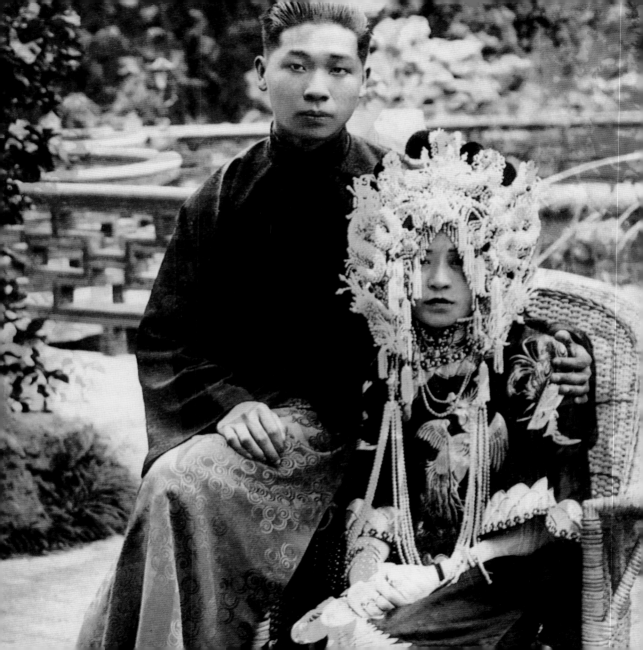

DOUBLE HAPPINESS囍 *(shuangxi)*

Two characters for happiness (*xi*) are joined to express the joy of wedded union. Good things come in pairs. Chinese culture favors equilibrium; yin is balanced by yang, the dark by the light. Symmetry is an underlying principle not only in art and architecture, but also in all realms of design, terrestrial or celestial.

BEAUTIFUL BRIDE

When I was a little girl in a Hong Kong Catholic school, I'd look out the window and see weddings at the big church inside the compound. It was exciting to wait for the bride with her veil and flowers—first when she arrived in a rush and stood waiting while her bridesmaids fixed her veil, and then later when she came out with the groom, almost floating, with people throwing confetti and rice.

I loved the wonderful mix of the different textures of white in her dress—satin, lace, tulle netting, and embroidery. The low necklines showed the neck and shoulders in a beautiful frame, and the giant puffy sleeves were luxurious and feminine. These dresses were entirely different from my mother's cheongsams or the clothes that grown-ups wore around me in everyday life. There were sparkling jewels and glowing pearls at the ears and neck; cinched waists and huge ball-gown skirts like something out of a Western fairy tale—*Sleeping Beauty* or *Snow White*. The bride wore long white gloves past her elbow, just like Her Royal Highness, Queen Elizabeth, who waved good night at the end of every night's TV broadcast. And for that day the bride was royalty—first a princess and then a queen.

At restaurants in the evenings, one end of the dining room would often be filled with a wedding party. Most Chinese restaurants are decorated in red and gold, and it's mostly for the wedding business. The wallpaper is deep red, sometimes flocked velvet, and a huge gold double happiness symbol hangs in front, wood or plastic covered in gold paint, framed with gold

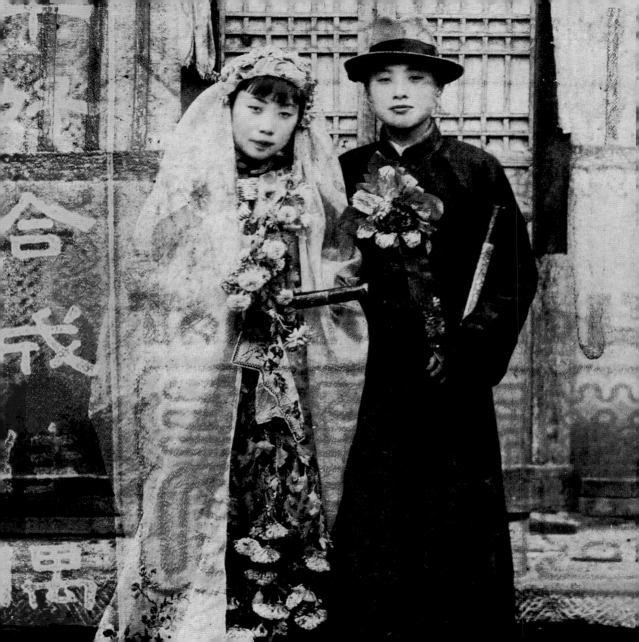

and silver dragon and phoenix carvings that symbolized the emperor and the empress. New couples, rulers for the day, would pose for the photographer in front of these decorations, and I always liked to look for the small blinking red light in the dragon's eye—that meant the spirit of the dragon was alive!

At these wedding banquets the bride dressed more traditionally. She changed out of her white tulle into red silk. Sometimes she'd wear a red wedding suit, so heavily embroidered that it was almost three-dimensional, the jacket decorated with dragons and phoenixes in gold and silver metallic thread, and the pleated wrap skirt sewn with gorgeous flowers and trimmed with tassels. She wore an elaborate headdress, trimmed with bobbing pom-poms and feathers. Then she might change into a series of cheongsams, first red for joy and virtue, and then gold or silver, worn with heavy gold bracelets carved with dragons and phoenixes for good luck. Or she might wear a Western-style evening gown, slinky long satin or with a billowing Scarlett O'Hara hoop skirt. Her hair was different with each outfit, swooped up or let down, and stuck with hairpieces. Everything was decorated with feathers, pearls, sparkling jewels, and sequins, which looked so beautiful in her jet-black hair. She wore matching shoes, gloves, and handbags. Usually, a special bridal salon planned the day's costume changes. Each change created a new look.

I could feel the spirit of the bride's excitement. Every costume change was a chance to make herself look even more beautiful for her new husband, their family, and their friends. Their reaction had to be considered—was the neckline too low for her parents' friends, would Western friends understand her traditional dress? The hair, makeup, dress, and accessories—everything had to work together to express her feelings, from the inside out. There was anticipation each time she made a new entrance.

These weddings and banquets were my first fashion shows. Women were dressing up to be as beautiful as possible, in clothes that personified fantasy and glamour. Of course, there was the feeling of waiting to go on, performing, showing off, and, most important, the deep sense of celebration and joy. Maybe that's why I love to use so many Chinese wedding elements in my designs.

In my New York shop I've placed a dragon on the wall—he's even got a bright electric blinking eye! Instead of gold he's painted red, to blend into the wall. I've always surrounded my work with red—it stops everybody's eye. It has such a strong positive feeling. It looks good with every color. When I painted the walls in the shop red, everyone told me it would clash with the

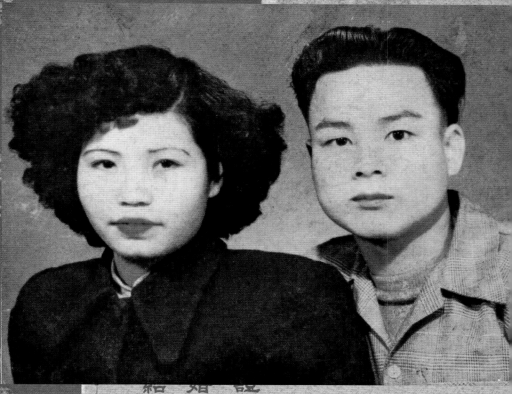

結　婚　證

虹结（86）字第13120號

姓名 張雯华　性別 女　出生 1962 年 6 月 26 日

姓名 莫．骄　性別 男　出生 1958 年 4 月 22 日

　　自願結婚，經審查
合於中華人民共和國婚
姻法關於結婚的規定，
發給此證。

發證機關

發證機關

1986 年 9 月 10

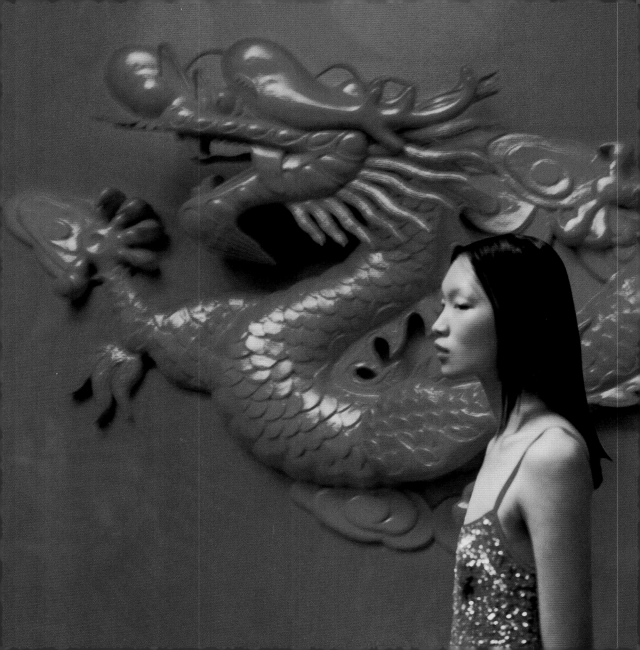

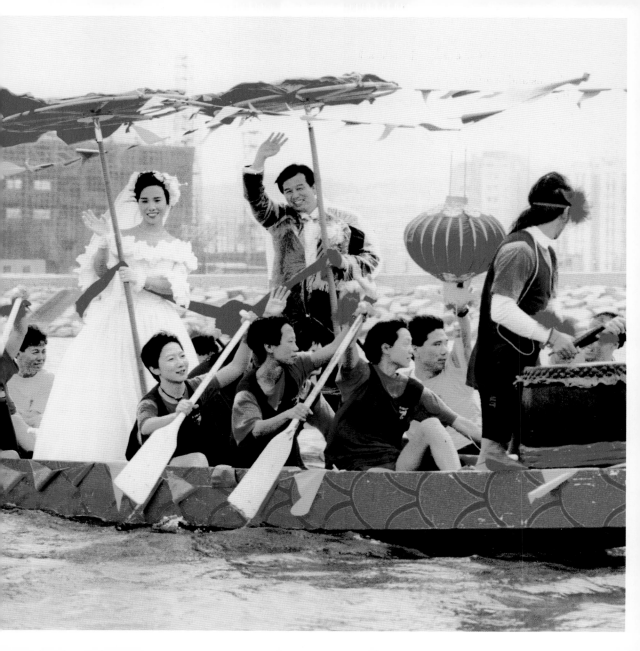

clothes and overpower them. But the red actually makes the designs look much richer and gives them more power.

In China red stands for joy, passion, justice, triumph, and righteousness. In clothing it brings light to the face and energy to the body. It makes the skin glow and the hair shine. I learned this from wedding design. In Hong Kong everything connected to weddings was decorated in bright red. Chinese-style wedding invitations were printed on red pasteboard, and even the traditional Chinese wedding cakes and pastries were packed in bright red boxes. I used to buy them just for the packaging. On my first trips back to China later, I saw that red was the primary color of wedding bed linen and housewares. I bought yards and yards of red fabrics: deep shades of crimson and maroon printed with bright oranges, greens, and blues. The color combinations were strong and powerful and taught me the positive power of red. The wedding prints—a combination of peonies, chrysanthemums, peacocks, and parrots—made me happy.

The Chinese have a saying: "Good things come in pairs." That's why you have two chairs in a hallway or two matching tables. Scrolls are hung in pairs, each one inscribed with half of a couplet. The dragon and the phoenix are a heavenly match, representing mythical male and female power.

I've used the double happiness, or *shuangxi*, character in my work and in the interior of my stores and offices. I like to use it as a cutout design in the wall. The strong geometric shapes play with space, acting as both a window and a screen. The shape is very modern and graphic, like an abstraction of two people holding hands—but it also has meaning, because it's the Chinese symbol for a happy marriage.

Xi by itself means joy. It's perfectly balanced and symmetrical by itself, but when you double it, *shuang*, the character becomes even more solid.

The original meaning of the double happiness character goes back to the Sung dynasty. At the beginning of his career, the famous statesman Wang Anshi sat for the grueling imperial examinations. On his wedding day, just as he was about to marry a beautiful woman from a noble imperial family, he was told that he had not only passed the examination but also earned the highest score. He was so happy that he wrote the character for happiness twice and joined them together—to express his double joy.

Doubling creates a space and also an opening, because when you place two things next to each other you've automatically made an entrance to walk through.

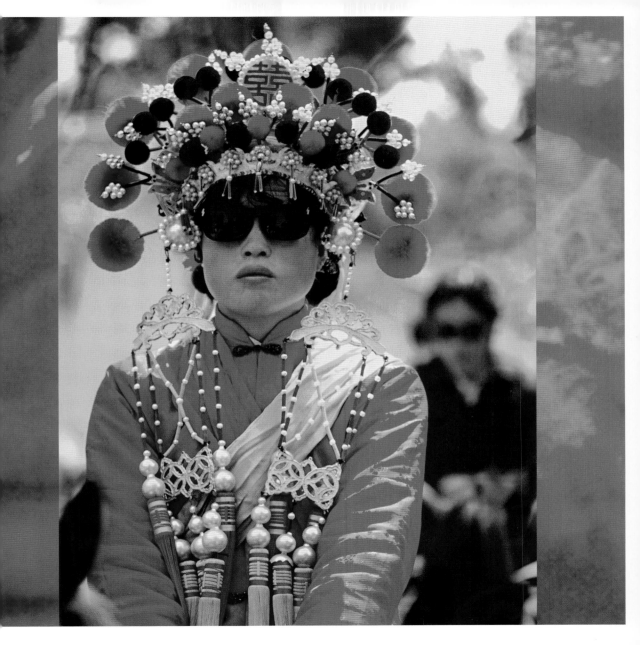

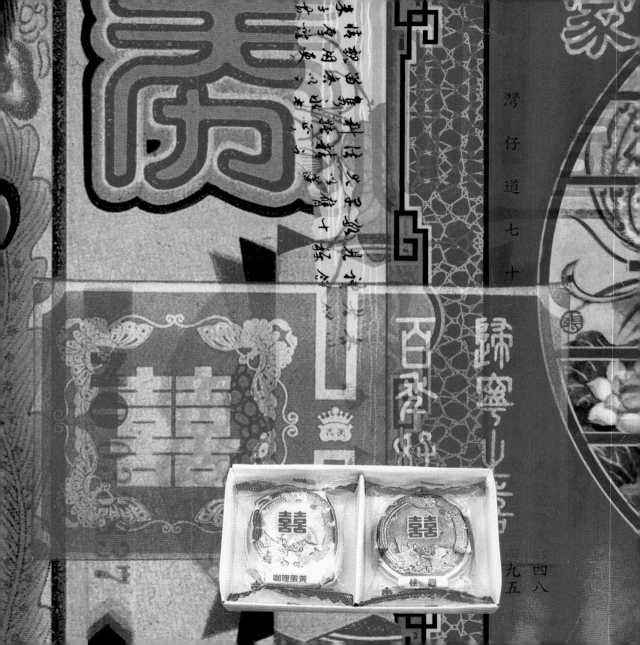

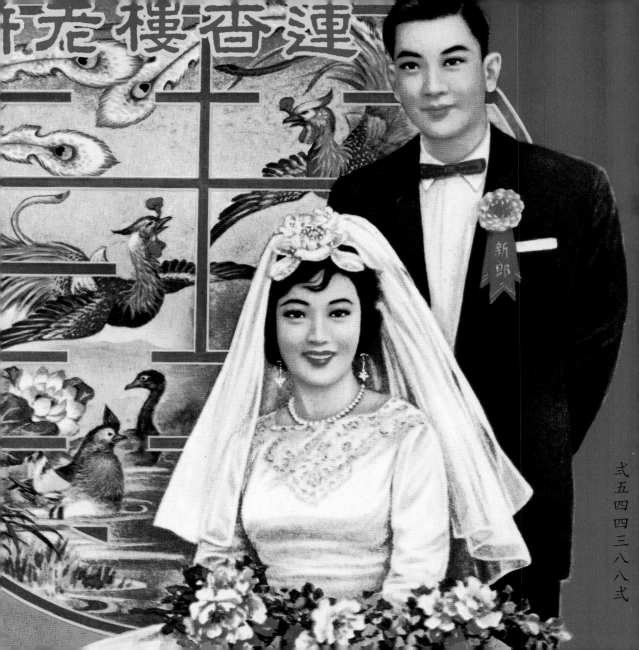

WEDDINGS

Today, marriage in China is still a family affair. Even if the couple is a love match, on the wedding day the ceremony and ritual emphasize a union between two houses, and the hope that the family line will be carried forward with children, especially sons. The gifts and the dowry are from one family to another, and the practice of having a little boy from either the bride or the groom's family roll around in the future marital bed puts a lot of emphasis on having a son right away. Friends may scatter lotus seeds under the bride and groom's bed pillows to symbolize the hope for lots of children.

The bride may choose a Western wedding dress, but still keep some of the symbolic rituals that tie the families to their cultural past. Something as simple as arranging the bride's hair is filled with traditional meaning. The brushing motion is supposed to weave a kind of spell, one stroke for a good marriage, another for many healthy babies, and a third for sons.

On the day of the wedding, the groom comes to the home of the bride to take her to the marriage ceremony. All the bride's friends pretend to guard her, and won't let him see her until he pays them "lucky door money" counted out in nines. Whether it's $999, $99.99, or $9.99, the point is that the word for nine, *gao* in Cantonese or *jiu* in Mandarin, is a synonym for "everlasting," and that's what everybody hopes for the marriage.

After the wedding, the banquet is a huge theme party, and all the food and decorations are about couples and pairs. The tables are round, symbolizing a perfect union, usually with twelve seats to a table, which can number anywhere from twenty to over a hundred. In Hong Kong, the groom's family traditionally pays all the expenses, and the number of tables at the dinner is a status symbol, so there is always a lot of discussion about it between the families. The tables are laid in every shade of red and may be decorated with a pair of polished coconuts carved with double happiness symbols. The bride and groom can be given colorful *duilian,* a pair of scrolls inscribed with a poetic couplet wishing them a long life, happiness, and many children. As the bride toasts each table, the guests drape her in gold and silver necklaces for prosperity, or the couple is presented with peaches for long life and pomegranates for fertility. The names of each dish symbolize eternal union, children, and a happy life. For dessert there is sugary lotus seed and almond soup, symbolizing a hundred years of sweet happiness.

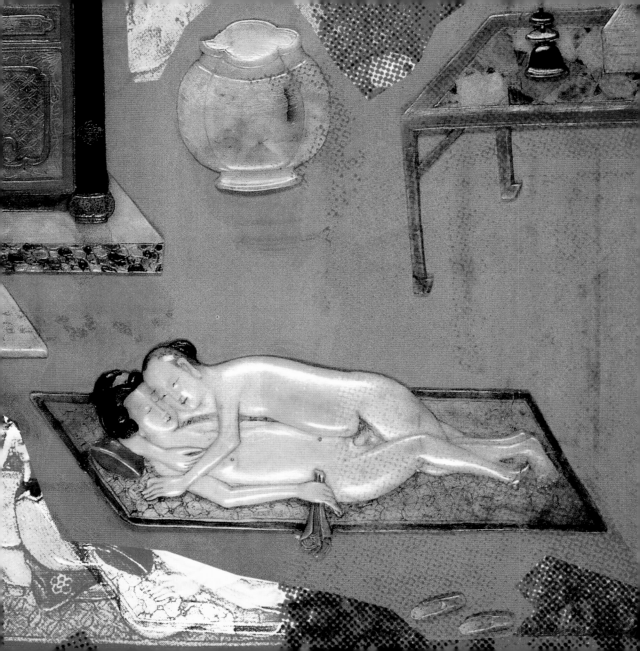

BUTTERFLY LOVERS

My favorite love story, the Butterfly Lovers, begins with a young girl who will do anything to be able to study the Confucian classics, but it's unheard of for a girl to show herself outside the house, much less sit in a classroom with male students. Her parents refuse to let her attend classes, and she begins to pine away, so much so that they start to worry about her health. One day, a young man comes to the gate of the house and claims he has the cure for their daughter's ailments. But after he writes his prescription, he tears off his disguise to reveal that this "doctor" is in fact their daughter. Because her new disguise has fooled them, her parents agree to let her attend the Confucian academy. In return, she promises to return to them on her sixteenth birthday.

On her way to the school, she meets a young scholar. They become great friends, and decide to be roommates. Over three years they become closer and closer, and a friendship grows that would normally be impossible for a man and a woman. On the eve of her sixteenth birthday, the young girl sets out for home, but not before leaving her friend a note in which she reveals her true identity and expresses her love for him. As the student reads the letter, he feels a sense of great relief. He is overjoyed that they can come together as man and wife and consummate their love for each other.

He travels as quickly as he can to the home of his beloved, but by the time he arrives she is already betrothed to someone else. In despair, he dies of unrequited love. When the girl hears the news, she swears that she will join him. She requests that her bridal procession stop at his grave before going on to her fiancé's home. In her bridal dress, she kneels before the tombstone. The burial mound magically cracks open, and she jumps into the grave to join her true love. They return to the world together as butterflies, fluttering around the grave.

Believe it or not, this is considered a happy ending, because the lovers end up together, even if they have to die to do it. In most Chinese romances, one or both of the lovers die and they never get together—when it comes to love stories, the Chinese don't raise unrealistic expectations. The stories are celebrations of great passion, but they nearly always come with a warning.

Traditionally, in Chinese society everybody had his or her place. There were five relationships: between ruler and servant, parent and child, husband and wife, older brother and younger brother, and friend and friend. There were four classes: scholar, farmer, craftsman, and merchant. To cross these lines was to create disorder.

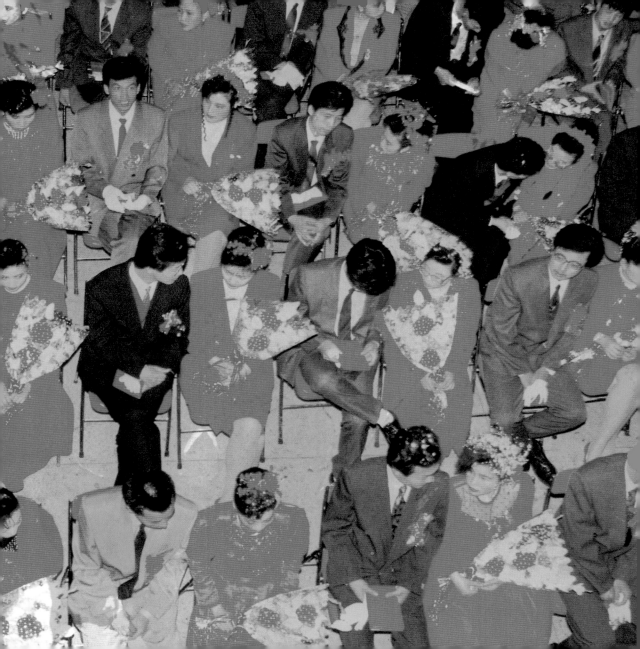

In Chinese love stories, fate is the most important element. According to legend, marriages are predetermined, and when babies are born they are matched in heaven by tying their feet together with a red thread—this is *yuanfen,* or predestined affiliation. No matter how far apart they may be born on earth, they will be fated to meet. *Yuanfen* is a kind of hope, making romance practical so that you can live with your desire: if things don't work out in one life, there's still a chance in the next. Lovers fated to meet travel together through time and lives. In Hong Kong, women wear a piece of jade around their necks, not on a gold chain but on a skein of red silk. Both the jade and the silk are a sign of the gods' protection.

Lovers in one life may never run into each other, each feeling that something is missing. In another life they may meet, but not recognize each other until it's too late. Or they may recognize each other, but their position in life may not allow them to be together. The improbability of finding a fated match is so great that people try to even the odds by consulting the almanac. In traditional times, matches were approved only after the fortune-tellers calculated the birth dates of the prospective couple. The animal horoscopes were consulted too—maybe someone born in the year of the dog was a good match for someone born in the year of the tiger. Only occasionally do fated matches manage to find each other, and this life must be treasured to the last drop.

Traditionally, matchmakers brokered marriages between families. The phrase *mang hun ya jia,* or blind, deaf, and dumb marriage, referred to couples who often didn't even meet until the ceremony. Child marriages were also arranged; a family purchased a young girl as a "wife" to their infant son to have the benefit of her housework before the son grew up. Sometimes, a husband and wife didn't even meet at their wedding. In 1905, the United States passed a new law setting a quota on the number of Chinese who could enter the country. Women could not enter unless they were married, and men couldn't go back to marry because they might not be allowed back into the States. So marriages took place by proxy—with a rooster in the groom's place. The two didn't meet until after her arrival in the States. In the early twenties and thirties in China, many young intellectuals caught in these "blind marriages" went away to university and often made a second, more modern love match. Of course, with first wives and children back in the country, they were always torn between two worlds. But it was their *yuanfen.*

LOVE CAN BE A MANY-SPLENDORED THING

I work in fashion and many of my colleagues and friends are gay. In Hong Kong the popular term for gay is *tongzhi,* or comrade: *tong* means the same, and *zhi* means will, ambition, or desire. After 1949, that common will was communism, and *tongzhi* was how people addressed one another—everyone was Comrade This or Comrade That. I would have been Comrade Tam. The term fell out of daily use after the Cultural Revolution ended in the mid-seventies. In the late eighties, activists in Hong Kong decided to use the word *tongzhi* to describe homosexuality, instead of the more clinical term *tongxinlian,* same-sex love. At first it was supposed to be a bit of a joke, an ironic play on words, but gradually a whole body of thinking about *tongzhi* culture developed. Today, *tongzhi* doesn't just mean gay or lesbian, it can mean anyone who believes in accepting differences.

When I asked young people about *tongzhi* culture, they emphasized the differences with the West. Family plays such a big part in Asian society, and people define themselves more by their place in the family than by their sexual orientation. *Tongzhi* are no different. They are less confrontational about their lifestyles, although they continue to look for love. Often the worst pressure is not discrimination, but the unrelenting pressure to marry and have children regardless of sexual orientation. Today there is a new version of Butterfly Lovers in which the boy is gay and when he discovers his friend is a girl, he is so shocked and disappointed that he dies.

The idea of *tongzhi* brings an added dimension to double happiness—a new idea that really comes out of a meeting between East and West, male and female, old words and new meanings. It's also a way of finding a more balanced perspective on gayness. Traditional Chinese society was sometimes more tolerant of differences. Homosexuality has never been illegal in China—except in Hong Kong, where the British imposed their own laws.

When I was working on this chapter, I realized that while the aesthetic of Chinese weddings is clear, the search for individual love and family commitment isn't. I wanted to go beyond the traditional ceremonies and symbols, and when I heard about *tongzhi* culture, it seemed like a good way to do it.

The point about using the word *tongzhi* is that comrades are not defined just by sexual orientation but by shared beliefs—in this case tolerance and openness.

YOUNG COMRADES Interview with Franco and Justin

Franco and Justin belong to a university *tongzhi* group in Hong Kong. Franco is a lesbian; Justin is gay. I asked them to tell me about their lives and about *tongzhi* culture, which became a hot topic of discussion in June 1999 when activists tried to declare a traditional festival, Dragon Boat Day, Tongzhi Day as well. They argued that the celebrated statesman-poet from the Han dynasty who committed suicide on that day had actually been in love with the emperor and died of unrequited love. When I asked the students their opinions, I was surprised that they felt very strongly about the practice of "outing," even if the victim had lived over two thousand years ago.

VT: What did you think about turning the Dragon Boat Festival into Tongzhi Day?

J: I understand the strategy of the organizers, who wanted to say that there were gay people in Chinese history, but I don't know if this is the best way to do it. There's no real proof the minister was gay. His poems are famous, and maybe if you read them one way he might sound gay; but that's just a matter of interpretation.

F: It's more fair to pick someone who is living who can defend himself.

VT: What's it like being gay in Hong Kong?

F: We feel a lot of pressure. Many people here still want to criminalize homosexuality; they think it's abnormal. So it's difficult to express our feelings to family, friends, relatives, and teachers. I think I've known I liked women since I was eleven. When I decided to tell my family, I consulted other people to prepare myself. I brought my girlfriend home to visit five or six times, and at first I just introduced her as my friend to prepare the ground. When I finally told my mom her reaction was okay, but she wasn't very happy. My girlfriend hasn't told her family yet. When I visit her, I go as a friend.

J: I didn't know I was gay until I was nineteen, just a few years ago. When I was young I looked

at guys instead of women, but I never thought it was different. Then one day I came across a magazine, the Advocate, and I knew. I began to feel different. I came out to my dad last year. I wrote him a letter before I went away on holiday. I was afraid of what would happen. I thought the worst thing was that he would kick me out. But he wrote me a letter back, saying that he felt terrible and he couldn't understand what I was doing. He said there was no way God created homosexuals—"God created Adam and Eve, not Adam and Steve!" He told me he wanted to help me with my disability. I refused, of course, and I yelled and argued with him. Then I tried to prove I was the same as I'd been yesterday, his son—I tried to impress him by being a good son. I did the chores. I made an effort. Gradually the situation became better when he realized I wasn't going to change. He didn't kick me out; he just stopped talking about it. He never even said the word "homosexuality," he just referred to it as "that thing." The turning point came when I asked him for the admission fee to the 1998 Tongzhi Conference in Hong Kong, which was quite high—HK$1,000, or about US$150 (because the conference wanted to subsidize the tongzhi who were coming from Beijing and Shanghai). I didn't say what the money was for. He knew, though, and he said, "If you can't afford it, don't go." I stopped asking. The next day, when he left for Canada, he gave me even more money than I'd asked for. He said, "Take this and buy yourself some clothes." This is a tacit response.

VT: You mentioned tongzhi in the PRC. What's it like for them?

F: I've had some correspondence with a tongzhi in Qingdao in northern China. He wrote because he found our group's address in a magazine. The open environment here surprised him, because it is so oppressive where he lives.

VT: What about gay life in the West? Do you think things might be easier there, or that you would be happier somewhere else?

F: I just relate my life to local culture. Of course I wish it could be better here, but being gay has made me more thoughtful about my family, my friends, and myself. It has made me more mature. Being straight would create other problems that I don't have to deal with now.

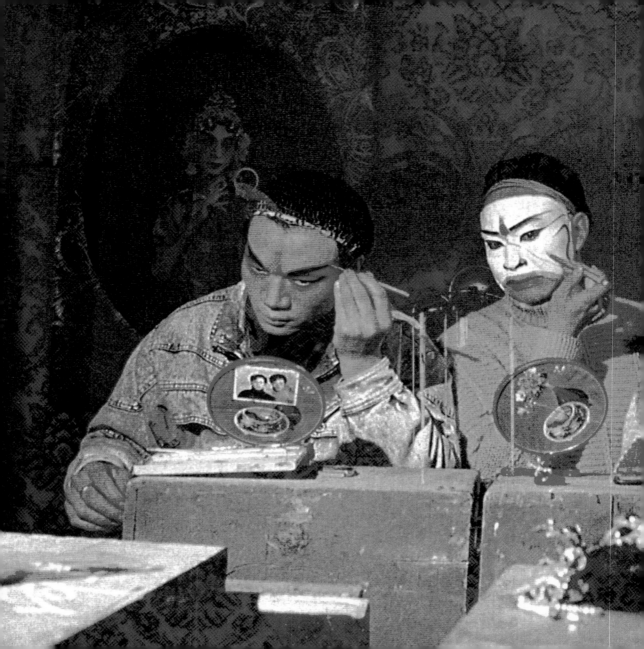

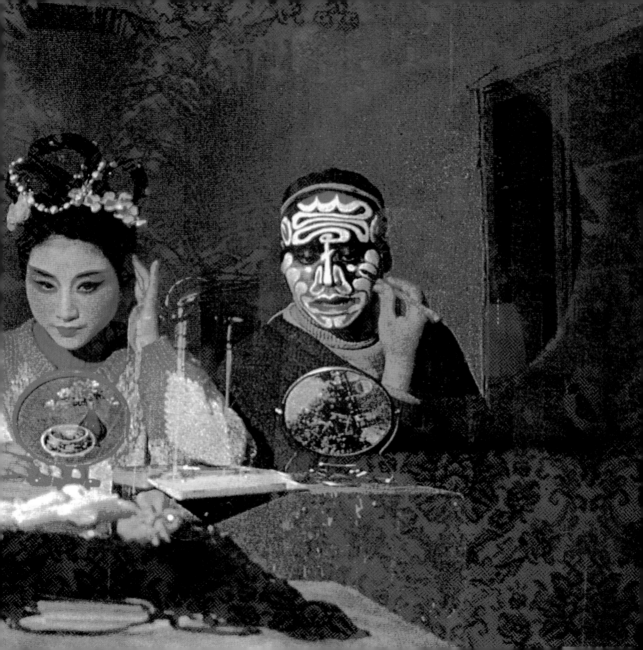

CHINESE OPERA

The pageantry of the Chinese wedding and the fashion show come together in Chinese opera too. I was raised on Cantonese *kunqu* opera. *Kunqu* has very old roots, dating back several dynasties, but its language is still very colloquial. Traditionally, *kunqu* was performed for the people, in teahouses and temples, and also inside private homes.

Most of the Chinese folk tales I've learned came to me first through *kunqu*. I loved the drama and the color, the way a fairy-tale kingdom could be summoned just by the swish of a silken sleeve or the stamp of a platform boot. Compared to *kunqu*, Beijing *jingju* opera is young, only two hundred years old. A mix of different regional opera styles, it was designed for the imperial court, and sung in the Mandarin that became standard during the Qing dynasty.

My mother used to sing to herself while she worked around the house. I remember listening while she prepared dinner and I did my homework in the kitchen. She would sing a song about moonlight and love in a wonderful soprano voice. She taught me the male roles, and she sang the female ones. Later I heard the same songs on television, and realized that they were arias from the famous Cantonese opera *Dai Loi Hwa* (*The Emperor's Daughter*).

In the story, a young princess is forced to go into hiding to avoid being caught by an invading army. But she is betrayed by everyone, until finally she meets a brave and loyal man, her fiancé, who proves his love by committing suicide with her. It's a moving tragedy, full of suspense and drama. Everybody in Hong Kong knows the songs from this opera—Cantonese opera is different from Beijing opera, because you can understand the words, and feel the purity of the poetry more easily than in the northern-style opera, which is more stylized and abstract.

The stories were always dramatic, and from the start the costumes fascinated me—those jewels, bright colors, and rich embroidery. I loved the high architectural hair ornaments, and the long "water sleeves" of the women characters—long white sleeves that could be dropped down past their feet. They moved the sleeves so gracefully every time they came onstage, posing to express every emotion—the fluttering and waving of the rippling sleeves could represent shyness, sadness, and fear, but also confidence and passion. Onstage, there were no props other than a table and two chairs. You had to imagine the rest—a man riding a horse simply held up a flag and bobbed as if he were in the saddle, a woman in a boat held a small oar and paddled the air in rhythm, and a long time

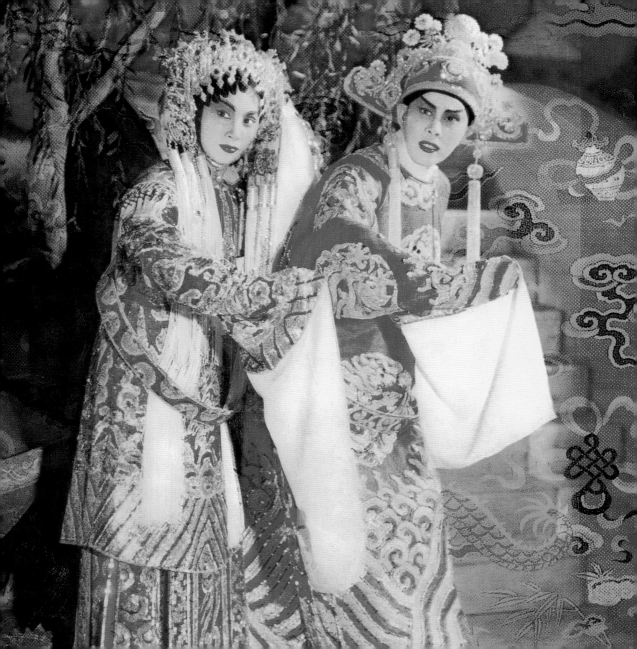

passing was symbolized by a walk around the stage. When I went home I'd act out the scenes with my brothers and sisters, trying to imitate all the steps and songs. Sometimes I put on my father's shirt and let the sleeves drape over my hands, practicing with my own makeshift water sleeves.

Chinese opera is really the love of amateurs: the man who drives the tram sings snatches while he waits for the light to change; people gossiping about a woman might describe her by quoting from an opera romance. On the street at night, you can hear small groups practicing the beat of the cymbals, the lonely sound of the *erhu*—the two-stringed Chinese violin–the voice of a person "clear singing," performing the arias out of costume. My father was a very skilled *erhu* player, but he had to give it up when we came to Hong Kong because he was too busy with work. Instead, he and my mother enjoyed the music at home and took us to local performances.

From a very early age I understood that these sounds, so familiar to me, were entirely different from the Western hymns and songs we learned in school. When I sang with my parents, the feel of the voice in my heart was strange, the vibration in my chest and throat completely new. The scales and harmonies were different—even the breathing. In school we learned to hold a note while Sister counted out the beats. My parents taught me how to rise from one note to another, and let the tone fall with my breath, like a sigh.

Chinese opera is full of cross-dressing. The women in Beijing operas have often been played by men; in fact, the most famous leading "lady," an icon of Beijing opera, was Mei Lanfang. He set the standard for feminine beauty and grace for a whole generation, beginning in the early 1900s. He became world-famous, performing in Europe, the Soviet Union, and the States, keeping company with Bertolt Brecht and Charlie Chaplin. Few remember his performances today, but just saying his name conjures up an image of the ideal woman. He had a soft face with a very white complexion, and large darting, sparkling eyes that could be flirtatious and lively or tragic and mournful. It's said that as a child he trained his eyes to dazzle by focusing on the path of swallows darting high in the skies. His hands were supple and expressive, trained in the hundreds of movements required by Beijing opera, each one signaling an individual mood.

One of his most famous roles was Hua Mulan. The story of Mulan, the young Chinese maiden who disguised herself as a man and went to war for her family, is so inspiring. She was so brave. I loved the rhyming song we sang as children—*tsik tsik fuk tsik tsik, Muk lan dang mun tsik*— Click click, click click, Mulan weaves with her shuttle by the doorway . . .

I love the twist of a man playing a woman who was pretending to be a man. The masculine and feminine sides of any person are fully exercised in Chinese opera. I was also a big fan of Yam Kim-fai, who was a Cantonese opera star famous for her portrayal of male scholars. She was part of the *kunqu* tradition of all-women troupes that performed just for ladies. With another female star, Pak Suet-sin, who played ingenue parts, they became one of the great romantic couples in Cantonese opera and film. Yam was so strong and handsome—even offstage she dressed in men's clothing to stay in character, and she and Pak lived together in private life. Their greatest success was also everybody's favorite—*The Emperor's Daughter*. We all knew the lyrics.

When I visited Shanghai later, I went straight to the Chinese opera shop and bought all the opera accessories I could find—hairpins and jewelry, arm cuffs, shoes, and robes. I even bought the makeup and tried to experiment on myself. It was a way of getting inside the opera, touching it with my fingertips and feeling it against my skin.

I loved *Farewell, My Concubine,* the film by Chen Kaige based on the novel by Lillian Li. In the story of a young boy trained to play female roles, the ritual and detail of life in the Chinese opera were exposed in all their beauty and cruelty. Beginning from the age of five or six, children were bought from their families and put through a grueling regime. Their personalities were formed by the roles they played. Boys and young men were drilled in voice, acrobatics, and mime. If they were good they became stars, adored by women and men. Born out of pain, their ability to create the illusion of man, woman, beauty, and sadness inspired passion, lust, and beautiful romantic poetry.

The crowd scenes in the movie reminded me of the first *jingju* opera I saw, twenty years ago. It was in a formal traditional Chinese theater with seating at separate tea tables placed below the stage. During the performance the audience was served tea from a huge copper pot with a long spout and little pastries stuffed with sweet bean paste and sesame seeds. The plays were historical, and there were fancy acrobatics and martial arts. The words were incomprehensible, and I had to keep turning away from the stage to check the translations scrolling down the side of the stage. But it was all there, between the tea and the sweetmeats—my favorite water sleeves, all the drama and the color. And at the end people clapping and yelling *"Hao! Hao!"* for "Good! Good!" I love that sound. It's better than bravos.

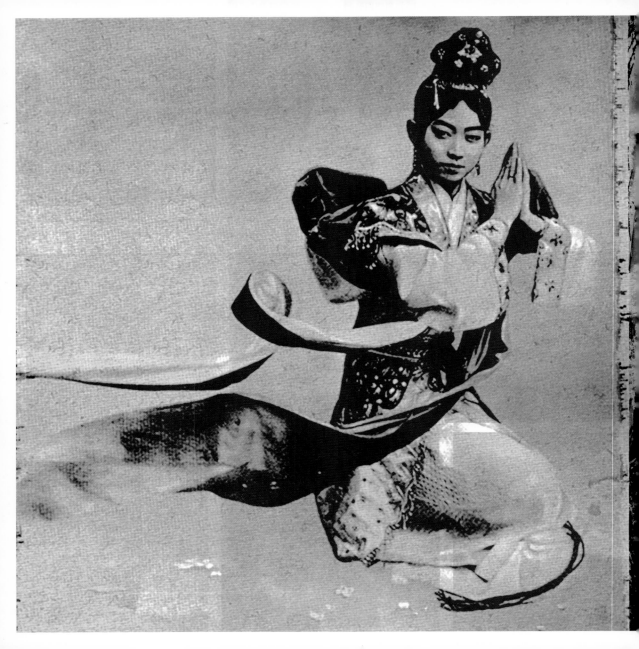

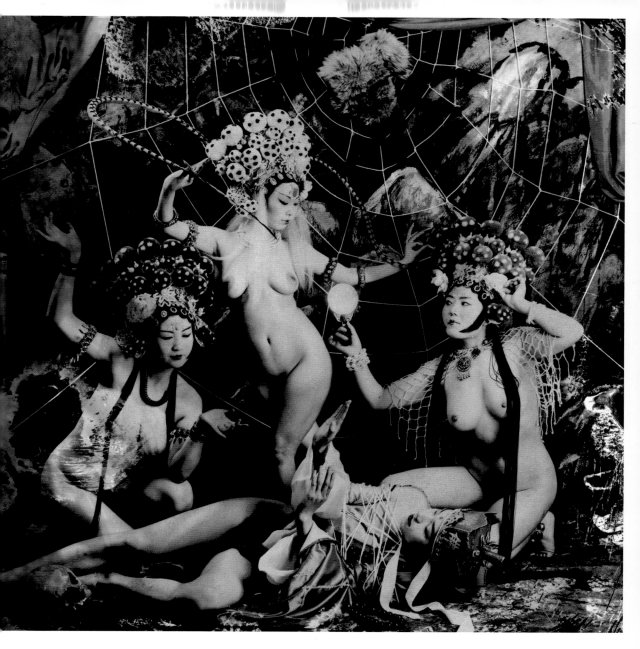

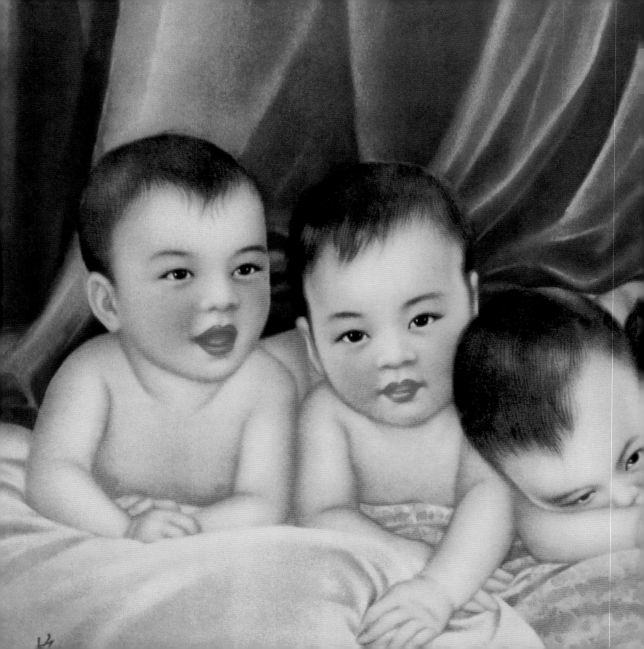

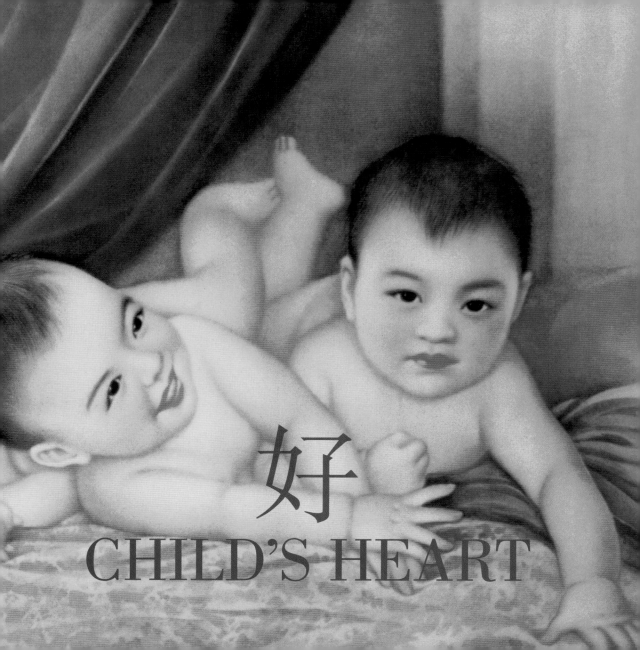

CHILD'S HEART 好 *(hao)*

Combining the elements of woman and child, or boy and girl, this character is pronounced hao. It means good or beneficial, an ideal condition. A word used for affirmation, it's also the most common expression for okay or even yes.

PURE CHILD

Images of children are about liberation. Children are born free. Babies have no fear. As you become an adult you begin to fear; this is an impurity. Babies' faces really show what they are feeling. They might be surprised or annoyed, but never scared, because they don't know what fear is.

In traditional times, the arrival of a child was a celebration for the entire community. Almost every house had a New Year's poster on the wall—usually a big fat bouncing baby with rosy cheeks and strong arms and legs, wrestling with a fish or holding a peach—both symbols of good luck and long life. People hung these posters to express good wishes and ensure protection for their children. Even today in China and Hong Kong, a pregnant mother is encouraged to look at these illustrations. Gazing at them is supposed to calm the mother and help her focus good thoughts and feelings on the child inside. This will help the baby become healthy and good-looking. The Chinese have a whole system of *taijiao*, prenatal or womb education, which includes listening to beautiful music and looking at pretty objects.

After the birth of a child, friends and neighbors contribute small scraps of fabric for the mother to stitch into a "Hundred Families" coat for the baby; it represents everyone joining together to protect the child. In my own family, the first month after each child was born, my parents gave away eggs dyed red to symbolize sharing their happiness. After the first fifteen days, my mother prepared a special stew to warm the body and rebuild her womb. When friends came she shared it with them. Ginger and brown sugar were steeped in black vinegar, and sometimes a hard-boiled egg was added. The combination was very warming—the heat of the ginger and vinegar and the meaty protein of the egg. My sister loved the taste, but for me it was too strong—even the aroma created a kind of energy when the pot was brought into the room.

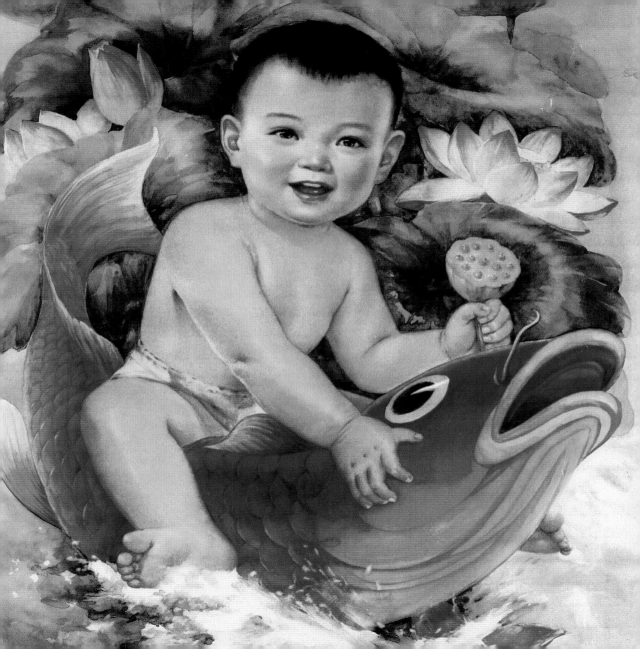

The naming of newborn children has always been very important, reflecting the hopes of the family and the child's place in the larger community. Traditionally, a child was given a three-syllable name—the first was the surname, the second designated generational standing in the family's history (brothers would share the same generational syllable, and sometimes, in a more enlightened family, sisters too), and the third syllable was the child's own personal name.

After the founding of the People's Republic of China in 1949, many families dropped the generational syllable, because it was considered feudal. Children didn't just belong to the family, they belonged to the nation. They were given names related to the New China, like Jianguo, "Build the Nation," or Jingsheng, "Born in the Capital City." In the fifties, when China clashed with America in Korea, names like Weiguo, or "Defend the Nation," were popular. Later, during the Cultural Revolution, shorter names were the style. One-syllable names like Dong for "East" or Hong for "Red" seemed terribly modern—strong and to the point, without any possibility of being mistaken for a two-syllable generational name.

Today, it's possible to tell people's ages or where they are from by their names. In Hong Kong, if you go to the post office or bank where the clerks' names are posted at each window, you will see that maybe seven out of ten names are about welcoming money or good luck. I have friends from overseas with names like "Thinking of the Source" or "Descendant of China." So the practices in Hong Kong and the People's Republic are not that different, just the ideologies and the sentiments.

Life is precious in China, so children—new life—are the most precious of all. When I was small, I helped my mother pick and match scraps to make a quilted carrier, and then I carried my sister in it. Making the carriers is still a traditional art. It begins with a square piece of fabric. Long straps, four to five inches wide, usually in a traditional flower print, are added at each corner. The main section, which touches the child's body, is embroidered or appliquéd with protective symbols like the characters for double happiness or longevity, or peaches and fish for fertility and wealth.

In China they make baby carriages out of bamboo, or build a small wooden box on wheels with a glass window. But to me the child seems very isolated this way. When I wore the carrier I felt very connected to my baby sister. I could feel her wiggling when she was restless and her heart beating as she slept. I loved walking around with her, the heaviness was a nice responsibility; it made me feel more grown-up. The carrier was very practical—my hands were always free. But you can't carry a baby around like that all the time; she may end up with duck feet. At least that's what my mom used to say.

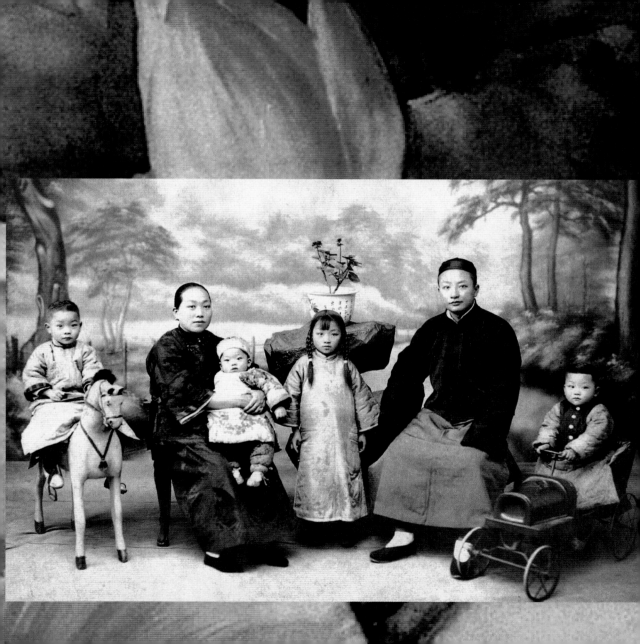

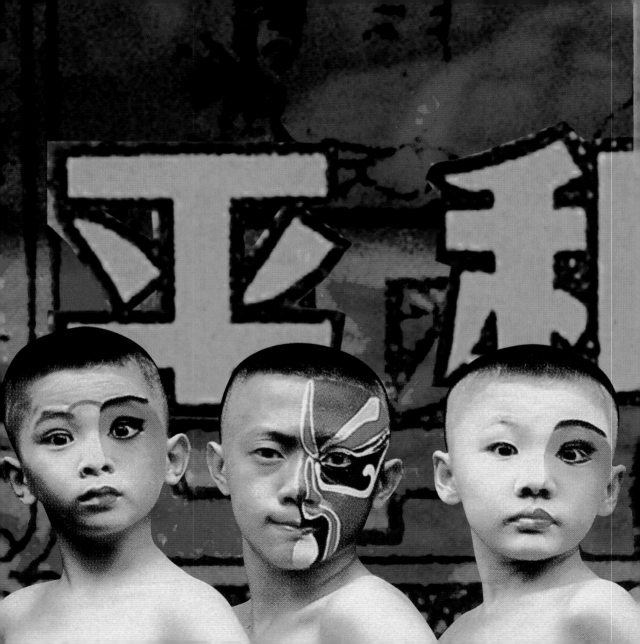

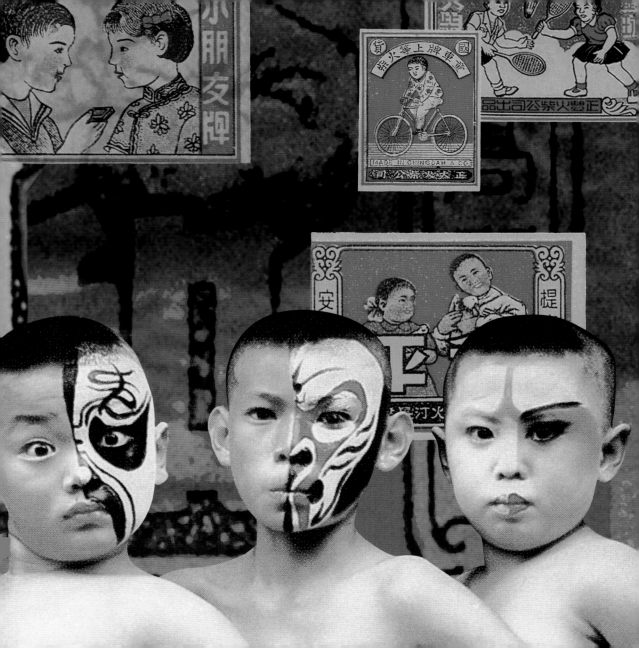

CHILD'S PLAY

A child's eye is so pure, different from that of an adult. Chinese philosophers talk about the child's heart, and how we should try to recapture it. The Taoist philosopher Lao-tzu says a baby can scream all day and not become hoarse, because her harmony is at its height—her bones and muscles are soft, but her grasp is firm. I love this image of weakness and strength. The late Ming Buddhist philosopher Li Zhi said a child's heart is a true heart—without it, one cannot be a true person.

Children are creative with limited resources. A friend of mine took apart his radio as a child because he didn't like how the outside casing looked. Then he discovered the inside, the vacuum tubes and the electric wiring, and he painted them black for texture. He used a black cord to hang his new radio on his white bedroom wall—it still played music! Another friend converted her bedroom into a mini art gallery by tearing off the covers of her father's *New Yorker* magazines and taping them on the walls. Then she and her sister decided to polish the floor to make it as shiny as a mirror, so you could see your face like in the television commercials. They pushed all the furniture aside, put half a jar of their mother's cold cream on the linoleum, and skated around barefoot the whole afternoon. No adult would ever think of that, only a child.

Living in crowded Hong Kong, we didn't have much personal space to decorate, so we concentrated on the spaces we could carry with us. I braided my hair differently every day and made hair accessories out of colored fishing wire, beads, and sequins. I made pencil cases out of different fabrics, and covered textbooks and notebooks in multicolored papers. And, of course, I was always making things to wear.

When I was small, people asked me, What do you want to be? I said I wanted to make clothes. By the time I was eight years old, I knew how to do different kinds of needlework and crochet. I wasn't interested in dolls, but I loved playing dress-up with my little sister and brother. I was fond of curly hair when I was a child, and I was sure I could give my sister Shirley Temple ringlets. After watching my mother curl her hair with plastic rollers, I invented a way to roll my sister's hair with two toothpicks twisted together, bending the ends to hold them in place. I was extremely excited as I waited for her hair to dry. We carefully pulled out the toothpicks, and beautiful springy curls came bouncing out. After that, I did it every time she washed her hair. Then I would drape her in different fabrics, wrapping her in blanket skirts and knotting striped towels into blouses or camisoles. When I was a child I knew what I wanted to do.

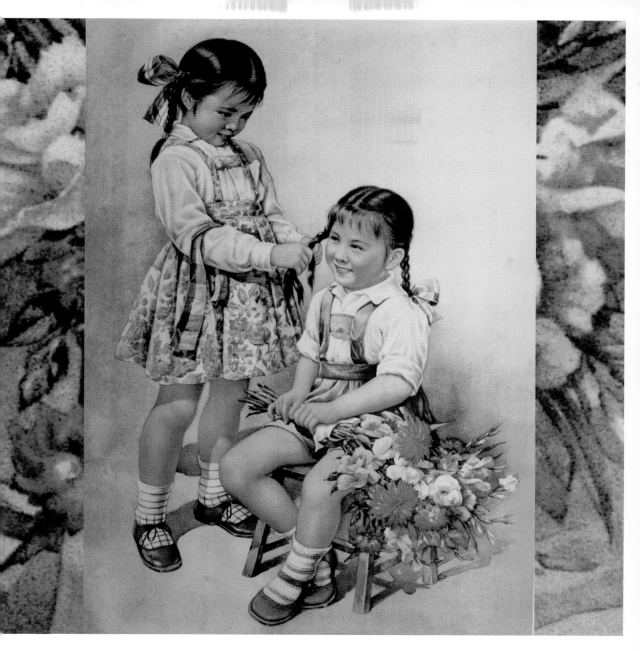

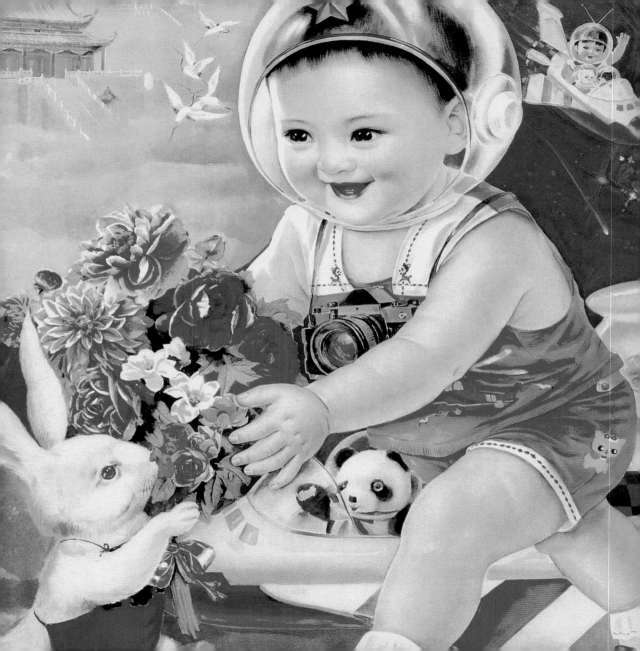

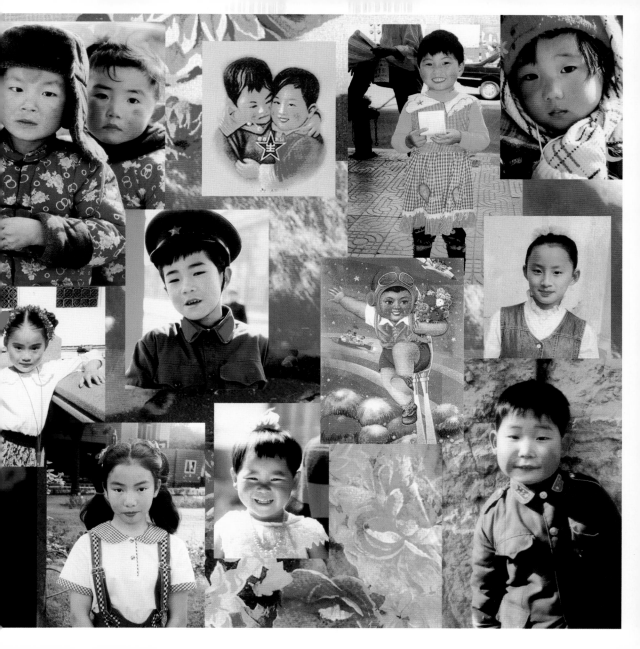

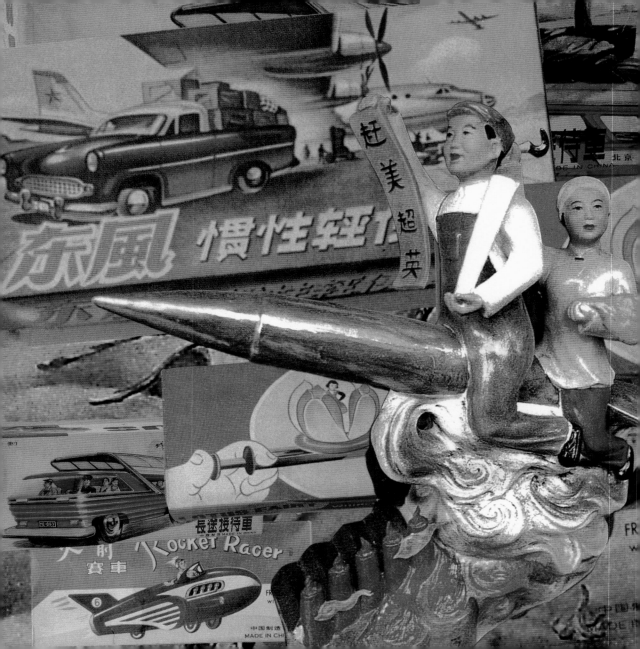

POSTER CHILD

When I went back to China in the late seventies and early eighties, the strongest graphic images were from posters, and many were about children.

The children in revolutionary posters, with their red Young Pioneer scarves, represented the pure and the strong—a New China. The way children were depicted changed along with political history. Immediately after 1949, when the PRC was established, poster children were happy and healthy, shiny and freshly hatched. By the late fifties, they were hard at work, dressed like little adults, studying hard in school, and going out to the fields to catch mice and shoot sparrows to save the crops. In the sixties, especially during the Cultural Revolution when young students were encouraged to denounce teachers and even their parents for having old-fashioned ideas, their faces began to look very fierce. By the end of the Cultural Revolution, they looked very angry.

There were also, of course, propaganda posters about birth control. In the seventies, China's population was growing too quickly, and there was a very real fear that there wouldn't be enough to eat, so the one-child family concept was introduced.

The one-child policy was very controversial, both in China and around the world. Enforcing it meant interfering with the most personal elements of family life, and people lost a lot of privacy. Couples who could have only one child usually preferred to have a son, to carry on the family name. Unwanted girls became a problem. The preference for male children has always been a Chinese family tradition, but the one-child policy exaggerated it. It's disturbing to think about girl babies being abandoned or killed in China. I was a Chinese baby girl after all, so it's hard not to take it personally.

So many only children—little emperors, the papers call them—is another problem. These children are very pampered and also very pressured. A photograph of a baby with no brothers or sisters, no cousins or extended family, is an image filled with silence—one of a lonely child who feels the pressure of being the sole focus of his family's hopes.

I remember watching children play in the park. Instead of a merry-go-round with horses, they rode on tanks, missiles, warplanes, and motorbikes. At first it was shocking, but then I saw their faces filled with innocent joy—to them that tank was just as much fun as a painted horse.

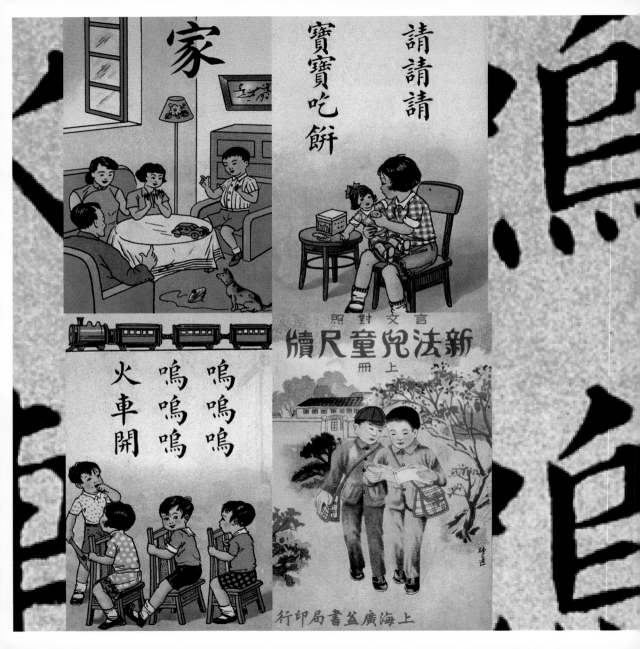

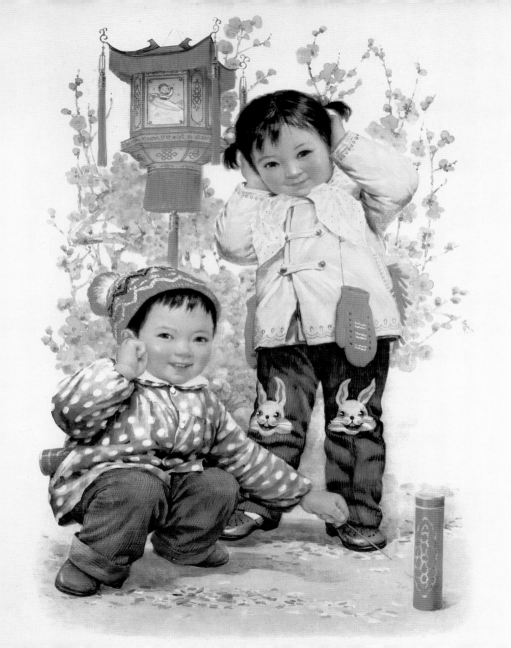

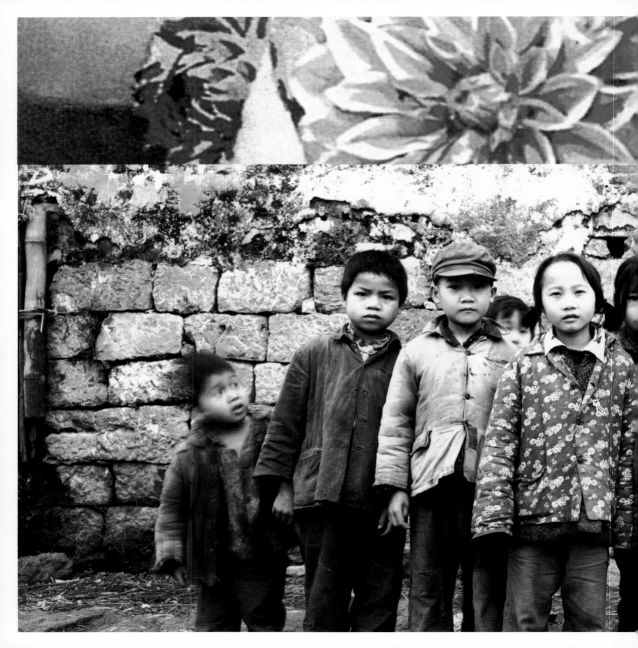

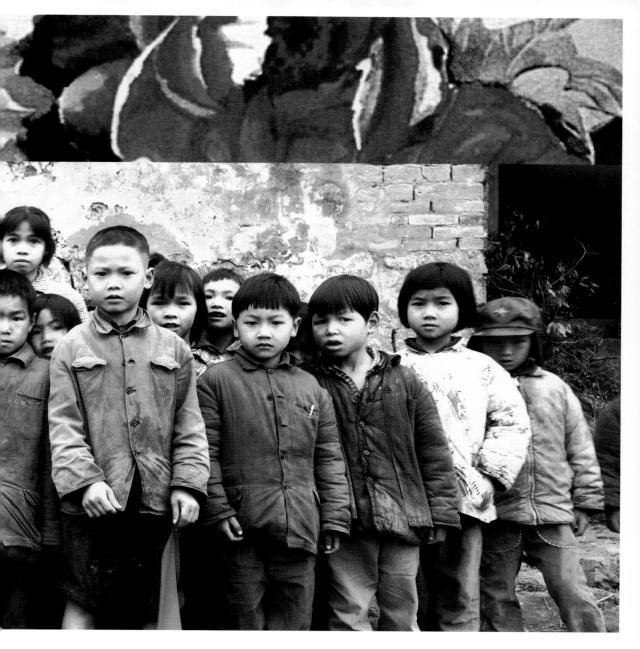

In general, children are treasured in China. This shows in the whimsy and love adults put into dressing children. When I strolled through the streets of Shanghai and Beijing twenty years ago, I was fascinated by what people were wearing. I found that no matter how plainly or poorly adults were dressed, their children were always decked out in many different colors. Adults might be limited to the blue or green of officialdom, but their children wore a neon-bright rainbow of colors. Their dress was like a state of innocence before politics could give them a uniform. Even if a child was dressed in a miniature Mao jacket, she might be wearing shocking-pink woolen leggings or shoes with bunny rabbit faces. Babies were dressed in homemade or tailor-made padded jackets in bright prints, appliquéd with ducks, chickens, or monkeys. Children's clothing was a mixture of old and new. They were dressed in traditional tiger caps to make them strong-willed, but they also wore little red scarves to show revolutionary spirit. Until they were toilet-trained, toddlers generally wore big colorful overalls, padded in winter, with a slit cut into the back. The first time I saw a mother holding her baby over the curb to urinate I thought it was funny. Then I realized how practical it was—very efficient, fast, and no diaper rash.

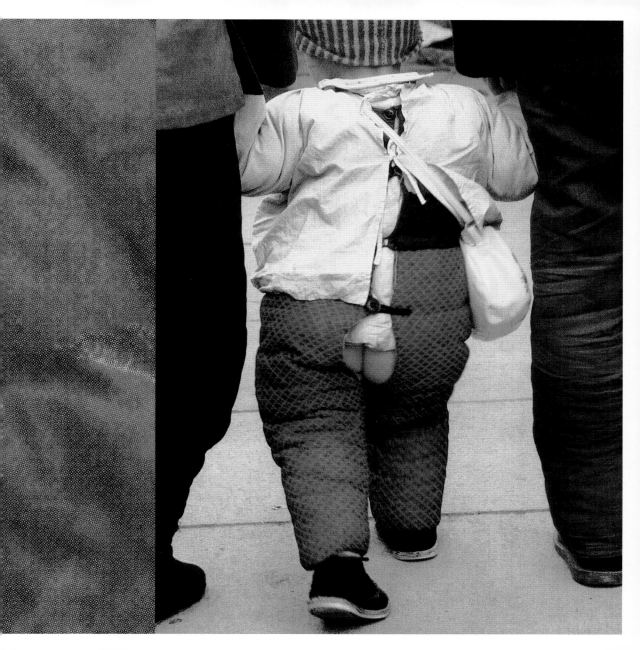

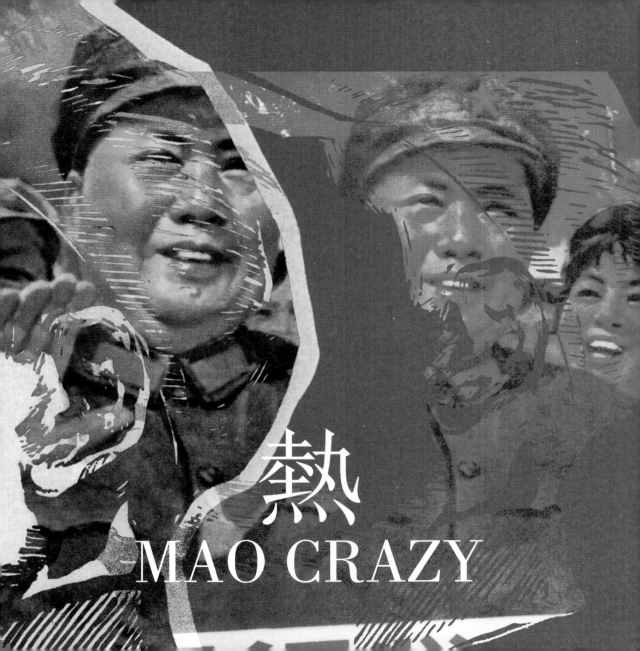

熱
MAO CRAZY

万岁！

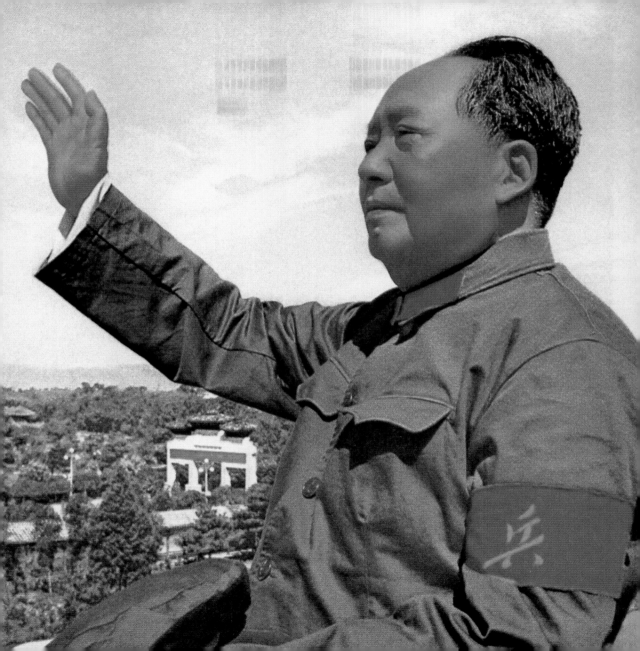

MAO CRAZY 熱 *(re)*

1. Hot. 2. Red revivals and retro revolution. Mao as a Chinese national icon is the message behind the "Mao craze" or "Mao heat." More than a fashion statement or a slick way of selling out to the status quo, for many Chairman Mao's message was summed up in one line: "To rebel is justified." But what he really meant was: Go for it; just make sure you don't rebel against me.

HOT MAO

The Cultural Revolution lasted a decade and disrupted an entire country, leaving a scar that is still healing. After a series of disastrous economic policies in China that led to a massive famine from 1958 to 1961, the Chinese leadership began a series of reforms aimed at building economic stability. Mao Zedong, who had lost some credibility, took back power by encouraging the young to challenge authority. He believed that revolution had to be continuous, that it was bourgeois to be too comfortable with the status quo. The Cultural Revolution was a reassertion of his power, and it was during this period that the cult of Mao reached its height.

During my trips back to China in the late seventies and early eighties, there were still a lot of style elements left over from this period. I would walk through the streets and just let the images and smells come at me. I ransacked bookstores and found the designs on the book covers and the propaganda posters overwhelming. There was so much history, and the graphics were so strong and powerful. I can still remember my excitement on seeing these fresh images—the strong outstretched fists clutching the Little Red Book, and the big blocks of color—bright reds, blacks, whites. It was totally different from my own visual experience. In the West, the graphics of the fifties and sixties were also very bold, but in a totally different way—at first they were strong and machinelike to show optimism and progress, then came neon-bright flower-power images. In the sixties, both China and the West were about youth and revolution, but one was psychedelic and the other was political.

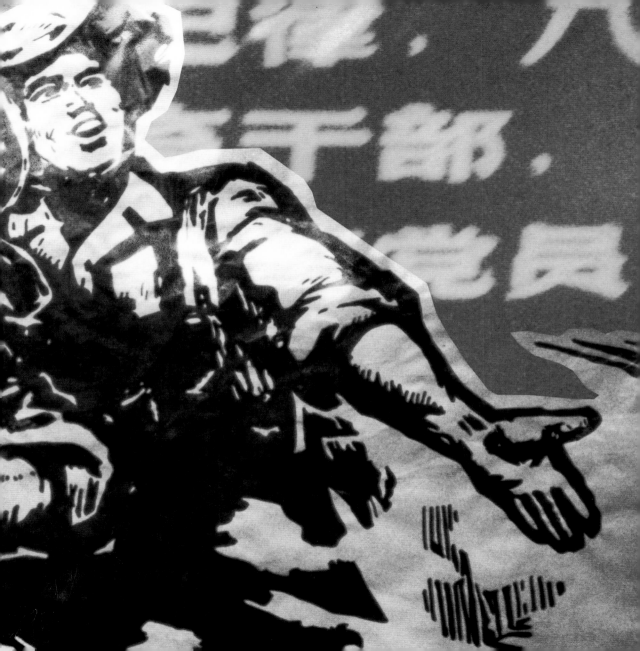

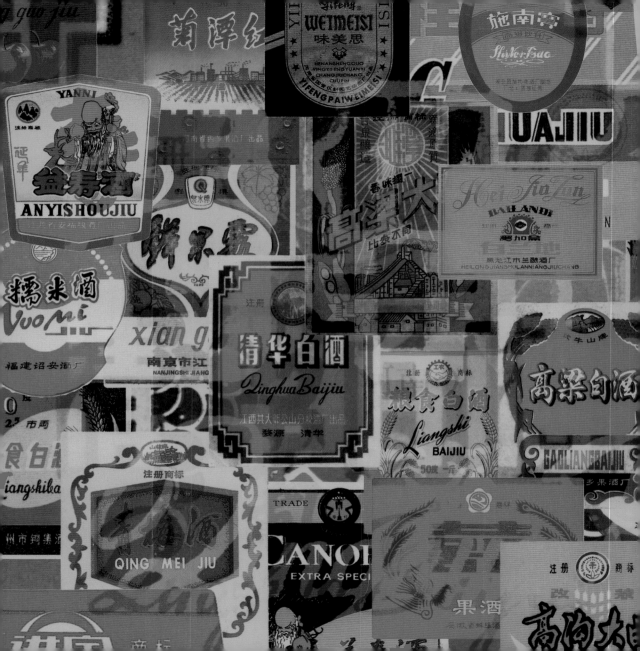

Even the writing in China was new—the script had been simplified to make it easier to teach peasants and workers to read. It was difficult for me to read, and I thought that destroying the traditional Chinese script was destroying Chinese culture. But that was exactly the point—to make even the words people used revolutionary. Today Hong Kong and Taiwan use a different script from the mainland.

The graphics fascinated me. Parts of characters had been deleted to streamline them, making them look more abstract. I'm a Cantonese speaker, and at the time my Mandarin wasn't good. I spoke with a very strong southern accent, so sometimes the only way I could interact with others was by writing. But only the older people could read my traditional calligraphy. Younger people had trouble making it out; instead they tried to practice their English with me.

I returned to Hong Kong with stacks of propaganda posters and Cultural Revolution souvenirs, including many portraits of Chairman Mao Zedong. The power of Mao's image is very important, both his face and his unique handwriting. His brush strokes had a lot of style and power: rhythmic, very quirky, and a little wild. His inscriptions were like an exuberant ink landscape. The first one I saw was plastered across one end of the arrivals hall at Beijing's Capitol Airport. His slogans were everywhere, very strong, although I didn't always understand them. Maybe he was trying to live up to the sage-king image by talking in puzzles.

I noticed the influence of his language on the way people talked. They often spoke in strange contractions, and instead of four words they'd use two or cut their sentences short into sharp militant phrases so that everything seemed to be in code. It was very different from the Cantonese spoken in Hong Kong.

During the Cultural Revolution, Mao's face hung in every living room, classroom, and office. People showed their loyalty by wearing his face on a badge. They thought of all sorts of ways to honor the Chairman, drawing his face on mirrors or weaving it into wall hangings. I've found a lot of these vintage items in city antique markets. My favorite is a needlepoint image. The dealer told me that when work was at a standstill and politics took over, many people used to make needlepoint portraits of Mao as home decor. This image of someone building Mao's face with stitches, punching the needle in and out of the net, part therapy and part indoctrination, is powerful—and a little scary.

In the early nineties, the power of Mao's face made a comeback in China as people began

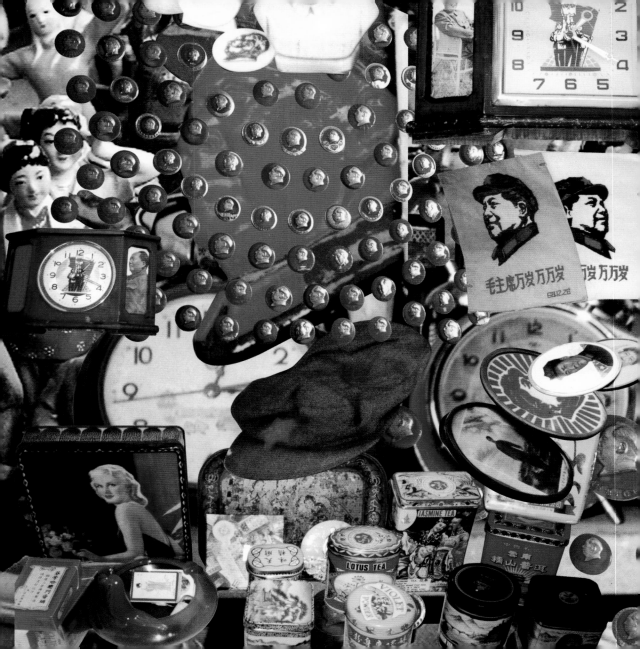

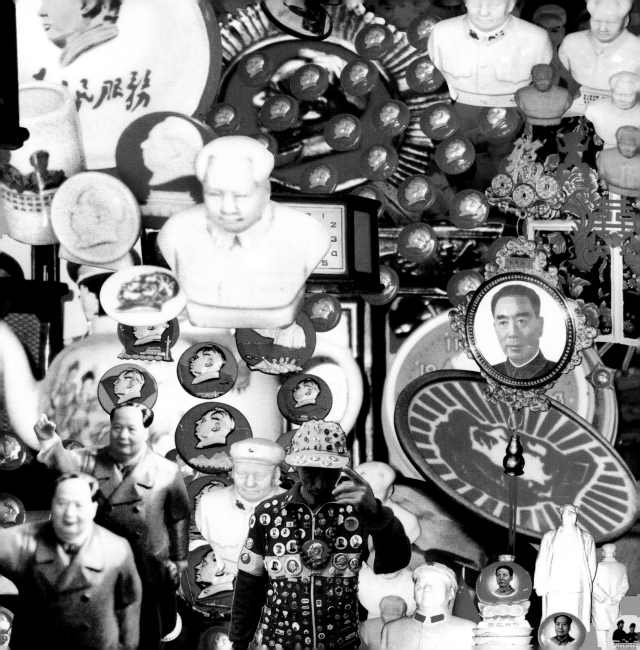

to use his image as a good-luck charm. Taxi drivers hung his picture from the mirrors, and the sewing ladies in factories had his photograph on their machines. He looked like a god, complete with halo.

In 1994, my close friend Danny Yung, a conceptual artist from Hong Kong, visited New York City. He took me to see a Chinese artist living in New York, Zhang Hongtu, who was one of the first Chinese artists to use images of Mao in his work. Hongtu's background, the concepts behind his work, and his haunting images inspired my Mao collection for spring 1995.

Hongtu had to overcome strong feelings of guilt to use images of Mao. The power of the man was still that strong. But his paintings had a great sense of humor. His art was political, but I thought I could loosen it up a bit with fashion, to represent the new openness of China. This would show its humor and warmth, and the growing freedom of its people from Mao's image.

Hongtu and I collaborated on eight images for the collection. He had done Mao with pigtails, and I added the Peter Pan collar and gingham dress—"Mao So Young." He had put a bee on Mao's nose, and I added stripes and a colored background—that was "Ow Mao." I added a clerical collar to the official portrait—"Holy Mao." We added dark hypnotic glasses, and had "Psycho Mao." A smear of lipstick made "Miss Mao," and we even tried a "Nice Day Mao" made from a yellow smile face.

When I finished the images, we applied the prints to T-shirts. To deepen the texture, I added patterns and sequins. The shimmering effect made the image come alive with movement and light. I repeated a series of four colored images to create an overall checkerboard pattern to reflect Mao's changeable character. The black-and-white woven images were more serious, symbolizing the positive and negative effects Mao had on Chinese culture. The fabric and the pattern were based on mass-produced tapestries of Mao. Since the weight was heavier, I did jackets and suits.

In the beginning, I had no idea that there would be a strong reaction to the designs. I was focused on the process of making the clothes, dealing with the visual imagery, colors, and textures. But by the end, I'd gained a lot of insight into Mao and his power.

I realized that his portrait was so powerful partly because it actually stopped people from doing things. For example, I had trouble finding a place in Hong Kong willing to print

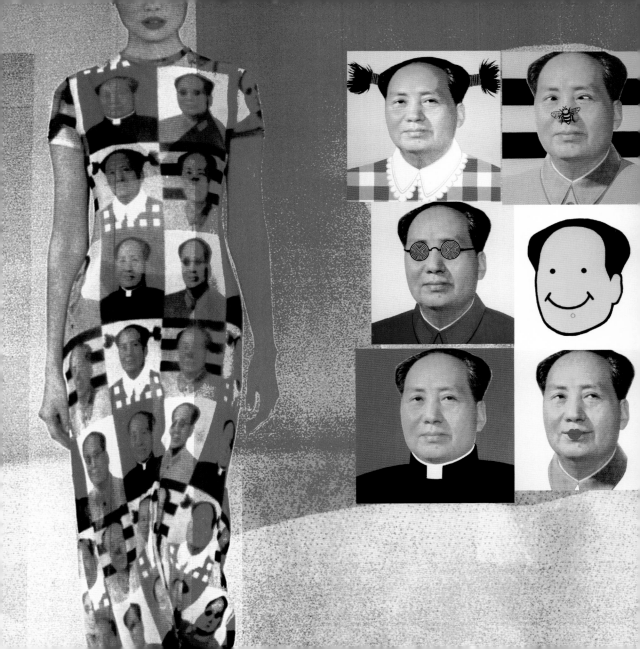

the images. We called almost every factory in the territory. When the batches were finally delivered, they were wrapped in layers of brown paper, as if they were high-security items. The first time the factory did the black-and-white Mao woven samples, a computer glitch made the sample number come up as 4 6 1997—then all the lights went out. In Chinese culture, reading numbers is a form of divination. Four and six were read as 4 June—the date of the 1989 Tiananmen incident when the Chinese army moved against student demonstrators—and 1997 was of course the year of Hong Kong's return to China. The whole thing was so unnerving that the staff had to go home early.

When the collection debuted in November 1994, reaction was mixed. CNN was supportive—Elsa Klensch made the connection with pop art, and immediately understood what we were doing. On the other hand, some buyers didn't even know who Mao was, but they liked the humor of sticking this middle-aged Chinese guy in a pop fashion setting. "Is that your father?" they'd ask. "Who is this May-yo anyway?"

Of course, the collection was controversial. Shops in Taiwan wouldn't carry it for political reasons, some U.S. shops decided not to put the items in their windows, and one U.S. magazine canceled a cover with the T-shirts. Japan, on the other hand, was very open. Naturally, there was a strong reaction in Hong Kong. There was a lot of press, both positive and negative. Parents wouldn't let their children wear the Mao T-shirts, so the kids would smuggle them out of the house in their bookbags and change into them later.

Suddenly, Mao was a symbol of rebellion again. At my shop in Causeway Bay, the salesgirls had to deal with angry people rattling the windows that were filled with all four T-shirts. At first, my staff was intimidated, but after a while they became braver and began to enjoy themselves. The look actually became very popular—counterfeiters did huge volumes, complete with a label and even sequins.

Once the line was in production, I felt proud. This collection allowed me to cross over from the fashion world to the art world: pieces from it have been included in several museum collections around the world, including the Museum at Fashion Institute of Technology, the Andy Warhol Museum, the Lighthouse Museum in Glasgow, and the Victoria and Albert Museum in London.

If I had stayed in China, I probably would have been a Red Guard.

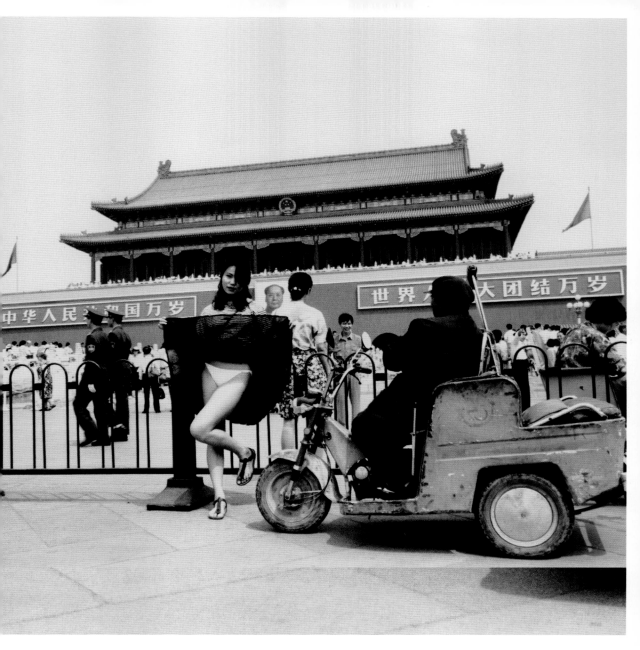

MAO ART Interview with Zhang Hongtu

Zhang Hongtu was born in Gansu province, but he attended high school in Beijing during the sixties and later trained at the Central Academy of Arts and Crafts. At this time the image of Mao was prevalent in the arts. In the early eighties, Hongtu moved to New York. I met him in 1994. I loved his paintings of Mao—his sense of humor and color spoke to me immediately.

VT: Your Mao paintings are very iconoclastic. How did you come to do them?

ZH: The first time I painted Mao was in 1987. I ate Quaker Oats every morning. As I ate, I would look at the round box, and think how similar the Quaker was to Mao. Actually, I think most Chinese would agree with me. One day I got some paints out and did something about it.
 I didn't take it very seriously, it was just a kind of doodling. At the time, I didn't want to have any kind of politics in my art, because that was my experience in China.

VT: But now you've done so many works using Mao. What changed for you?

ZH: After 1989 and the events at Tiananmen, I decided to concentrate on his image as a kind of mental therapy. I suddenly saw that although artists in China had been used to create propaganda art for the government, I as an artist also had the power to express my own political feelings. I believe in the power of the image, but I don't believe anymore in its authority. I began by cutting out his image and making collages. At first I felt guilty, as though I were committing a sin. You have to understand how powerful his image is for my generation. During the Cultural Revolution, in my teens, he was like a god. Now I had this feeling of needing to get away from that shadow, so that pushed me to keep going. From 1989 to 1990, I worked on Last Banquet, a painting that was a take on the Last Supper. I also did Mao as an acupuncture map. In 1992, I started Material Mao, a series of portraits on rice paper done in soy sauce, lipstick, or popcorn. I wanted to use everyday substances to create his image.

VT: It seemed natural to me to combine your art with fashion. But it took three months!

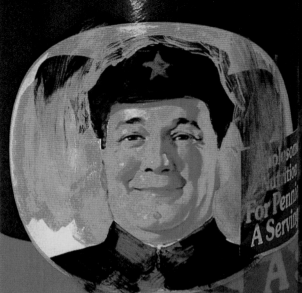

OLD FASHIONED
**QUAKER
OATS**

100% NATURAL

ZH: Yes, when we started, I didn't know how important the details were: the shades of colors had to be just right, every change had to be carefully considered.

VT: Would you say that the experience influenced your work?

ZH: In two ways. Visually, I thought these images could become a moving picture, not in a museum, but out in the street. Also, the images changed as the body moved through space. That was the thing that really hit me when I first saw the fashion show. People who looked at the collection had different reactions to the images depending on where they were from and the bodies that wore them.

Conceptually, I began to think about how art could be more related to popular culture, more interactive. I did a Ping-Pong table with the silhouette of Mao cut into both sides. The audience was invited to play with paddle and balls, but they had to try to avoid hitting the Mao because the ball would fall through the cutout and stop the game. The viewer participated by playing Ping-Pong. This was another combination of play and politics that could be related to life.

VT: How do you deal with the controversy about your Mao work?

ZH: It depends. In Hong Kong they see it only in political terms. A couple of students from the mainland came to my show there. They signed their names in the visiting book, but when they came out they scratched them out. It wasn't a criticism; they were afraid that someone might find out they'd been to see this "dangerous" stuff. I felt really sad.

VT: What about pop art? Andy Warhol did portraits of Mao too, but I think it's different.

ZH: Yes, Warhol just took the image of Mao as another mass icon, like Marilyn Monroe. But for Chinese artists, Mao is a political figure. I've been asked, If Mao was a dictator like Hitler or Stalin, how can it be okay to use his image as pop art? Isn't it tasteless to make fun of the suffering they caused? Good question. Mao is still controversial. Today, even if his deeds are criticized, the government still uses his ideology, image, and flag. I believe that any use of Mao's image which makes him less godlike, is a form of criticism. And it's necessary.

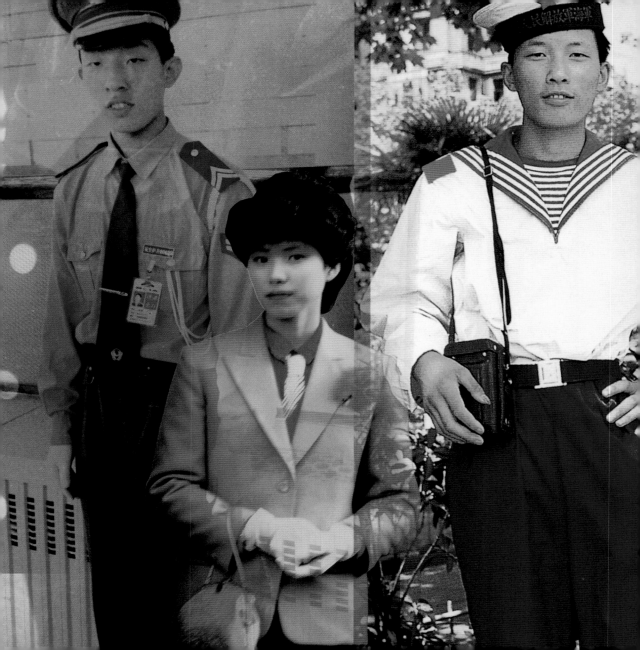

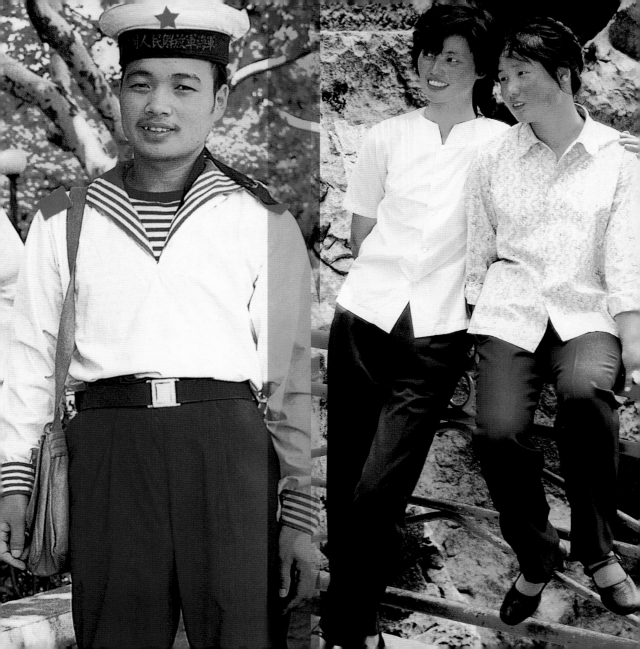

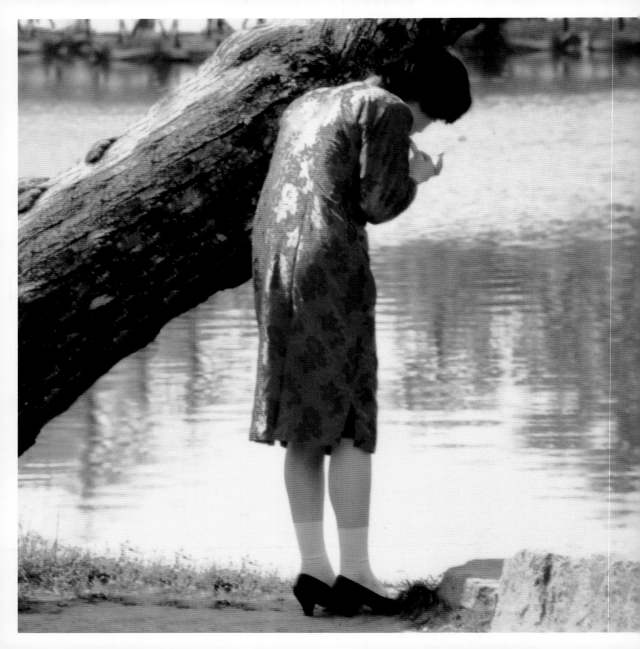

PRC FASHION

China has always been a very fashion-driven country. Where else could one man tell over one billion people what to wear? From the beginning of his political career, Mao Zedong was a fashion tsar. "We Chinese have our own customs," he reportedly said as he dressed on the morning of October 1, 1949, shortly before declaring the founding of the People's Republic of China. "Why should we follow others?" In those early days, he was never seen in anything but his Mao suit.

The cut was based on the Sun Yat-sen suit, named after the founder of the Chinese Republic in 1912. Sun copied the design from the Japanese schoolboy uniform, and the Japanese borrowed it from the Germans who wore them at the university—so actually, it's hard to claim that the Mao suit is Chinese. Every detail of the suit is supposed to have some symbolic meaning: five front buttons for the five branches of government, executive, legislative, judiciary, investigatory, and supervisory; four pockets for the Confucian virtues of propriety, justice, honesty, and shame; three buttons on the cuff for the Three Principles of the People—nationalism, democracy, and people's livelihood.

In the sixties, Mao signaled the beginning of the Cultural Revolution with another fashion statement. He showed up at his first meeting with the Red Guards in 1966 wearing a green army uniform. The outfit signaled his support for rebellion. Soon, young people dressed in green khaki and red armbands were rampaging across the country—real power dressing.

In the seventies, when President Nixon visited China, Mao welcomed him into his study still dressed in his Mao suit—but the public saw him shaking hands with a leader of the Western world dressed in a two-piece, single-breasted pinstripe suit. The gates to outside culture began to swing open.

Mao fashion has always fascinated me. It's really anti-fashion—the idea of putting everyone in a uniform and trying to make them equal—an attempt to cover up very real differences. On my early visits, I felt sometimes as though everything around me was a blur of green and blue. People did try to express themselves, but the differences were subtle, and you had to learn how to read them. For instance, Shanghai still maintained its reputation as a style capital, and its tailors were famous for making the Mao suit more flattering. I was so excited to find a sewing pattern for the jacket in Shanghai—I knew it would be the most stylish when I made it.

Young people experimented with the suit by going out of their way to find an antique Mao jacket, for example, or buying an army-green suit and bleaching it to a yellowish-green khaki. Army colors were in vogue then, just like in the States. Girls would braid their hair loosely so that it looked a little more kittenish, and they wore white sneakers without shoelaces instead of black cotton Mary Janes.

I liked the loose but tailored cut of the Mao suit, which was very unisex. This was to represent that men and women were equal for the first time, and it accompanied Mao's propaganda that "women hold up half the sky." These clothes gave women more freedom in their physical movements. At the same time, there were differences—men wore the high collar, but women wore lapels. The women's trousers zipped up the side, not the front. The basic Mao jacket is a very good design—the collar gives you a military feeling, and the pockets are very practical.

When I walked through Beijing and Shanghai, I was very surprised to see young men holding hands in the street. Young women too. They were dressed alike, and I thought, What's going on here? Since men and women couldn't hold hands with each other, maybe holding hands with friends was a different way of being affectionate. People dressed alike because they had so few choices. But if uniform dress takes away individual identity, it also creates a kind of intimacy. Friends can share the same style, and uniformity didn't have to be depersonalizing.

One of the first things I learned about clothing in the PRC was that it had to be strong. Most people could afford only one suit, and it had to last a long time. On the street, there were specialized repair shops for nearly everything—one for fixing collars, another for sleeves. The method of repair went beyond patches to extra stitching in patterns. To make the patch extra strong the tailor would run the machine back and forth over the patch in squares, circles, or just a free-form shape.

In those days, shopping in China was sometimes like being in a time warp—the aesthetic was still stuck in the fifties because China had been closed for so long. You could still have your photograph taken in an old-fashioned camera shop, and have the black-and-white film color-tinted, or set against an obviously phony background. It was one of the first things I did. The women in the portraits all posed like movie stars from the forties or fifties, one foot pointed out in front, or one hand placed on the hip. Very retro.

Then there was the product packaging. Everything seemed like a vintage item—emblazoned with names like Great Wall, Red Star, Temple of Heaven, Golden Cock, Panda, and Pearl River. The window displays were old-fashioned, filled with practical things like housewares and linens instead of

fashion. Department stores like the state-run Friendship Store just put all their stock out on the floor—row after row of shocking-pink sweatshirts, thermoses, or water carafes. It was visually very stunning.

I always visited the arts and crafts sections on the top floors. I found beautiful crochetwork, embroidery and appliqués, beading and sequins, rolls and rolls of beautiful silk, batiks, cloisonné and jade. I loved the Mao jackets with detachable collars and winter wadding, and the brilliant neon colors of the knitted long underwear. People often wore three or four layers of clothing in the winter, the bright color hiding under drab cotton. It was a revelation the first time I went into the public restroom in China: all those plump-looking women would strip off layers of padded clothing, and underneath they were actually skinny.

When I went shopping, people followed me around to see what I bought. Sometimes they would buy the same thing. If I tried something on, the person behind me would ask to see the same model. People were curious to see what a foreigner wanted to buy. They would say to me, Oh, this is so ugly, why do you want it, it's already been discontinued! When I went through customs, the officials made funny faces and asked me why I was buying so much ugly stuff.

I was also fascinated by the home and furnishing textiles. Although there were many flowered silks behind the counters, I was more interested in the heavy velvet prints and bedroom linens, bedspreads, and towels displayed in great bolts of interesting textures, patterns, and colors. These provided inspiration for my designs and sources for my materials.

When I saw women wearing something interesting, I'd ask them where they'd bought it. They thought this was really funny, and said, "Oh, it's nothing special, but if you like it, I'll sell it to you." It might be a woolen jacket with a strangely colored plaid, or a see-through blouse with a burned-out wave design. The transparent pattern would be sexy in the West, but worn on the street next to Mao jackets it could be a bit jarring.

At first I thought this kind of dressing was an attempt to be outrageous and that they were just experimenting. Maybe they thought that if this was Western style, it had to be okay. Sometimes a skirt would be totally transparent, with no slip, and you could see the underwear; or a girl would wear a long cut-velvet skirt over a white lining just down to the crotch. Then I realized that this was a fashion of limited means and that people made do with what they had. In those days, the average monthly wage was about US$15. Maybe the lining was short to save fabric, and maybe it was white because that was the only color available.

毛主席语录

我们的文学艺术都是为人民大众的，首先是为工农兵的，为工农兵而创作，为工农兵所利用的。

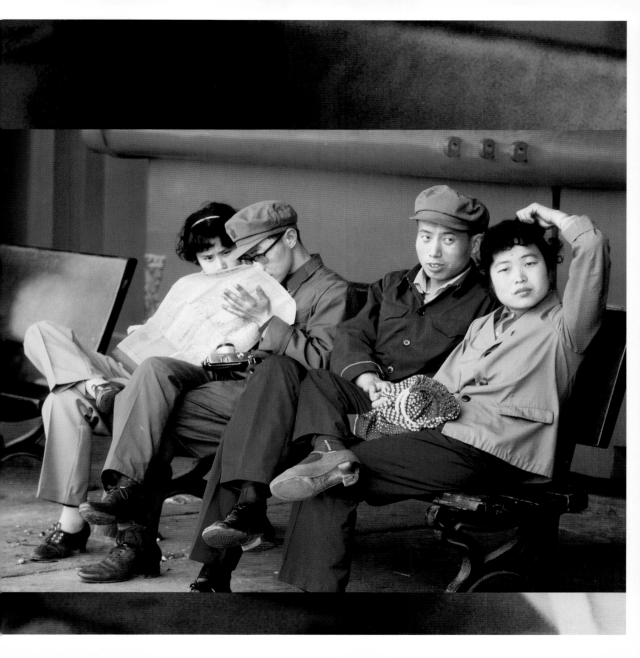

In the summer, girls wore knee-high stockings and plastic sandals with knee-length skirts, or short nylon stockinettes with big clunky black Mary Janes. They were unconscious about fashion, but what they wore often seemed very edgy. Their style was borderline bad taste and hip—because they were borderline Cultural Revolution and Western modernity. It was great to see some of these looks become Western style trends in the nineties.

In menswear, I loved the different military uniforms. Along Shanghai's Bund, I could see sailors in their blue trousers, sailor shirts, and blue-and-white striped T-shirts underneath. Then I saw the same T-shirts on civilians, worn under green Mao suits. In the countryside, men wore blue and green Mao trousers over neon cotton singlets. The pants were always oversize, cinched tight at the waist with a thick leather belt. They never had real socks, just sheer anklets, beautiful knitted silk jacquard hose.

The shoes—there were black cotton Mary Janes, kung fu slippers, thick felt-soled shoes, green army sneakers, and sometimes leather T-straps. Molded plastic sandals, with little wedge heels in all kinds of jelly colors—pink, blue, white. They were difficult to walk in, because they wobbled so much. Most of these shoes were inspirations for my own footwear designs.

Everything was understated, but with great panache. A woman might be very nicely dressed in a skirt and blouse, and then she would put on a pair of crocheted gloves and tie a nylon chiffon scarf over her entire head to keep out the city's grit and sand. So you would have this very ladylike figure with a head like a red lantern bobbing along in the bike lane.

The way the Chinese dressed was very inspiring. They were creative and adventurous. They weren't bound by set ideas; everything was new to them. When one of Mao's later successors, Deng Xiaoping, declared that to get rich was glorious, dressing well became politically correct. Local companies rushed to make cheap copies of Western styles. Both men and women permed their hair. Suits with the Yves Saint Laurent and Pierre Cardin labels still sewn on the sleeve and sunglasses with the UVA stickers still stuck to the lenses—available only with foreign exchange—became status symbols. I love that—they were having so much fun.

This kind of bravery and innocence makes for pure fashion. It's not just following the crowd.

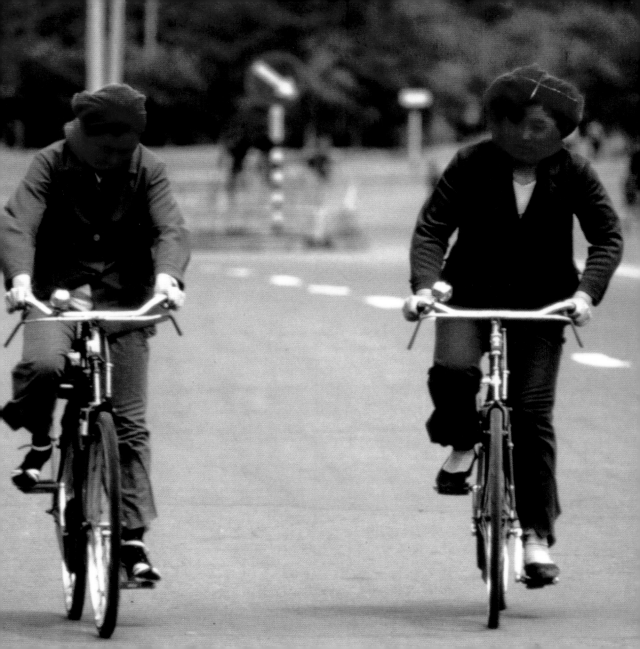

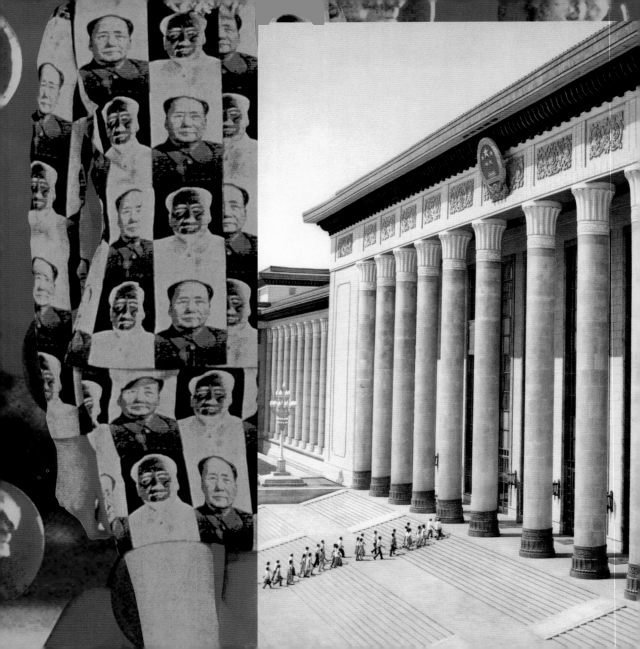

REVOLUTIONARY MUSIC Interview with Tan Dun

In the early nineties I saw a documentary on the famous twentieth-century painter Chang Dai-Chien, and I was struck by the music—it fit the painting beautifully. I called the producers of the film, Long Bow, and they put me in touch with the composer, Tan Dun. At that time he had a studio in New York City's Chinatown, and when I visited him there he showed me his collection of ceramic pots. When he struck them, the sound was very earthy and tribal. The music he made was powerful because it came directly from the earth.

Tan Dun was born and raised in China and is now based in New York City. His music is a very personal signature, a wonderfully rich combination of Eastern and Western music. His symphony, written for Hong Kong's return to China in 1997, included a cello solo for Yo-Yo Ma (representing the present), a children's choir (the future), and, best of all, ancient Chinese bronze bells (the past) that were thousands of years old. The effect was truly magical.

VT: Where do you come from?

TD: I was born in Hunan in 1957. The area once belonged to the Chu culture, which was shamanistic. The environment I was born into was pretty ritualistic. Every day there was a wedding, every day there was a funeral.

VT: What a contrast . . .

TD: Yes, and it was great, because every day the band was playing handmade instruments, eating handmade food, wearing handmade textiles and handmade clothes—everything. Everyone was a designer and an artist. They did everything for themselves—only for themselves, not for sale. When I was seven, my parents decided I should go to the city to be educated. Before then, I was part of a band of wild mountain kids. We just followed a group of country musicians around the mountains while they played for weddings and Buddhist ceremonies. That was my early musical education.

VT: What was it like to go to the city?

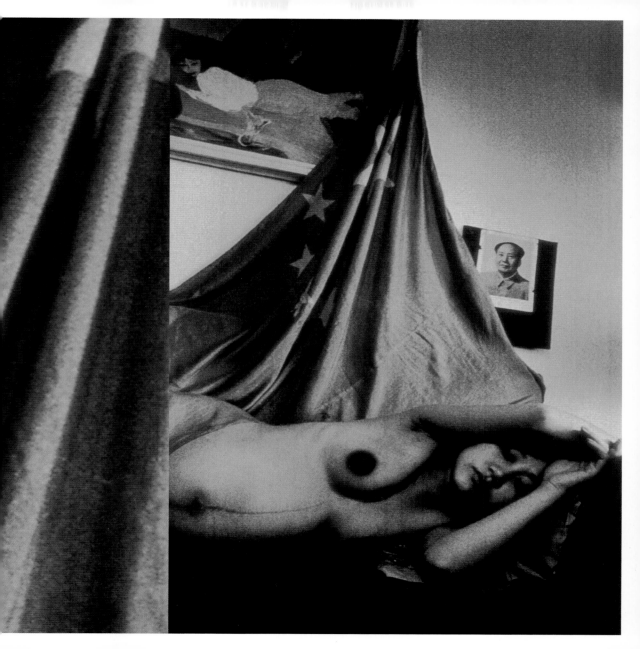

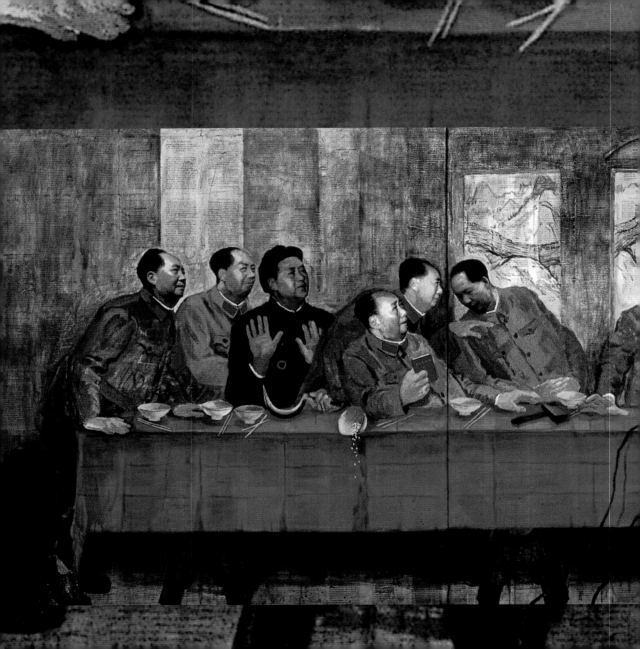

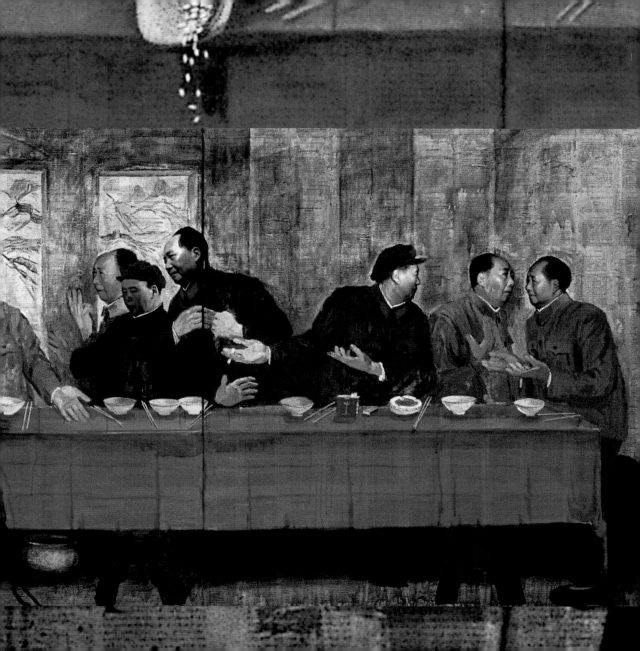

TD: Well, it's hard to say, because the Cultural Revolution started, and traditional things were prohibited—particularly any good things. It was all destroyed. I suddenly realized that everybody was wearing Mao suits and playing propaganda music with a lot of shiny instruments. I'd never seen Western brass instruments before that.

VT: But that music was so different from what you heard in the mountains . . .

TD: Yes, very, very different. It was strange; revolutionary but with a shamanistic flavor. The musicians were all local people. They tried to catch the new fashion of Communist propaganda, but everybody was still a product of shamanistic culture.

During the Cultural Revolution, I went to middle school and high school. It was basically a half day of study and a half day of sacrificing my life to the revolution, jumping around to see the propaganda and street operas about revolution.

I trained as a musician, first by tagging along with those musicians at home, and then in the city where I learned to play traditional Chinese instruments—the dizi flute, the erhu two-stringed violin, the pipa lute. I also took up the Western violin. At sixteen, I tried to join the local opera company. They told me I was good, but unfortunately, according to Mao, every young person had already been polluted, and I must go to the countryside for reeducation to clean up my mind.

The harsh part was this: if we only had to go to the countryside for a couple of years, that would be great fun, right? But it wasn't just for a couple of years, it was for your lifetime. So I had to sign a contract saying, "I, Tan Dun, will permanently stay there, I will give up my life and set up my home in the countryside."

VT: It was like that for all the students?

TD: Yes. Everyone signed with tears. Why should you have to leave your family to go to some remote life to plant rice, watermelon trees, and vegetables? We were teenage students who knew nothing about the mountains, about rice planting, about watermelons.

When we arrived, we ate all the watermelons in the fields, because we were so young. So

the farmers had to reeducate us. We were sixteen or seventeen years old, working in the fields fifteen or sixteen hours a day, about twenty of us in every assigned spot.

We had a big family thing. For example, we didn't have enough food to eat at times, only a bowl of rice with one piece of chili pepper or a piece of spicy cheese, and not even salt. When it got cold, we didn't have warm clothing, so we had to share the covers and stay together. Everybody was naked touching each other. Maybe that was the same in the States at that time, but not for the same reason.

If you weren't naked, you weren't allowed to come in. It was nothing romantic, but just to keep warm. We didn't have fuel for heat, just some dry branches that we had to save for cooking.

That year I began to organize local villages to play opera and traditional folk music. I was the conductor and music teacher.

VT: How did you find the time and energy?

TD: After work you had to do something, otherwise you would go crazy. Almost everybody cried the first year, missing home. You didn't know why you were harvesting the damn rice. After a year, we became much stronger. Now I think it was a good education. We became good farmers, but we were so young, always horsing around.

VT: Did you wear Mao suits?

TD: No, they were too expensive. The Mao suit was considered very fashionable; only Red Guards and radicals wore them. I had a very beautiful one, a gift from my father. I met a guy playing violin in the park. He saw that I was watching him practice. He said, I love your Mao suit. I said, I love your violin. He said, You want to trade? So we did.

VT: Was there time to play around?

TD: We were planting and playing! We learned to tell dirty jokes. None of us had ever made love, but we listened to the old farmers talking about sex. They had a lot of ancient shamanic

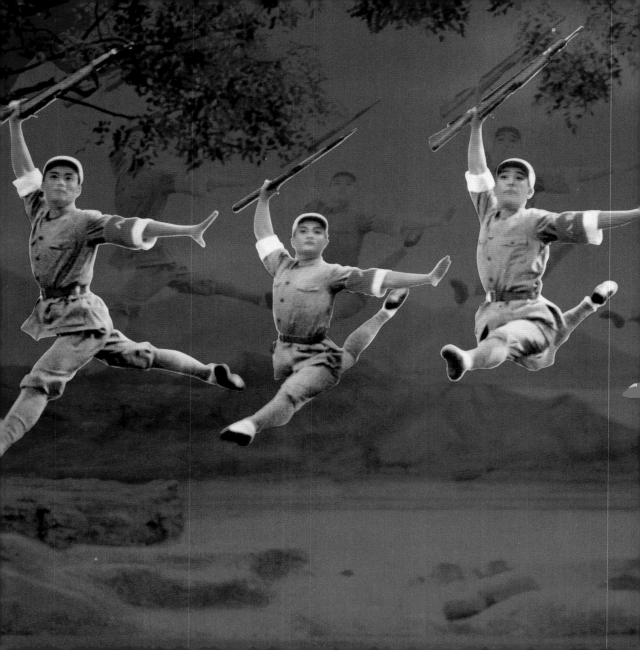

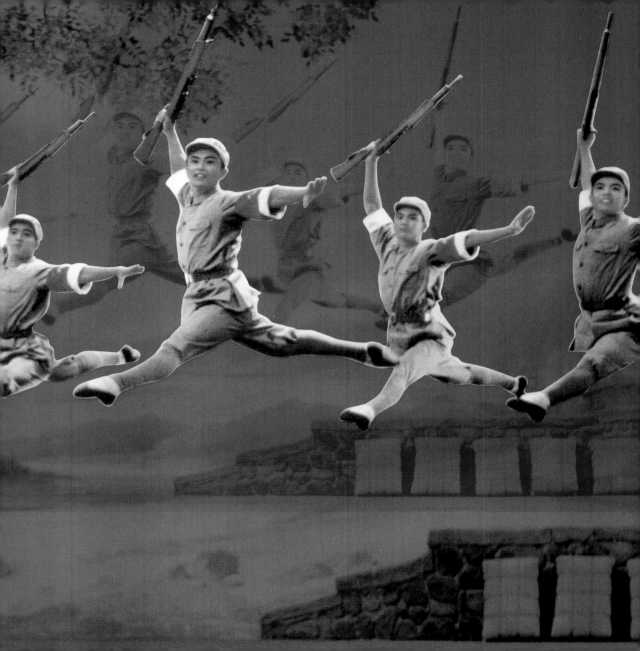

ways—we had no idea about it, we had just graduated from high school. Nobody had the facts. Society was still quite feudal, even though it was revolutionary.

After two years, one day we saw someone climbing up to our village on the mountain. We were teasing the girls, Hey, maybe it's a heavenly boy sent to date you! After almost an hour, he arrived. He said, Which one of you is Tan Dun? I have something to discuss with you. I was a little scared, because I'd been playing all these shamanistic traditional operas at night; maybe that was a political mistake, even in such a remote village.

He was the secretary in charge of the local opera troupe in Hunan. It was actually a very tragic story. The troupe had been en route to a performance, and in a trip across Lake Dongting, the boat carrying the orchestra sank. They needed to rebuild, and I was one of the young musicians called back. I was so happy and also so sad. The night before I left, there was a huge party. The village people were sad because they were losing their music instructor. They brought out all their stores of rice wine. Everybody got so drunk. In the morning, we couldn't remember what had happened. Nobody said anything, and they just saw me off in silence.

VT: What happened when you got back to the city?

TD: As soon as I got there, I went to the river to swim. Suddenly the public address system began to shout: "Five minutes from now there will be a very very important news item for the whole country. Please get ready to listen." I swam back. Then some very slow brass band music came on. Then it stopped, and I heard, "Our father, our greatest leader Mao Zedong, has died."

I was shocked. I felt empty. In those days, everybody thought of Mao as God. Everybody was crying. I have no idea why, it was automatic. Even people who'd been punished by him were crying; they didn't know then that he was the one who had punished them. But life started again. After Mao died, all the professors came back to the music academy from feeding pigs in the countryside.

VT: The life contract was finished?

TD: Yes, all my friends came back. But there were no good jobs, the factories had been closed, schools were just opening—so people became barbers, or they sold meat and vegetables in the

market. It was great fun. I would rehearse local opera six to seven hours a day, and the rest of my life was just goofing around in the shops and markets. I knew everybody.

The troupe began to perform Peking opera instead of revolutionary opera. Every time we learned a new piece, it was like a world premiere. People hadn't heard this kind of thing for more than ten years. So after extremely revolutionary music, suddenly tradition returned. It felt completely new, almost avant-garde.

VT: Did you stay in Hunan?

TD: No, later I went to Beijing to study at the conservatory. I was nineteen years old. I remember the day I arrived. I was walking through the train station with my baggage hanging from two ends of a bamboo shoulder pole. A professor met me at the station. He had just come back from working in the countryside. He asked me, Do you want to go to a concert? . . . What concert? . . . The Philadelphia Philharmonic Orchestra . . . What's Philadelphia? . . . A city in America, the orchestra is a Western one, with about a hundred people, with violins, do you know what that is? . . . Yes. . . . Trumpets? . . . No. . . . French horns? . . . No. . . . Piano? . . . No.

I didn't know anything, so he took me there. They were playing Beethoven's Fifth—pam pam pam PAM. I said, My God, this is MUSIC. I'd never heard anything like it before.

VT: What's the difference between Eastern and Western music?

TD: On the one hand, you can say there's no difference at all as long as the spirit of the music can touch you. But there are differences because each is constructed from a different language, and music is very connected to language. Chinese language is tonal, whereas Western language is rhythmic. When they come together, it's very powerful. One is rhythm, signal, and concept; the other is landscape, line, and movement.

Chinese music is supposed to be written for yourself. The tradition of Chinese music asks you to have a dialogue with yourself or with nature. Western classical music was developed in a court setting, composed and performed for the king and his guests. It's a performing art. Now the two are becoming more alike, merging together, with different styles, but as one. This is today's life.

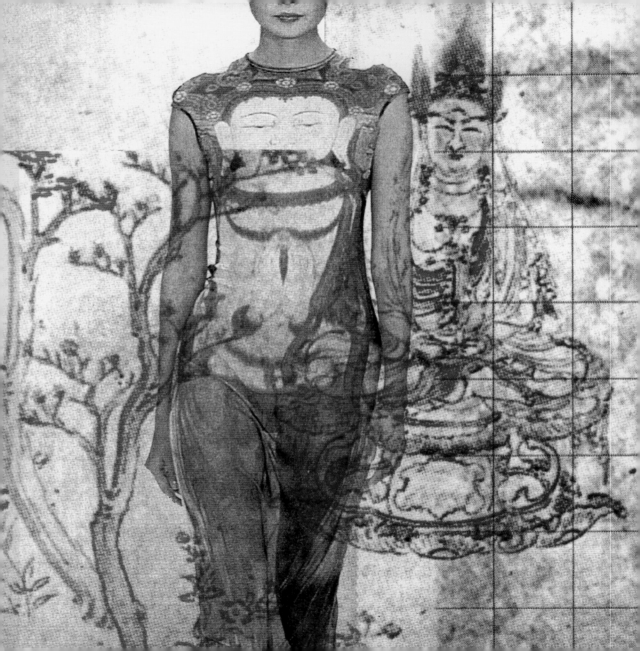

BODHI通 *(tong)*

To move through space, partake of the rhythm of things, to arrive at some understanding, or to achieve a penetrating vision—these are all aspects of tong.

TEMPLES

My mom waited in line almost a whole day to enroll me in a Roman Catholic primary school because it had a reputation for high academic standards and good English training. Next to the schoolyard was a beautiful old church, and I would try to get to school early to explore the inside of it. I liked dipping my fingers in the holy water, crossing myself, and genuflecting in front of the altar. I loved wandering through the nave, peering up at the stained-glass windows, watching the patterns of light that shone in through the colors, and trying to make out the stories intricately carved into the wood paneling. High up in the soaring roof, slow-rocking fans hung from heavy beams stirring up the morning heat. I remember the musty smell of dust on old velvet cushions. When the school bell rang, I ran to get in line, and we all filed into the big meeting hall for assembly. We sang hymns and said psalms and the headmaster read a lesson with a moral about how to be a good person.

Out in the streets of Hong Kong, there were miniature temples everywhere. Small shrines were tucked in all sorts of odd places—outside stores, under steps, or outside the hair salon. Neighbors, relatives, and my parents' friends usually had small Buddhist altars hanging in a high alcove, the red light bulb stuck in the candleholder glowing all night. Or they placed incense holders dedicated to the guardian of the door on the floor near the entrance. We tried to go to temple on the first and fifteenth day of every lunar month, although usually we managed to make it only when it fell on a weekend.

I can't say that I understood the temple visits—I just followed my mom around as she said her prayers. I learned to bow three times, to count out three incense sticks for each shrine, to light them and say a prayer, then stick them carefully into the ash holder so they could burn down slowly. At the last altar, we used all our remaining sticks and stuck them in the biggest ceremonial urn. Then we knelt and bowed our heads. We were surrounded by the sharp piney scent of

incense curling up from the prayer sticks and from the thick gold-colored incense coils hanging overhead. I loved the combination of brightly colored silk hangings and colored lights dulled by the darkness and the smoke. My mother brought oranges to place on the altar, beautifully stacked in huge pyramids. When I was little, I thought they were there for people to eat, but once I took one, and my mother slapped my hand and made me put it back. She said the oranges symbolized plenty, and they were offerings to the gods.

I loved exploring paper and incense stores. It was odd to see brand-new house altars and incense burners, shiny red with new paint, unsmudged and unchipped. It was a kind of hardware and stationery store combined, only instead of wash buckets there were fire cans for burning sacrifices at home. In Chinese culture, burning is a purification, but also a way of communicating with the spirits. In the Chinese lunar calendar, the fourteenth day of the seventh month is the Ghost Festival. People burn paper outside their doors for protection and respect. Many people stay at home that night to avoid running into a wandering ghost. My family didn't observe this festival, but I remember that when we moved into a new place, my mother would light special burning paper in porcelain bowls set in the four corners of the apartment. She explained this was to pay our respects to the old presences so that we could have a peaceful life there. I loved those papers—rough rag paper stamped with gold leaf, or red and green circlets cut into snowflake shapes.

All these things have inspired my designs. As I explored, I bought lotus lamps and incense burners, different kinds of burning paper, and packets of paper clothing traditionally burned for the dead so that they would have something nice to wear in the afterlife. The packet for women came with a blouse and skirt or trousers, shoes, maybe even a handbag; the men's kit came with a Chinese-style suit, shoes, and a hat. I loved the prints, textures, and simple shapes of paper clothes, but I couldn't bring them home because my parents wouldn't have liked it. Instead I've kept them in my office for reference.

As a child, when you do something you don't really understand, you look around and try to figure out things for yourself—especially if you have to sit still and be quiet. So I had time to notice that the statues in the temple were very different from those in church. Big Buddhas instead of Baby Jesus, scary monsters—half beast and half man—instead of angels, and instead of the Virgin Mary there was Kuanyin, the goddess of mercy.

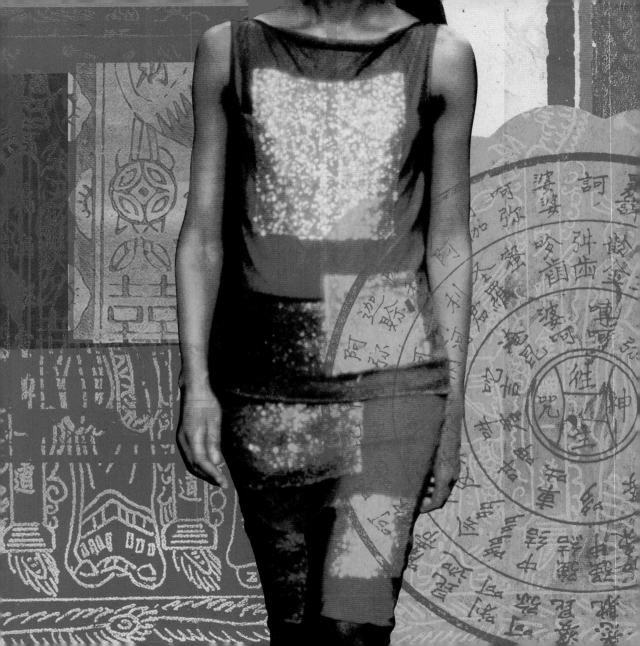

即說真言曰

唵 金婆金婆帝求訶求訶

咥羅尼帝尼阿羅帝尼加你

帝庶訶雄帝薩婆訶乾帝訶

神　煞　諸　鎮　帥　大　張

衣獸鎮　等人鳥鎮　怪畜馬鎮　神等釜鎮　怪被帳鎮
冠污鳥　符家入禽　符等犬牛　符缸灶怪　符等枕床

（符篆）　（符篆）　（符篆）　（符篆）　（符篆）

大佩此硃　門貼此硃　處貼此硃　房貼此硃　大佩此硃
吉帶符書　吉大符書　吉怪符書　吉廚符書　吉帶符書

符怪般鎮　之等為鎮　等人獸鎮　鹽怪車鎮　怪具血鎮

KUANYIN

Bodhi is the Sanskrit word for enlightenment. In Buddhism, a bodhisattva is a being who is worthy of rising up to Nirvana, but chooses to remain on earth to help humans toward enlightenment. I grew up with the story of how Kuanyin became a bodhisattva.

Once upon a time, there was a little princess who was so pure and devout that all she ever wanted was to become a nun. Her father tried to force her into an arranged marriage, but she escaped by running away to the mountains, where she lived on berries and water, covered in mud and with twigs in her hair. One day, her father grew very sick. The doctors who examined him looked very serious, and they said that the only possible cure was a potion made from the arms and eyes of a pure soul. The palace sent messengers to seek such a soul, and they found the princess in the mountains. When she heard the news, she gouged out her eyes and chopped off her arms. When her father recovered, he found his daughter, now piteously blind and still bleeding from her wounds. He tried to apologize, but she stopped him, saying, "I suffer no pain." Then the earth shook and she was transformed into Kuanyin, with stars for eyes and a thousand golden arms. Beneath her body, a golden lotus flower took root, lifting her up in its petals, out of the filthy mud, clean and beautiful.

Kuanyin is the goddess of mercy, and people pray to her for good health and happiness. Her image is everywhere in Hong Kong, not only in the temples but in people's homes. *Kuan* means "to see," and *yin* means "to hear," so she knows all about us, both our suffering and our joy. She's not so much a god, but a kind, wise presence.

Many of my friends say they have had encounters with Kuanyin. There are stories of people who have had near-death experiences who meet Kuanyin at the end of a long tunnel, and others who pray to her during difficult times.

I loved the story of the little princess who became a bodhisattva, and the image of Kuanyin also felt glamorous to me. She was so beautiful—her hair was coifed in a complex design, her skin was smooth and white, and the look on her face was so graceful and peaceful. She was draped in layers of richly colored silks and prints, and the fabric floating around her body made her look like a fairy-tale princess. She wore fancy jewelry everywhere—in her hair, around her neck, on her arms, legs, fingers, and toes.

The earliest stories about Kuanyin depict the bodhisattva as a man. The idea of Kuanyin as a woman began only with the Tang dynasty, when more and more women were turning to Buddhism and needed to find an enlightened being they could relate to. During this dynasty, women were very vital and strong, and you can see this in the period's sculptures. The women are dancing or working, their bodies are plump and healthy, and the lines of their clothing are full of movement and energy.

There are many embodiments of Kuanyin. The white-robed Kuanyin represents purity and benevolence, and people pray to her for help and good fortune. Kuanyin with a fish basket symbolizes nurturing and plenty. The sitting Kuanyin denotes meditation and quietude. And people pray to the Kuanyin holding a willow branch for rain and prosperity—the drooping willow branches are supposed to scatter enlightenment like drops of dew. Kuanyin of a thousand arms and eyes sees and hears everything that happens in the world, and signifies that karmic law has no boundaries. These different Kuanyins are reflections of people's needs and desires. A bodhisattva can take any form and changes to fit the needs of those it helps. But the bodhisattva has no fixed gender or appearance—everyone has the potential to be one; we are all born with that spirit.

BUDDHA FACE

Although Buddhism was part of my childhood, I didn't really understand it. I returned to the images and practices of Buddhism later and tried to appreciate the truth behind them. I practiced Zen meditation and began to understand the power of Buddha and Kuanyin's message: in the end, we all possess a Buddha nature—we have the potential to realize a completeness in ourselves, and each person is a manifestation of Buddha spirit.

When I decided to use images of Buddha and Kuanyin in my work, it was an affirmation of that important personal experience. I wanted to make these powerful images more accessible to everybody, not to keep them just inside the temple. On major festival days, villagers would traditionally go to the temple and place statues in special chairs, decorate them with silks and flowers, and parade them through town to spread their grace and celebrate their power. I think using these images in fashion is a modern version of the same thing.

The Buddha face I chose for my designs is a profound and serene expression, but also a very uplifting one that conveys a message of beauty. When I used Kuanyin images, I wanted to emphasize the bodhisattva's beauty and grace, but also the feeling she radiates of trust and nurturing. Some people said that using this image in fashion was disrespectful, and that these figures shouldn't be placed in such a lowly and worldly context. But for me the images are very strong—when people wear them, they sink into the heart, and remind us of something good. If people are curious about the images, the message will get passed on. Whether they understand the full impact of that message or not, they feel connected, and they will begin to cultivate some awareness about themselves. When people ask me who the figure is, I explain and they appreciate it.

Combining fashion with images can bring out their essence. When Zhang Hongtu and I did the Mao pictures, the T-shirt and dresses made his image seem more ironic. But with Buddha and Kuanyin, the clothes brought the universality and accessibility of the images to each person who wore them.

CHI LIN NUNNERY

The Chi Lin nunnery is a *siheyuan*, or four-sided compound, made almost entirely of wood, its back up against a mountain and its front gate opening toward the sea—the best direction according to feng shui. When I first visited Chi Lin, I was stunned by the beauty and serenity of the buildings. Canadian cedar and South African abba wood had been carved to precision in Anhui by workmen trained in the traditional art of intricate Chinese joinery. The scale of the structure is huge, but once these pieces were shipped to Hong Kong, it took only eleven months to assemble the buildings, all without a single nail. My guide explained that later some nails were added to comply with building codes, but that in principle they weren't necessary. The wood is unpainted but stained a glowing deep brown, and the courtyards leading from one hall to another are magical spaces of meditation and natural beauty. The sense of peace seems impermeable, and it is hard to believe that above the gentle curves of the tiled roofs huge high-rises loom, or that a busy highway passes in front of the main gates.

Every time I visit the temple, I learn new things. Studying the structure has made me aware of design itself as a form of meditation. The joinery at the roof where the beams meet the side columns are small masterpieces, as complex as the overlapping petals of a flower. The building begins with one simple relationship, one piece of wood slotting into another, and this connection multiplies like a growing cell, naturally. To appreciate this beauty is to contemplate life.

The design was adapted from the original plans of a Tang monastery found in the archives of the Department of Ancient Architecture in Beijing. The decision to use these plans was made partly because Buddhism flowered during the Tang period. People believed that the pinnacle of harmony was achieved through Buddhism. The architecture was very human, its lines joyous, as natural as smoke rising. Man occupied the position at the melting point between heaven and earth, and the architectural principles of the *siheyuan* allowed human activity to gather and disperse naturally.

The plans for this temple were authentic, so it's possible to see the teachings of Buddha as we walk through the structure. My guides tried to explain it this way: If you take a peach, first there is the skin, then the flesh, and deep inside is the pit, the source of everything else. When you build, everything must come from the inside, but each layer is important.

Every detail of the overall plan was considered. The main entrance, or *shanmen*, allows the visitor into the brightly lit space of the lotus ponds, symbolizing a cleansing of the mind. The ponds are placed so the surface of the water cools the air, which is carried into the temple by the breeze. The slats in the vertical window latticework are cut in diamond shapes—the diagonal sides allowing light to enter at an oblique angle, shielding the interior from rain, but letting in the sun and air. The bell tower and the drum tower mark the time of daily earthly activities and signal the times for ceremonies, communion with the heavens. In the rear is a beautiful pagoda. Each ascending story symbolizes the gradual purification of the heart and mind.

When I visit Chi Lin, all my senses are heightened. There is the faint aroma of incense; the natural colors of wood, plant, and sky; the sound of the bell; the touch of the heavy wooden beams; and the taste of clear dew. The design exercises a sense of space—of enclosure and openness, of protection and complete vulnerability, of fearlessness and peace. A trip through the temple can become a journey through your own soul.

Within the compound, the life of the wooden structure is complemented by a collection of plant life from all over China. The placement of each tree and plant is perfect. I could feel the synergy. They actually felt very happy to be with one another, joined in such perfect surroundings. The garden embodies ecology, and reminds its visitors to think about the environment, the harmony that can be achieved and maintained between heaven, earth, and man.

When I told the nuns at Chi Lin that I was working on this book, they gave me a saying to carry with me, *Shen ru qian chu*, which means "Enter deeply and exit lightly." Aim to investigate thoroughly, but don't be heavy-handed. This was always in the back of my mind. Months later, when I told my mother about my experiences at Chi Lin, she told me that she'd already stood in line for hours just to give money for the roof—one roof tile for one wish, each inscribed with the donor's name. She donated one for every person in our family.

THE BODHI IS A TEMPLE

> When emotion moves us, words are formed.
> If words are not enough, there is sighing.
> If sighing is not enough, there is singing.
> If singing is not enough, the hands dance.
> If hands dancing are not enough, the feet begin to jump about.

These lines from the preface to *The Book of Songs*, one of the earliest collections of Chinese poetry, make me think of a child who can't contain his emotions. If she's happy she has to dance, if she's excited she hops around, and if she's angry she stamps her feet. From the day they are born, children wave their arms and legs around to express themselves. Emotion and the body are closely linked. It's only when we grow up that we learn to suppress that.

Maintaining this connection is the most important key to good health. Man takes his place between heaven and earth, acting as a conduit. Energy moves through the body—as sustenance or food, and as action or exercise. When that energy is disrupted, the balance has to be adjusted, with teas, Chinese medicine, exercise, and meditation.

Depending on the illness, a Chinese doctor will prescribe dietary changes as well as herbal preparations usually taken as infusions or tea. Even if you are healthy, teas can be taken as tonics to maintain good health. Small "healthy tea" shops are in every neighborhood in Hong Kong, each with a huge brass samovar where medicinal herbs stew all day. Bowls of tea are laid out, some for good health, others for colds, stomach disorders, or just low energy.

As soon as you enter a Chinese medicine shop, the cool and mentholated aroma draws you into a space walled with wooden cabinets, with rows and rows of small drawers filled with herbs and dried animal parts. Ancient Chinese medical texts list almost two thousand different items, and more than eight thousand prescriptions for their use: cordyceps, or winter worm, for the kidneys; lingzhi fungi to enhance the immune system; red dates to build the blood.

In front is a long counter, or long dragon, where prescriptions are filled, sometimes with as many as thirty or forty different ingredients. The clerk uses an abacus to calculate the amounts, and one or two helpers begin measuring the herbs, while another readies small squares

of paper on the counter, one for each dose. It's an intricate dance—each ingredient is weighed on a small hand scale, and then the clerks divvy up different types of ginseng, licorice root, grains, seeds, dried caterpillars and cicadas, animal parts, cinnamon bark, or whatever, among the papers. Each square is then folded into a bag and sealed. It's your job to boil each packet for a couple of hours. It tastes terrible, but the Chinese say bitterness builds a stronger will. If it's a nice shop, they throw in a packet of fruit sweets to help wash down the drink. More modern shops distill the prescription into convenient pill or powder form.

While you're waiting, it's fun to look at display cases lined in red velvet with gold-colored boxes of shark's fin, abalone, bird's nest, deer antler and penis. These delicacies are rare luxuries and very expensive. When I work on my collections, my mother makes me bird's nest soup every morning—it's good for energy and skin. These foods are considered extremely nutritious, but the writer Lin Yutang says that they have something else in common—they have almost no flavor or color, and the texture is gelatinous, very slippery and chewy. I guess it's an acquired taste. In the 1920s and 1930s, gelatin was introduced into Shanghai high society along with ice cream as a fashionable dessert—probably because it approximated that same feeling.

Food and drink help balance the body's yin and yang elements. Extremes are a sign of bad health, so nutrition should be consumed hot, warm, or room temperature, but never cold. In restaurants I make it a point never to drink cold or iced water. Exercise works to channel the *qi*, or vital energy, through the body. Western exercise is about aerobics and toning, the number of heartbeats per minute, or the number of crunches per muscle group. Chinese exercise, including the martial arts, is about smoothness and fluidity of movement, of controlling the breath so that the air moves freely throughout the body.

Taiqi is the system of controlling the flow and balance of *qi* in the body through mind and body exercise. My parents are elderly, but when I watch them practice *taiqi*, suddenly there's so much grace in their movement. It's so beautiful—very round, very perfect. In accordance with Taoist principles, the *qi* is visualized as the flow of energy that must be concentrated and kept in dynamic circulation. Ultimately, *taiqi* exercises are meant to preserve the body's vitality. Popular with all ages, it can be especially beneficial to the elderly. In China, if you're willing to get up early enough, you will see the parks filled with groups of men and women moving slowly and gracefully through their *taiqi* regimens. This sense of peace and concentration is very moving.

Qigong channels the *qi* to a higher level. Using kung fu and meditation, practitioners claim to heal serious illness by directing their own powerful *qi* through the patient's body. Although there's no medical proof of the efficacy of *qigong*, there are indications that the exercises may help relieve stress. Many people combine *qigong* exercises with Western medical treatments.

Most people know kung fu as a martial art. Although kung fu originated as a form of self-defense, the most famous form was developed by monks at the Shaolin Temple near Loyang in Hebei province, where exercises were developed as a way of activating the *qi* after long intense periods of meditation. During meditation, the *qi* was thought to lie in the belly. Afterward it was necessary to get it circulating. The kung fu exercises were so essential that they became part of the meditation practice. Shaolin kung fu's power comes from this close relationship with the spirit as well as its discipline of the body. It cultivates self-discovery and inner peace.

The *qi* flows through the body, through all living things, so the movement of the body connects us to the world. The best exercise creates a body consciousness, making us aware of place and movement at all times. Holding the body still is as much an exercise as running and jumping. When the *qi* is balanced and flows naturally, the body enjoys life and feels beautiful.

When people ask me about beauty, I think it all comes back to this—to *bodhi* consciousness, to the child who feels so much joy that it just dances out of her.

CHINESE MEDICINE Interview with Dr. George Wong

Dr. George Wong is director of Preventive Oncology at Strang Cancer Prevention Center, which is affiliated with Cornell Medical College. His primary research is in cancer prevention, where he adopts an integrated approach combining Chinese medicine with Western science. At present, he directs an herbal medicine program at Ann Fisher Nutrition Center at Strang Cancer Prevention Center. The emphasis of this newly developed program is in the integration of Chinese medicine with modern nutrition.

When I first met Dr. Wong, I was impressed with his knowledge of Chinese medicine, and I especially liked the way he talked about Chinese principles of health as a natural part of everyday life. He explained the importance of taking care of the body and of being happy to ward off health problems.

VT: Tell me about your work.

GW: One of the things I'm focusing on is an herbal medicine program in which we combine nutrition and herbs to treat gynecological problems. This came about because of the many breast cancer cases we see. Women are being diagnosed with breast cancer very early and the treatment often leads to premature menopause. So what can we do? We can't give them estrogen because of the risk of cancer recurrence. But with Chinese herbal treatments, we can help them maintain a healthy hormonal balance, raising their own estrogen enough to alleviate menopausal symptoms but without placing them at undue risk. Sometimes we can even bring back the menstrual cycle and improve fertility.

VT: How is raising the level of hormones naturally different from giving doses of hormones?

GW: It's better if you encourage the body to produce hormones naturally. You can't focus on just one hormone or vitamin or mineral. Health is not an exact science. The body has to be treated as a whole. If there is a skin problem, it is usually due to a digestive problem. Poor digestion leads to a dirty environment inside your body, and this becomes manifest in the skin. This can be treated, not just with herbs, but by changing the lifestyle.

VT: So you have to look at the whole person and also her environment?

GW: Yes. Chinese medicine is very practical: it accepts that individually we cannot totally change the world we live in. If we can improve the quality of life, that's good, but inevitably the world makes certain demands on our bodies, and we have to find a way to fortify our bodies to deal with them. For instance, I usually take good care of myself and eat the right things to keep my body in balance. But once or twice a week I do eat out just to challenge my immune system! It might be overspicy, or very oily, but I enjoy it. If I don't challenge my system, it gets weak, so there is no point in pampering myself. Emotionally and physically, the body needs challenges.

VT: So you can actually build up the body to ward off problems.

GW: Yes. The philosophy for treatment is something called zhi wei bing, treating the disease before it happens. In other words, in the Chinese system, health is a matter of maintenance. The system should be optimized as much as possible. It makes sense—people optimize their material possessions, why not their bodies? Western medicine tends to see illness as a sudden process—a person feels sick, and then gets treatment to fix it as soon as possible. Actually illness is usually a manifestation of a long-term imbalance. In the West, the self is seen as a state of being, rather than as a process.

VT: How does this relate to your work applying Chinese medicine to chronic diseases?

GW: Chinese herbology is based on a long history of experience and research into the safety and efficacy of herbs. We have two or three thousand years of history on that research. And the medical system is based on the balance of energy in the cosmos—so we have a very strong theoretical system as well. I've set up the American Foundation for Chinese Medicine to try to apply these principles and methods to chronic diseases like cancer. It makes sense, because some long-term treatments can really take a toll on the body. Using Chinese herbal medicine and giving the patient holistic care allows us to work with the body instead of against it.

CALLIGRAPHY

I remember the first time I held a calligraphy brush. It was supposed to be held straight up in my hand, perpendicular to the paper. The teacher poured ink into my dish, and I loved the salty smell as the dark liquid dried. She taught us not to dip too long into the puddle, or the excess ink would drip onto the page before we started. At first, we used practice sheets, with the outline of the characters printed inside the pink-lined box. Each page was divided into squares, four across and two down. One stroke might start out fat at one end and then taper to a point, and we had to make the ink on the brush do that too, with just one motion. It was very difficult.

Later we bought our own practice books. Each page was divided into big one-inch squares to help us space the writing. At the stationery store children were allowed to pick out copy-book tracings taken from stone carvings of the writing of famous calligraphers, the characters etched in white against black. My favorite calligraphy was by Wang Yizhi of the fourth century, because the movement of his strokes had so much energy. I stuck the sample between the pages and tried to copy it.

We were taught to see each character inside a square, and to fill that space, to center the characters with every part in proportion and balance. Calligraphy was about discipline—how to restrain yourself in order to control the brush—down onto the paper, moving across, maybe making a hook, maybe tapering, the brush curling into a final point. Each stroke was experienced physically.

At the end of the class, the teacher gave us exercise sheets to fill in at home. Practice was all about repetition, the same character over and over. We worked from right to left, so we had to be careful not to smudge what we'd already written. Our wrists had to be firm but flexible— "dangling with a purpose." When you hold the brush straight, you automatically sit up, the energy flowing from your feet on the floor to your arm moving freely from the shoulder.

Once you learn to control your hand and body, the *qi* or breath fills you up and expands the space inside you. When you're a kid, you are just filling in squares, but at the same time, you feel Chinese history at work in you. Each character has its own composition and landscape, left to right, up to down.

Once you master the skill, it becomes effortless. You write. The stroke can be joyful or solid and plain, depending on your mood. When you are sick or troubled, the stroke is weaker, and if you are elated the ink fairly spatters off the page. Each stroke has a "bone," or *gu*—the

tension or force of the energy coming from your hand into the brush; it also has "flesh," or *rou*—the way the ink falls off the brush, down to the last whisker. Emotion is the pressure you transfer into the ink on the page.

It's quite scary to copy someone else's style, especially in the case of calligraphy, where the brushwork is supposed to be a direct expression of your personality. But when you're young you have to practice something. Once you master the basic skills, you have choices, and you can create your own style. Body and mind come together, and the hand moves effortlessly.

I loved practicing calligraphy. My mother would have to yell to get me to stop writing characters and come to dinner. I could do it for hours, a form of meditation. In the evenings, when we packed schoolbags for the morning, we had to be sure to include all our writing supplies. We had a big bottle of ready-mixed Chinese black ink for calligraphy and another bottle of dark, sweet-smelling blue ink for Western penmanship. We packed both Chinese brushes and old-fashioned pen nibs and penholders. We learned to do Western block, italic, and cursive script. My own handwriting—especially my signature—is a mix of these types of writing. From a very early age, we were training our hands, bodies, and minds to express themselves in two languages.

Once we got to secondary school, most of our classes were in English, and we stopped using Chinese so much. When we did write compositions in Chinese, we just used a ballpoint. But the paper was still those little squares, one hundred to a page. It made it easy to count the length of our essays. And when you count like that, everything is equal—a period or comma takes up the same amount of space as a word. Words and silence become equal, and every pause has meaning. Just as breathing out is as important as breathing in.

A friend told me about a new form of exercise popular among older men in Beijing. They gather in the early morning at some piece of flat ground and score it into large squares with chalk. Then they take a wooden stave about two or three feet long, and on the end they wrap some soft spongy stuff that's dipped in water. Slowly each man takes up his giant brush and writes a large character on the ground. Wielding the long handle loosens the upper body—the shoulders, elbow, wrist joints, and muscles. They do a kind of dance, flexing the whole torso and strengthening the leg muscles. I think it must be like dancing on paper—firm steps and great sweeps of strength and joy and celebration. Afterward, they can watch their characters evaporating into the air, the soft points going first, the thick base strokes fading last.

明
MING

MING明 *(ming)*

The sun and the moon in harmonious combination create the brightness that is Ming. It is the name of a dynasty but is also a word denoting illumination and clarity.

THE NATURE OF GARDENS

Although we lived in the city, when I was little we would spend a month or two every summer in the country. We stayed with close family friends, my father's godparents, who had a farm in the New Territories north of the city, and quite close to the Chinese border.

Today, the New Territories are filled with new towns built in the seventies, and there's a new subway line for residents to commute into the city. Less than one-tenth of Hong Kong is farmed. Only a tiny percentage of Hong Kong's population work in agriculture to produce fresh vegetables, fruit, pigs, and chickens for market. This area is also home to several reservoir parks, nature reserves, and hiking trails. For children in the sixties, growing up in the dense urban world of Hong Kong and surrounded by high-rises and noisy traffic, these trips to the farm brought us closest to nature.

My god-grandparents grew all kinds of vegetables and raised livestock. For my siblings and me, the pigs were the best part. We spent hours in the sties, playing with the soft-skinned piglets and giving them baths. Once, we set up cots in the barn and slept there. It was a few days after my father's godfather had passed away. Traditionally, it's believed that on the seventh day after someone dies he returns for a visit before going on to the other world. That evening, my god-grandmother set up the table in the dining room, and laid it with things her husband loved to eat before we all spent the night in the barn. We were a little frightened, because we didn't understand that he was coming back out of love to say goodbye. I can still hear the soft breathing of the pigs in their sleep grunting in their dreams, as if they were being chased, or enjoying a huge meal.

Every morning we awoke to the chirping of birds. After breakfast we helped feed the ani-

mals. At first we were even allowed to collect eggs, but we kept breaking them. Sometimes if we were lucky we'd find a chick just starting to hatch.

After lunch we stayed inside because of the heat. We had to do a few pages of homework a day, and sometimes we read. But there was always something else to do: once we spent the whole afternoon watching a sparrow build its nest. My mother told us the sparrow had chosen us as neighbors, so that meant very good luck. The sparrow made precise and beautiful movements, and its colors were wonderfully subtle, all black and gray—so different from the bright yellows and greens of tropical birds. Later we watched the babies hatch and saw the mother sparrow working hard to feed them.

When the sun began to weaken, we went out into the fields. We picked flowers, chased butterflies, and caught grasshoppers. Sometimes we just lay in the grass and watched things at ground level. Life passed in front of us, and I could feel it against my body when an ant crawled up my knee, or a yellow-brown frog hopped dry and clean against my bare foot. We looked for *pak chow,* the "shy grass" that curled up its fronds as soon as you touched it. When we returned to the house in the late afternoon, my mom made us strip in the courtyard and doused us in freezing cold water drawn from the well.

I loved the feeling of being freshly washed and tired, then being well stuffed on my mom's cooking. The whole family sat outside on stools to catch the breeze. My god-grandfather would tell us stories or talk about what we would do the next day. He might promise to take us into the villages. He would buy us cotton candy, and we could watch an old man make grasshoppers from dried bamboo leaves. He folded and wove the leaves so intricately, we could never figure out how to do it ourselves.

We looked for shooting stars and chased fireflies. I remember the sound of our feet running in plastic sandals slapping against the cement patio, and the small dragonflies mating in the moonlight—their backs curving, sometimes into the shape of a heart. The sound of crickets was all around. We kept cool with woven palm or sandalwood fans, and when I close my eyes I can still smell the soft spicy scent.

These childhood memories remind me how important it is to have gardens in the city. The Chinese garden is a way of bringing that experience closer. The earth gives birth to trees and plants, which in turn give breath and energy to man. The colors, shapes, forms, and textures of

plants are marvelously different, but blend in a harmonious whole, never clashing. The setting refreshes your eye and body, a natural form of rest and replenishment.

A Chinese garden is a process, while traditional Western gardens are very balanced and geometric. The first time I went to Paris, it felt so strange to stand at the entrance to the Tuileries Gardens and see the whole plan stretched out. In a Chinese garden, you have no idea what you will see after you pass through the gate. There is something new around every corner, and the circuitous routes give you the illusion of traveling a long distance when you've only just been circling. A Chinese garden is all about making space intimate by cutting it into shapes, confusing the viewer's sense of direction and time. You might climb only a short distance up a small artificial hill, but then you can spend time in an exquisite pavilion, enjoying the panoramic views and appreciating the calligraphy carved into the columns. You might walk down a curving path and come to a still pond, savor the calm of its mirrorlike surface, and experience peace and the reflections of a quiet spirit.

Chinese scholars savored the pleasures of the garden, an important source of inspiration and energy. The wildness in the garden was always carefully thought out and arranged, art and nature working together. When a scholar walked through a garden, he appreciated not only nature but the art of nature revealed. Garden elements represented the movements and change of the earth, reminding him of his place in the grand design.

Gardens were also about display and entertainment. Poetry and drinking parties would turn the quiet solitude into a lively realm of humor and writing. After a bit of warm wine, men and women would write verse or compare calligraphy. If the host was a rich merchant or official, famous writers and artists would be invited, perhaps to leave behind an example of their art.

One of the best ways to savor the garden is to drink tea there. According to the writer Lin Yutang, tea symbolizes earthly purity. Harvested from plants, carefully cleaned and dried, brewed with the clearest water, tea is a distillation of nature itself—the essence of the garden. My favorites are light jasmine and a beautiful rose petal tea that a friend mixes for me in Hong Kong. But the lightness is deceiving. Since tea is purified from the earth, it's actually quite strong, so it's not good to drink too much. The flavor of tea is to be treasured in small amounts.

In a Chinese garden, small pools are filled with lotus pods and goldfish. Tiny rivulets and waterfalls wind endlessly through the landscape, and groves of fruit trees and willows are filled

with songbirds, grasshoppers, and butterflies. Appreciating these elements became the basis of traditional connoisseurship. Scholar rocks—natural rock formations that mimic in miniature the shapes of mountains and hills—are rare finds. They usually come from lakes where the waters have worked on them for thousands of years. You can only tell a true one by listening to its ring when struck. Sometimes their beauty can be enhanced by carving, but then they must be left to rest in a river or stream, sometimes for generations, to let the water wear away the marks of the chisel.

Raising goldfish is also an art, the cross-breeding of different types resulting in shapes that mimic other animals. When we were children, my brother had a huge aquarium decorated with colored marbles, and seaweed hung from the sides. When we fed the fish, we put our fingers on the water's surface to feel their kisses. The best part was watching them grow. We were so excited when the baby fish hatched, and we felt proud when they grew. We went to the fish market to buy new varieties—goldfish with bulging dragon eyes, ball-shaped bellies, ferocious lion heads, or even bubble eyes, sky-gazing eyes, and panda markings. I loved the way their tails and fins flowed, like the long white sleeves of Chinese opera heroines or the silk strands of the ribbon dance, graceful and ethereal.

The colors, shapes, and textures of plants continue to amaze me. They feed on light, sink their roots into the earth. Their forms are the forms of life. Flowers begin from the deep vibrant center, the color radiating organic and sensuous. From the garden, I've learned that keeping color combinations as they occur in nature helps to maintain a natural balance, and unexpected colors can go together without clashing. If I can translate these elements into a piece of clothing, preserving its meaning, then the garment can connect the wearer to that elemental natural power.

The garden has influenced my wardrobe; because of it I find myself wearing less black. Black is really a city color, and it's so easy—you don't have to worry about matching anything, and it usually looks good and very slick. I remember going to an event at the White House where everybody from the fashion world was dressed in black—it was like a uniform. But it's not good to lose your identity or to blend in too much. Almost everyone in my building on Fashion Avenue wears black, so my staff and I stand out a bit.

SCHOLAR ROCKS Interview with Chung Wah Nan

When I stayed at the Grand Hyatt Hotel during Hong Kong Fashion Week in 1999, I was struck by a series of black-and-white photographs used throughout the public spaces and rooms of the hotel. They made me feel as though I was not in a modern hotel, but in a Chinese garden. They gave me a real sense of peace.

The photos were by Chung Wah Nan, who had traveled around China in the seventies taking pictures of gardens. He produced a beautiful book of photographs in 1980, *Chinese Gardens*. Because his pictures were so eloquent, I wanted to ask him about his feelings for these gardens and about scholar rocks.

VT: What do you think is the difference between the Chinese garden and the Western garden?

CWN: Western gardens with residences, including Middle Eastern and Indian ones, have a strong symmetrical layout from the main building to the garden. They are dominated by mansions, perched at a high point and looking down on the garden, which spreads out symmetrically. The building assumes the commanding position in a rural landscape.

Chinese gardens are normally built into the urban fabric, are relatively much smaller, and rely a lot on walls for privacy. The residence or buildings are subordinate to the garden, which represents nature and therefore occupies the center space, with buildings at the periphery. The geometry of the buildings contrasts dramatically with the organic forms of the garden such as curved poolside edges, winding footpaths, grotesque rocks, crooked bridges. It's an interplay of the solemnity of the house against the fluidity of the garden, hard against soft, high against low, yin against yang.

VT: Why are so many of your photos of rocks?

CWN: It is necessary to understand the importance and meaning of rocks to the Chinese. In the mythical story, Pan Gu was the first man on earth, and when he died his flesh turned into mountains, his bones into rocks, and his blood flowed into rivers. Rocks are still worshipped by country folk and admired by literati and collectors.

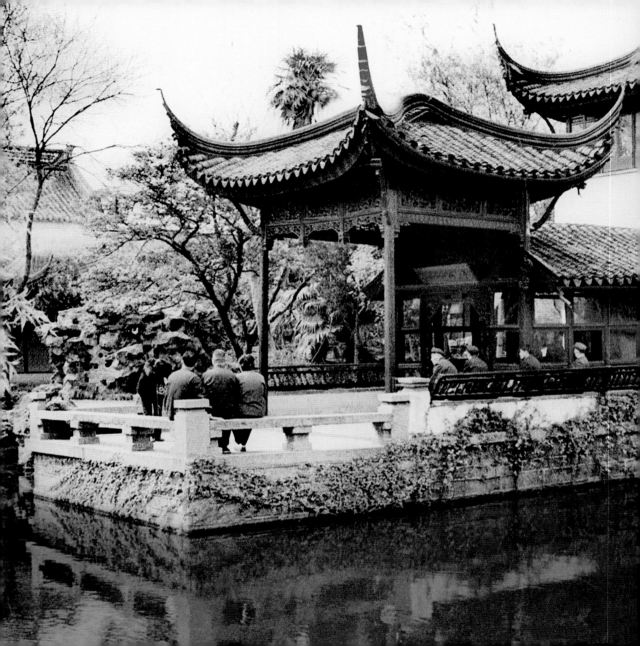

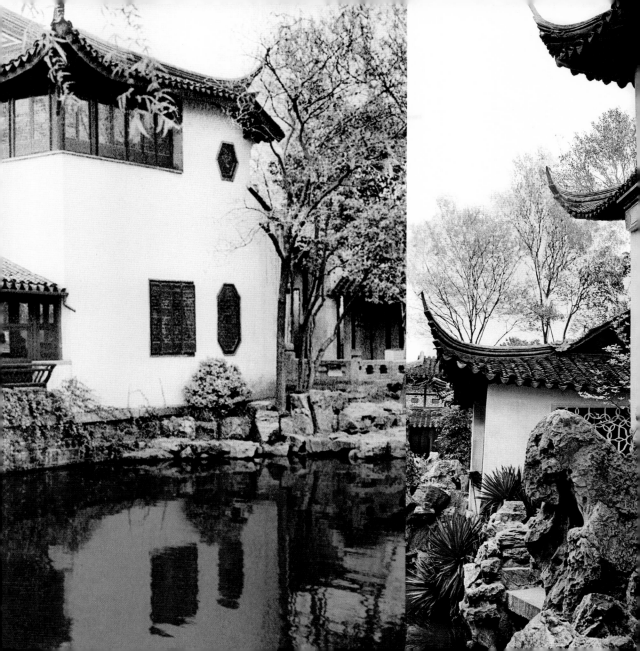

Rocks in the Chinese garden are seen as yang, and water as yin. They provide the necessary contrasts with plants, leaves, flowers, and water as something "constant" against something "changeable." A single piece of stone can act as a vertical feature like a totem pole. Rocks are admired individually as well as collectively as natural sculpture. Their composition can represent mountains and landscapes, injecting color, texture, and form into the garden design. Rocks become a medium to break straight lines and hard edges. Pond-side rocks represent peninsulas or islets, and they may be submerged or protruding, forming a natural riverside or coastline. A single vertical rock placed in a small "sky-well" reaching out to heaven represents the owner's wish to be lofty, and symbolizes the upright character of man.

In Chinese culture rocks have many mythical, philosophical, and historical representations as humans, gods, and demons. Above all, rocks represent nature, including human nature.

VT: I like the way scholar rocks are miniature landscapes—like a world within a world. And you can see them evolving—except of course it's not the rock that's changing but the passing light—and our own shifting vision. Each time we look, we're in a different time and place, so the rock looks different too.

CWN: A good piece of rock is a book without characters; a teacher without words. Of all the different interpretations I prefer the philosophical meaning of rocks. As the saying goes, "You can look at a piece of rock for ten thousand years and it will always inspire new ideas." Of course, nobody lives ten thousand years.

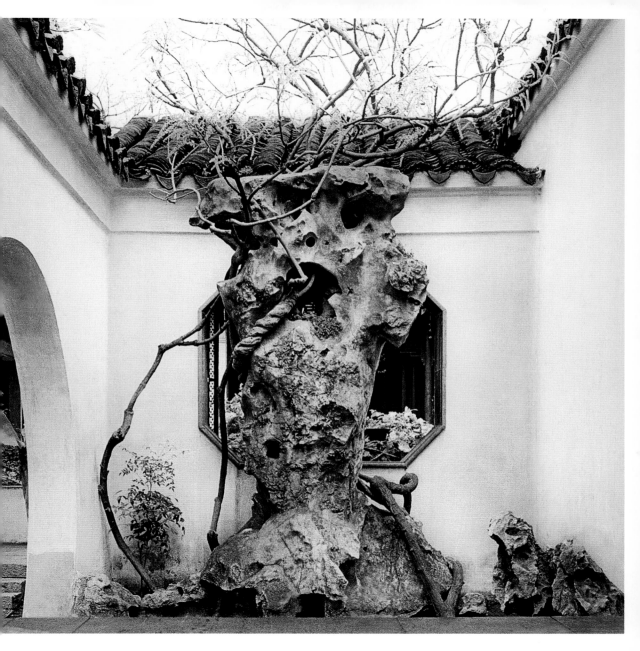

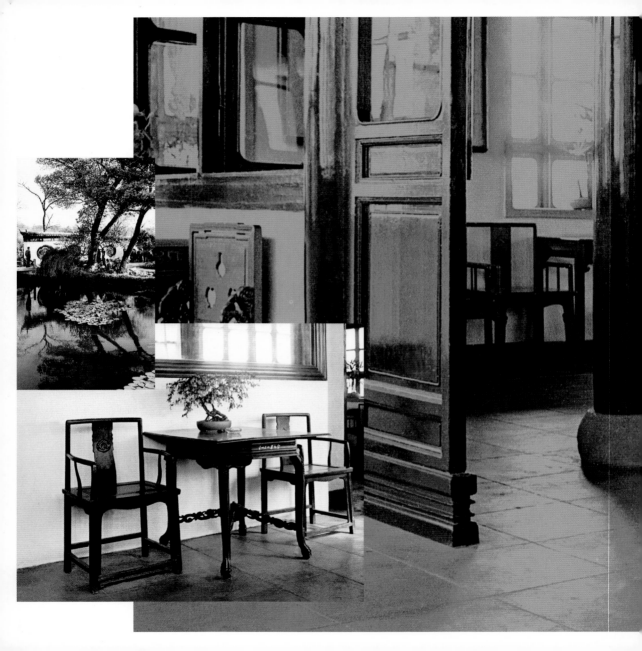

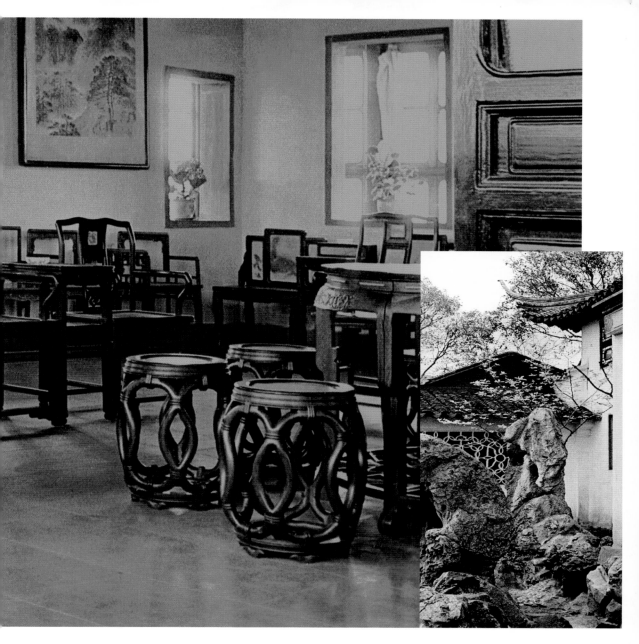

RISING AND RESTING

Until I was a teenager I slept on an old-fashioned wooden bed made of wide slats and covered with bamboo matting. In a tropical climate, my parents believed this was healthier than a Western-style mattress. When I first saw Ming period furniture in the antique shops on Hollywood Road, the shape and feel of the wood seemed very familiar, and the hardness didn't seem uncomfortable. The lines seemed streamlined and modern. I was surprised to learn that the pieces were over four hundred years old.

Ming dynasty style has become my favorite, both for furniture and for interior design. It's simple and elegant—beautiful without being overwhelming, substantial without empty decoration. In fact, there's almost no decoration—the chair itself is decoration in the very simplicity of its lines. The high point of the Ming dynasty, in the fifteenth and early sixteenth centuries, was one of the more peaceful periods in Chinese history, and you can see it in the culture. People had the leisure and stability to refine their tastes.

No matter what the function, the lines of the best Ming furniture are spare and clean. For the homes of the wealthy, the wood was usually hard, picked for translucency of color and the pattern of its grain. For commoners, the material was often a softer wood, but still durable. The material used determines the cut and construction, so there is a unity of form and substance that is timeless.

The construction of the furniture parallels the structures of traditional Chinese wooden architecture. The carpentry of the roof, braces, and pillar is mimicked in the joinery used for the legs of a table, a chair, or a cabinet. Simple and clean lines always begin from a firm, beautifully made base. This gives the whole piece—whether a chair, bed, or screen—its particular combination of substance and weightlessness.

In Chinese flea markets, I saw many pieces of Ming furniture, both the folk and high versions. I was interested in learning about different types of wood—the golden transparency of the *huanghuaili,* or yellow-flowering pear wood; the silky shimmer of boxwood; the dark purple black of *zitan,* or rosewood, all with amazing textures and lines. I met a history professor who was an expert in Chinese furniture, and he taught me to appreciate the smooth but complex joinery—sturdy and fitted together without glue or a single nail or wooden peg, meant to be taken apart and put together again whenever the household moved. The professor also showed me how to feel the vibrations in the wood with my hand. He could tell a piece's age by tapping it and listening.

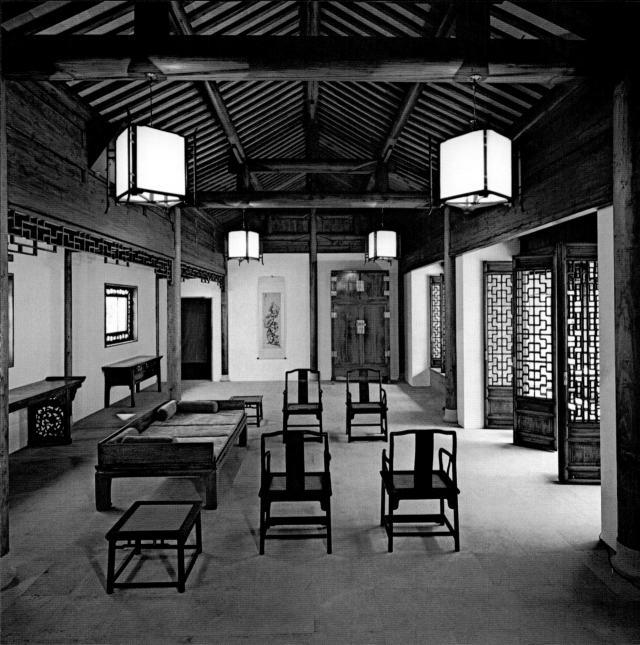

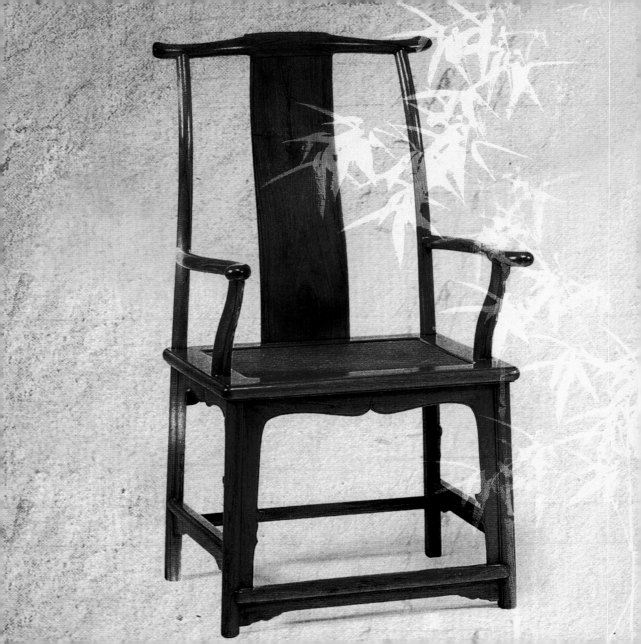

The professor acquired his collection of Ming pieces during the Cultural Revolution, when people were afraid to own such traditional things because they were labeled feudal, and simply threw them out. Instead of being chopped up into pieces, the furniture was taken apart and tied together in bundles for cheap firewood. The professor bought whatever he could and hid the pieces until it was safe. The beauty of the design actually helped save the lives of these chairs, and the professor was very proud to have played his part.

The essence of Ming style is an appreciation of nature, an attitude cultivated by scholars and officials as well as poets. Regardless of their occupation, these men (and a few women too) found relaxation in painting, writing, and calligraphy inspired by nature. Like the Ming garden, Ming furniture brings nature into an urban setting—not by carting in a lot of plants and animals, but by emphasizing the process and rhythmic pulse of nature. At first glance, you might see only a static shape, but if you look closely you can find movement in a subtle curve of an armrest, or the narrow straightness of a leg strut. The lines are refined, peaceful to the eye, uncomplicated. Ming design combines the child's innocent heart with the adult's wisdom and maturity. That's why it's so timeless and modern.

My favorite chair is the official's hat chair. To me it's the simplest, purest version of the Ming style. Everything is set at right angles—the arms, the back, the seat, and the legs. There might be the very slightest undulation in the struts, which enhances the purity of design. This chair was commonly used by scholars, who had to sit working at their desks for long periods. When you sit in an official's hat chair, you can feel its lines creating a box around you. The back curves very slightly, just enough to support the shape of your own back, and the arms extend into small curves that you can feel in the palm of your hands like a kind of anchor. Where it touches your body, the Ming chair supports you gently and centers your body within a square, drawing your posture straight from every direction. It's really quite comfortable.

Traditionally, Chinese scholars are supposed to be upright—straight and true. The body and head are always held in a straight line. Holding the body erect was originally a matter not of discipline but of nature; the straight posture of the body is the natural way children stand when their bodies are fully relaxed and healthy.

Today we push ourselves so unnaturally that our bodies react by slouching into soft furniture, a response to exhaustion and stress. Otherwise we would stand and sit with the *qi* flowing naturally. From that point of view, the Ming chair represents a balance, a healthy way of living.

CHINESE SPACE Interview with Calvin Tsao

I met Calvin Tsao in 1994 right before the first show for my Vivienne Tam label. He was born and raised in Hong Kong, went to the States to study architecture, and is now based in New York and Boston. We clicked immediately. We'd had similar experiences, growing up in Hong Kong and establishing ourselves in America. Our cultural references were the same, and we both worried about keeping our energy levels up so that we could maintain our schedules. The next day he sent a beautiful silver thermos filled with coconut bird's-nest soup to my office.

After studying architecture at Berkeley and Harvard, Calvin worked with I. M. Pei on the Fragrant Hills Hotel in Beijing and the Bank of China in Hong Kong. He is a partner at Tsao & McKown Architects in New York, and is also the Eliot Noyes Visiting Critic in Architecture at Harvard's Graduate School of Design.

I asked Calvin to talk about Chinese style, and how Chinese architectural aesthetics had informed his work. I wanted to know more about Sunset City, a huge complex that his firm had recently completed in Singapore, which has a center garden that epitomizes Chinese sensibilities about living space and architecture.

VT: How would you define Chinese style?

CT: China has such an old culture—there is the Han dynasty, the Tang and the Sung, the Ming and the Qing. China throughout the centuries had many different influences, different invasions creating all kinds of conditions. For instance, the Qing dynasty was ruled by Manchurians, and their sensibilities were different. It's hard to say what is good or bad or true Chinese anymore, because they are so mixed up. There is the almost Zen minimalism of Han or Ming style, and then you have the very rich and baroque style of Qing. I think Chinese culture embraces all these different aspects, making Chinese style so difficult to understand. Ultimately, it celebrates the vitality of human spirit and its different moods. It's better to talk in terms of sensibilities rather than styles, because these different Chinese sensibilities can't be contained within one style. That's what confuses people.

VT: How would you define Chinese sensibilities?

CT: Well, take feng shui. Whether you believe it or not, Chinese style is generated by spirituality, mythology, folklore, something greater than this world. It's a religious culture, but a very spiritual one, and there is a belief in life after death, in reincarnation, all that. Much of the Chinese or Asian aesthetic looks for the long term.

Take the pagoda. What's that about? It's something that has been in the Chinese tradition for many many centuries. Whether it's really simple like the Ming pagoda or a Qing pagoda with a lot of lines, it's an uplifting roof.

VT: Is that roof about worship, pointing up to the sky?

CT: It's about cosmology. It's about the roof as interface with the sky, and our relationship with the sky. The roof is not a downward thing, not just about shelter, but about embracing the sky. Style is generated by an attitude—a philosophical attitude, religious attitude, or spiritual one.

What's interesting about Chinese culture is that it can be metaphorical, but it's also highly rigorous. The geometry is set by a highly ordered cosmology, and the use of numbers, even or odd. It makes a difference in the design. So much of the aesthetic is not based on what looks pretty or not. Instead, what looks pretty or not is decided by the elegance and beauty of solving these cosmic issues.

Even the color red is not preferred because it's pretty, but because it symbolizes vitality. In the West, red symbolizes alarm, violence, and so on. But in China, red symbolizes prosperity, blood as a life force—a good thing, not morbid—and fire. Without fire there would be no culture. Energy is red. All colors have meaning.

VT: How is this meaning translated into architecture?

CT: So much of Chinese architecture is about politics and sociology. Take the courtyard house. It's a map of social interaction. Remember the movie Raise the Red Lantern? It's about trying to keep the politics and relationships in the family within categories. It's very highly organized and structured. The style comes from the need to create order within society. A lot of Chinese style comes from resourcefulness. China has always had a problem with overpopulation, a lack of resources. So the whole hierarchy of values comes from that.

Basically, the Chinese sensibility is respect for nature. You can see this in the Ming dynasty designs.

VT: But there was also the influence of the West, and the Manchus were not so cultured, right?

CT: Yes. Things were much louder in Qing because they wanted to let people know who they were. But the two sides coexist. A lot of people have always said, Don't show off, because you'll use it all up. This philosophy of conservation generated so much style. All of these generations were conserving their resources and being very simple, elegant, and quiet. Suddenly, in the Qing everything just turned around. It's a yin-yang thing, always a swing between extremes. They see the value of both and they jump back and forth.

I remember a Tang dynasty painting of a beautiful woman with a little dog. Her dress was all gray and browns, but flaring inside you could see a hot-pink lining. Even during Communist times, when everyone wore Mao suits, you could see red wool socks or bright green sweaters inside.

VT: How do you use these elements in your work?

CT: Chinese style today is not trying to repeat Chinese style a hundred years ago. It doesn't necessarily mean just using dragons and doing carved wood. The fundamental principle is that everything is not what it seems—there's an element of surprise, of closing, of revealing, of different layers.

In your store there are definitely Chinese elements, but the Chinese would never carve a wall with a double happiness. A friend of mine once asked, "What a cool wall, what is that pattern?" I said, "That's not a pattern, that's a word!" It can be both pattern and word, which to me represents this Chinese sensibility in a nutshell. The style and the aesthetics are embodied in meaning.

I try to go back to important Chinese cultural meanings, and humility is essential—it's an approach, an attitude. Humility, responsibility, and humor, it comes out in the balance of revealing and covering, in the layering of space.

VT: Tell me about the amazing garden you did in Singapore.

CT: The garden is the centerpiece for a big development of buildings. What you take away from the earth, you have to put back. This is a very important sensibility in Chinese culture. Since we built this complex of high-rises, we decided to plan a big garden as compensation. There was also the issue of movement and rhythm—buildings are static, we needed natural elements to flow. The conceptual idea was that there should be a well as deep as the buildings were tall. We weren't able to dig a real well, so we built a fountain, but instead of a Western-style fountain that flows up, out, and away, our fountain flowed into a hole. The movement is one of conservation, and returning energy to nature. That was the gesture.

The press asked us about the ideas behind the park, so I explained about giving back to nature and to the earth. People were curious and lined up to see the good feng shui. When they saw it, they were skeptical. The fountain didn't look very Chinese or Asian, it looked very modern, made of steel, bronze, and granite—contemporary materials. So that was a challenge. One man tossed in a coin and wished he could win the lottery, and then the crazy thing was that he did. A woman wished for a baby, and she got pregnant.

VT: Tell me about the Fragrant Hills project built near Beijing in the early eighties.

CT: We designed everything for that hotel—the knives and forks, the uniforms, the carpet. When we designed the staff uniform, we did it in a style that was fashionable for the eighties. But perhaps because they had been so isolated from the world for thirty years, the Chinese seemed to feel that they needed to go through the entire Western fashion oeuvre that they'd missed when they closed the door in 1949. So in 1980, everybody dressed like the West had in the fifties. By 1982, they'd reached the sixties. They went through it all very quickly. They didn't want to skip anything. By the time we were designing these uniforms, they were really into the seventies, and loved these big collars. Our design called for the smaller collars of the eighties. The manufacturer just changed my specification. When I saw the samples they all had gigantic collars, and I said, "What happened? I didn't make this collar so big!" They said, "Oh, Mr. Tsao, nobody with good taste would wear a collar so small, so I thought maybe you made a mistake, and I corrected it for you."

COURTYARDS AND SPACES

Zhang Yimou's film *Raise the Red Lantern* is a powerful evocation of family life in China in the early twenties. The rhythms and patterns of the household are so striking, the flow of a complicated family life flows through the mazelike, clean, whitewashed walls of the traditional *siheyuan,* or courtyard home. The traditional Chinese family house has rooms organized around a series of courtyards, spacious enough to allow the cohabitation of "four generations under one roof," as the Confucian saying goes. Zhang's film emphasized the confusion and tensions that can sweep through the rooms when familial pressures become too strong.

The courtyard house offers a communal lifestyle in which each family group has its own rooms arranged around a central communal space. The biggest courtyard house in China is the Forbidden City: the rooms are clustered around open linked courtyards, one for each generation or concubine. Sometimes one or two courtyards may be put aside for meeting the public, but the rest are for private living.

At its best, the courtyard house reflects a mix of yin and yang elements. The platform floor represents earth, the curving roof is heaven, and the two are held together by pillars instead of walls, which creates a floating, airy feeling. The open ground in the center also lets in light and air, creating an outdoor space. The entire compound is usually surrounded by a windowless wall, turning exterior space into interior secret, and closing the household away from the public street. Walls carve out straightforward rooms and walkways complemented by the use of screens and small cutout windows that can disorient the visitor but still allow for a propitious flow of *qi,* or life energy.

The windows are often cut into the shape of fans, lanterns, flowers, moons, and rectangles, each one carefully planned and placed. To look out these "picture windows" is to see a carefully composed painting, with beautiful plants and flowers. The simple courtyard design also allows for overlapping and additional quadrangles, resulting in a kind of maze effect similar to the Ming garden. Without a guide to help you, the first time you walk into a large courtyard home, you can't be sure you'll be able to make your way out.

The courtyard house is a space of peace and protection. At the main entrance is the spirit wall, a large solid screen placed directly in front of the opening so that anyone entering has to

walk around. This shields the space from bad spirits, since ghosts can't make quick turns around obstructions. They can't step over them either, which is why a *menkan*, or wooden threshold, is placed across a doorway. Although it's a beam less than a foot high, ghosts can't get past it. When I decorated my office I wanted to install a *menkan*, but the insurance people said people might trip over it. Ghosts can't get around a *menkan*, but insurance brokers can get rid of them entirely.

In the Ming-style *tingtang*, the preferred furniture is light, airy, and movable, so that nothing obstructs the *qi*. Chairs and vases come in pairs and are placed next to or opposite each other; scrolls and inscriptions are hung in doubles to ensure the balance and harmony of the living space.

The use of large folding screens in structuring and dividing a room is also a special art. Traditionally, the screen was placed to the rear of the host's seat at the front of the room. Symbolically, the screen blocks off space but still allows penetration. In the Forbidden City, it was literally a way to watch the emperor's back, a form of protection from his advisers. But it was also a place of concealment, where his minister or concubine could stand to eavesdrop on state business, and offer advice to the ruler in urgent whispers.

Any ideal space was supposed to be in agreement with the cosmos, perfectly aligned with the poles as well as heaven and earth, creating an environment of power. Today, in the real world it's impossible for every space to be so uncluttered or so perfectly aligned. The masters of feng shui, or geomancy, are like priests or diviners—they interpret the meaning of the environment and try to find ways to let man and his home fit into the spaces allotted by nature. The orientation and placement of rooms is crucial. Ideally, every home should face south, and the corners of the room should meet at right angles, with clean lines and a flow-through of air.

Feng shui masters work at correcting our environments to compensate for imperfections, and keeping a fine balance. For instance, mirrors can open up a cramped corner, a bowl of gold-fish adds a water element to a room with too many hard edges and sealed windows, but too many mirrors in a bedroom may cause bad dreams. A ceiling beam over the bed means bad health for the persons who sleep in it. The color of the walls, the placement of the windows and doors, and the position of furniture can all affect feng shui.

The technology and science of modern life can also be reinterpreted and their energy

incorporated into a natural life. For instance, you would never put a bathroom near the main entrance, or rent a shop space near the building's public toilet—all good luck would be immediately flushed away. Some friends had a feng shui master inspect their offices, and he took one look at the photocopy machine and made them move it: the paper trays were like the jaws of the dragon, so they had to be careful to see in which direction they were pointing, otherwise the person sitting there might be gobbled up!

The first time I consulted a feng shui expert myself was in the early eighties, when I moved to New York City. I found a great loft space that was long and airy, with windows all along one side that looked out onto the Hudson River, and two square columns down the center. I slept in a small alcove near the door. When the feng shui man came, he took one look and asked, "Do you have stomach problems?" And, in fact, I did. He said, "You have to move your bed. You're sleeping too far from the window, under the fan and behind the pillars. The *qi* is blocked, and the fan over your body is making you sick!" After I moved the bed, I felt much better.

In my office, my colleague Brian was experiencing a lot of back pain. The feng shui master took one look and said the Ming-style clothes racks stacked in the corner were pointing straight at Brian's back, and that was the reason for his problem. When we moved them out, he felt better very quickly.

When I moved into my last apartment, the feng shui master came for another look. My living room was filled with Chinese furniture, but he focused on the large Ming bed being used as a sofa in the middle of the room. He asked me, Is this an old bed? Where did it come from? When I told him it had been shipped by sea from China, he was very relieved. He said ghosts can't travel across oceans, so I would be all right.

INTERIORS

I work long days at the office or in my workshop, so for me home is a place to unwind, a haven where I can relax, meditate, and renew my energy.

The first time I saw my apartment, I was drawn to the wood parquet floors and the clear flow of space through the rooms. I loved the view of lower Manhattan and the Hudson River. The balcony faces south, which is really important for *feng shui*, and the shifting flood of light tied the main room closer to nature, giving the room a very Ming feeling. To take advantage of the light, huge potted trees and exotic plants bring live wood and earth into the room. To add an element of stone, I stripped some of the columns down to the concrete. Under the Sheetrock was a beautiful unfinished surface that's almost sculptural. The modern limestone fireplace adds fire, earth, and metal elements.

I love balancing classical and contemporary, East and West, in my home as well as my clothing designs. The front door is red, like a traditional gate. Next to it is a contemporary artwork, "Lipstick Mao," by my friend Zhang Hongtu. In the foyer are antique Chinese screens mounted as closet doors, lined with black fabric, adding a subtle shadow to the room at night when lit from behind. They contrast with the high narrow wooden flip-doors to the bedroom, which are turn-of-the-century American.

The centerpiece of the living room is a beautifully crafted antique Ming bed with a rattan base that I purchased in Beijing on the advice of a Ming furniture expert. He said, "Wherever you put this, there will be a good feeling." He was right.

But not everything has to be Chinese. In the dining area is a beautiful Scandinavian dining table and modern chairs covered in black leather. The elegance and simplicity of these designs have the same timelessness and contemporaneity of the Ming. A simple sixties Western sideboard, topped with a marble slab, is the setting for a scholar rock and one perfect white Chinese porcelain vase. In the study is a simple Qing desk with a contemporary Miller chair. In the bedroom, the bed is covered in hand-embroidered and appliquéd linen from the PRC, white on white. A modern lamp with a yellow moonlike globe sits on a Ming side table. In my red-walled bathroom, a beautiful old wood-framed Chinese mirror is over the sink. You can mix different things together to create a new balance. This balance creates a sense of well-being and peace of mind.

I love coming home at night. I can sit under the trees with a cup of tea and contemplate a scholar's rock or the lights of the World Trade Towers.

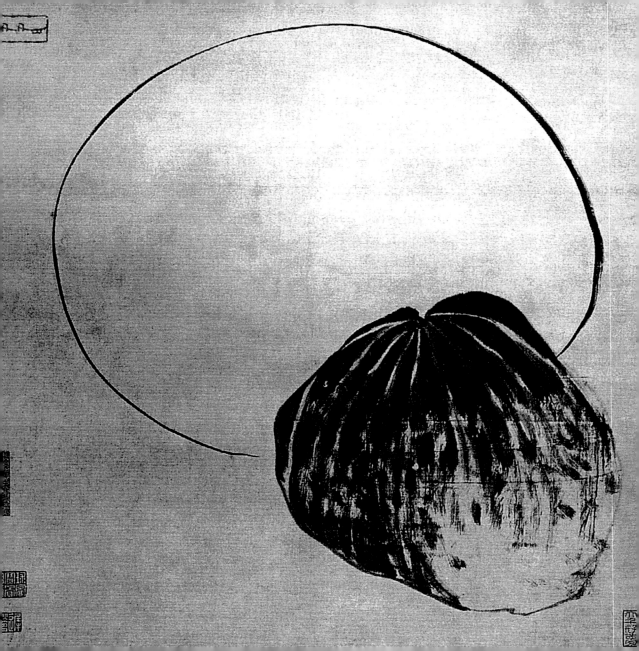

BADA SHANREN

One of my favorite Chinese painters is Bada Shanren, or Man of the Eight Great Mountains. His brushwork is sure and strong, and every painting has a strong feeling of irony, humor, and sometimes darkness. Chinese painting is always a bit abstract, but Bada Shanren's compositions are even more minimalist. He places one fish on the page, and his use of negative and positive space is so clever, you don't know if the fish is swimming or flying, or if the space is water or air. You just feel the strength of the whole painting's direction. While other painters do huge landscapes, Bada Shanren takes a bug's eye view of things. Instead of a river, he paints the giant petals of a lotus rising on its stem along the riverbank. Instead of a hillside of trees, he paints a bird with a sarcastic squint perched on a withered branch. A lumpy winter melon basks in the glow of a perfect oval moon. When I first saw his work, I thought he was a contemporary artist.

Bada Shanren was born into nobility at the end of the Ming dynasty. He was used to the very best—the most exquisite rooms and gardens, the most scrumptious food, and the most interesting playthings. He was eighteen when the Qing emperor took over in 1644, and in response he and his father shut themselves away and refused to speak or to hear. Bada Shanren later lived as a monk and poured all his emotions into painting. You can see it in his strokes— for him madness is a game of liberation—he walks the edge but he never loses his balance. He makes very bold and dramatic statements, but with an air of detachment.

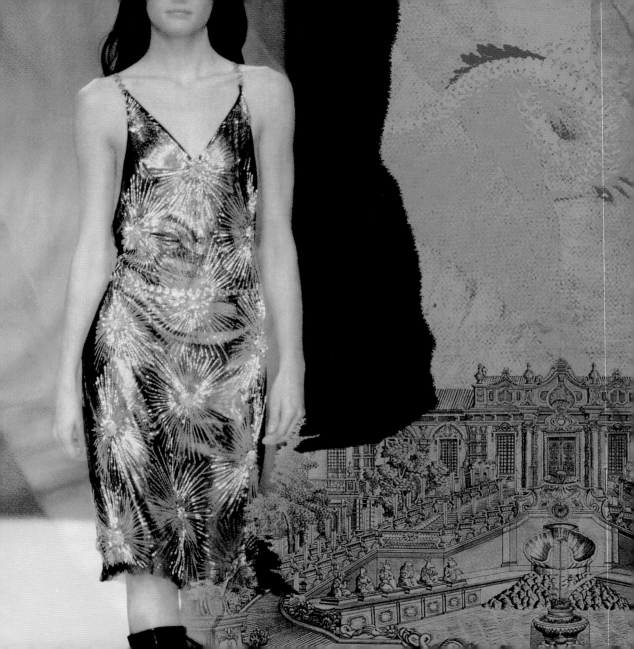

清
QING

QING 清 *(qing)*

Clarity or purity. Can also be a blue or green that can range from clear sky to deepest ocean; the color of air and water.

WHAT IS CHINESE?

What is Chinese? As a child, I never thought about it. I lived in a world where Chinese and English were mixed up, but there were things that were purely Chinese—my mom and dad, the food we ate at home, the chopsticks we used—simple everyday things. In history class I learned about the different dynasties, but later I understood that every period had a different style.

When I traveled outside China and Hong Kong, it was shocking to see what was considered Chinese. Old-fashioned gaudy pagoda roofs painted red and green, Chinese restaurants decorated in plush red and shiny gold, heavy dark carved wooden furniture inlaid with swirling marble, brocaded Fu Manchu robes and mandarin long fingernails, the opulent smoke of perfumed incense: it all was too much—it was Qing.

The Qing dynasty was the last imperial reign before the Chinese Republic was established in 1911. If the Ming was classical, the Qing was baroque, or rococo. It was also the period when the West began to know China better. The style and aesthetics of the Qing are what Westerners think of as Chinese, and what *Chinese* think of as Chinese. When I visited the Great Hall of the People in Beijing, the style was the same—heavy dark carved furniture and screens, ornate porcelain vases, thick velvet drapes.

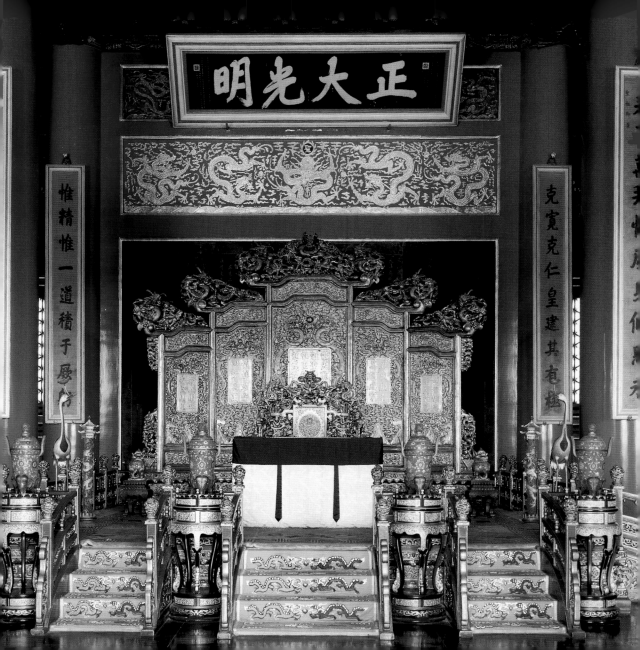

As outsiders, the Qing court was influenced by new Western ideas and style. Jesuit monks were installed in the court as astronomers, mapmakers, painters, and architects. Emissaries from Western governments brought gifts of furniture and playthings that decorated the imperial living rooms. The paintings and buildings that come from this time are among my favorite examples of East meets West. They're mixed together blindly, but the blend is really creative. The result is almost too rich, like a cake with too much frosting.

The word *qing* means "clarity" or "purity." But the meaning is ironic; the style of the Qing was never really clear or pure. But *qing* can also be a color, a shade that matches the color of air and water from palest celadon blue to deep black. It exists only on the surface.

How does East meet West? To begin with, they're far apart, so it takes time to get to know each other. But sometimes, it's like looking in a mirror.

CHINOISERIE/EUROPEANOISERIE

On the coast just an hour south of London, the Royal Pavilion was completed in the early 1800s for the Prince of Wales, later George IV. The exterior is all lacy Mughal marble tracery, but inside the look is Anglo-Chinese at its most fantastic. The first time I visited, the scale of chinoiserie was overwhelming. The combinations were so strange—instead of bamboo furniture, chairs and tables were carved of beech to look like bamboo, or there would be a bamboo-shaped cast-iron railing. Chandeliers hung in the shape of lotus blossoms, decorated with gilded dragons that look more like Alice in Wonderland gryphons. They had wings!

The Pavilion reminded me of the Forbidden City, because the style was greatly influenced by the Qing, and also because of the ambitious scope of the design.

The first time I saw the Forbidden City, the skill of craftsmanship and the scale were stunning. Every surface was decorated with grand colors and textures. The colors were so bright because the Manchus were Buddhists, and the decor was influenced by temple designs and painting. The effect was gorgeous, and when I was designing my shop I visited the Forbidden City for inspiration. Decoration brings warmth to a room, but I found myself fighting to keep things simple.

The Pavilion interpreted traditional Chinese motifs in the same way as the Qing—as outsiders. It reveled in rich decor, but with a lighter touch. Working in a Chinese idiom freed the designers to use as much color as they wanted, and they chose different shades. They used pastels and candy-colored shades instead of the deep primary hues of the Qing. The stained glass used in the ceilings and windows rendered color lighter and brighter than in a real Chinese room. The paintings borrowed Chinese motifs, but reproduced them in a more realistic way. The figures are more rounded and finished, and there's no consciousness of brush strokes. There are Chinese characters painted on the walls that don't mean anything at all.

I like the sense of humor best. I love the models of the Chinese mandarins lining the Long Gallery—the heads are movable, and they nod as you walk by. In the hallway, there is a dragon-shaped box for donations. When you put in a coin, the dragon's tongue pops out. It was really whimsical, and it made me laugh.

Entire rooms were inspired by a few pieces of Chinese wallpaper made for export—and

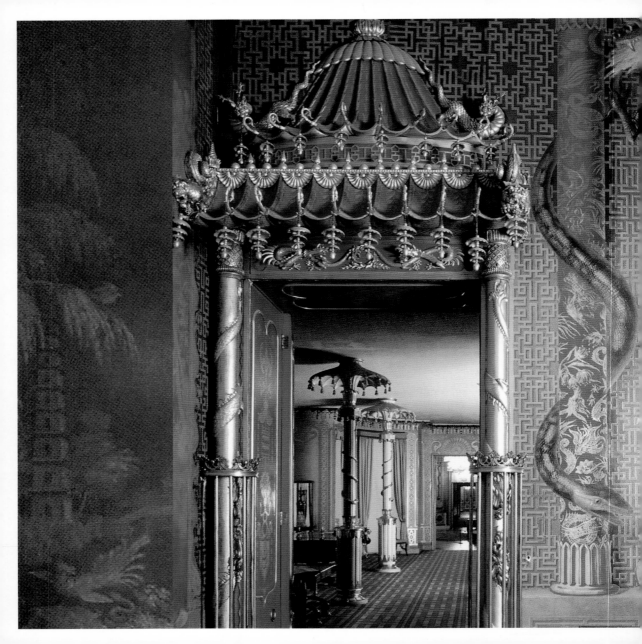

then carried forward by English artisans. The dragon wallpaper in one room is a takeoff on the dragon robe itself, starting with a wave pattern at the bottom, and rising up with giant lotus blossoms and dragons—only it's monochromatic. The ceiling of the music room looks like a giant enameled cloisonné vase, and when you stand under it, you feel as if you are a genie in a Chinese bottle. The walls are lacquered in red and gold, illustrated with scenes from old English engravings of famous Chinese buildings. In the banquet hall, there are hand-painted murals of a Chinese bridal scene with the bride proudly unveiled, being carried aloft on a big cushion for everyone to see. None of these things existed in China, but to the British, the Pavilion was a fantasy of what China *should* be.

Strolling through the Pavilion reveals how Chinese style can be translated. The Pavilion approaches Chinese elements from a completely different angle and makes them new. The designers were always in control of their craft, but open to surprises.

The Prince Regent, later George IV, built his dream house in stages. At one point, his architect drew up plans that were based on a famous Chinese palace in Beijing—Yuanmingyuan, the Garden of Perfect Brightness. Unfortunately, there wasn't enough money to build it. Eventually, he used a new design with exteriors based on the Taj Mahal. What's great about the might-have-been Chinese plans is that when the European palaces of Yuanmingyuan were built in the mid-1700s, their designs were based on Versailles. Yuanmingyuan was a classic piece of Europeanoiserie—with a mechanical fountain, carved animals and fruits, and great marble arches. After the Qianlong emperor built it, he felt he possessed everything the West had to offer. The Prince of Wales probably felt this way about China after he had his Pavilion. Yuanmingyuan translates as "the Garden of Perfect Brightness," and the Pavilion is at *Brigh*ton—another matching of fate.

The engravings of the European palaces at Yuanmingyuan were published in the West soon after they were built. Today, they reveal that when East copies West, the result can be quite heavy, but when West copies East, the aesthetic is much lighter. Yuanmingyuan became famous in the West not for its heavy Western pavilions, but for its Chinese-style gardens, and it served as the inspiration for many grand and beautiful chinoiserie gardens throughout Europe.

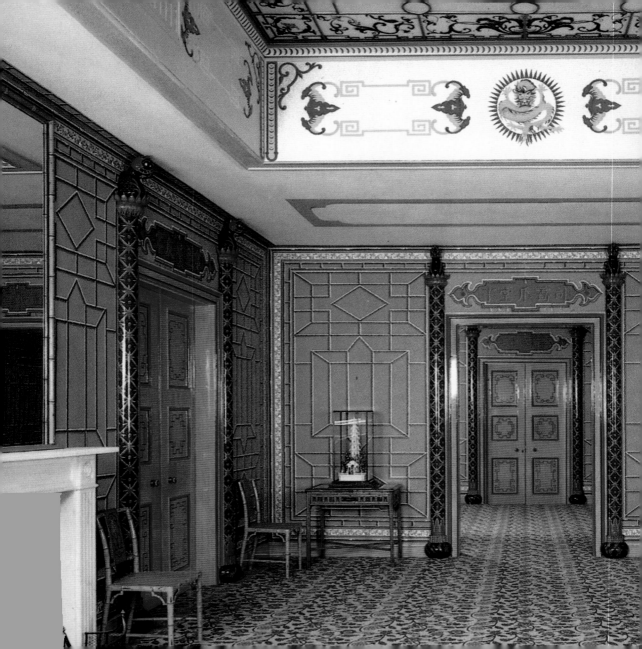

THE GARDEN OF PERFECT BRIGHTNESS Interview with Geremie Barmé

I asked my friend Geremie Barmé to tell me more about the mix of East and West in Qing style. We met when he wrote about my 1995 Mao collection in *Shades of Mao,* his book about the ways Mao's thought and image have influenced contemporary China. Geremie is a research scholar at the Australian University in Canberra and the author of many works on China. His other books include *In the Red,* about contemporary Chinese commercial and dissident culture, and a new work on the life and work of Feng Zikai, a modern essayist and artist. He also wrote the screenplay for the acclaimed documentary *Gate of Heavenly Peace.*

Among my Chinese friends, he's famous for his flawless Mandarin. His calligraphy is beautiful, and his Chinese essays have been published in China and Taiwan. His knowledge and enthusiasm for things Chinese are contagious.

VT: How did you get interested in Yuanmingyuan?

GB: My interest in the old imperial gardens outside Beijing was sparked by a trip I made to Las Vegas in 1994. I visited the Luxor, a thirty-story-high black pyramid in the desert, as well as other new theme casinos on the Strip. After that, I became interested in looking at theme palaces in China, first the modern, then the classical. To me, Yuanmingyuan was one in a long line of what Charles Moore called "palace kingdoms." Disneyland would be another one. The inspiration for Yuanmingyuan also came from tourists—Jesuit missionaries. To convert souls, they tried to ingratiate themselves by offering their services as mathematicians, astronomers, and painters. Giuseppe Castiglione was an artist who impressed the Qianlong emperor (1736–95) with his realistic oil paintings of the royal hunt, horses, ladies, and court scenes.

VT: I've seen some of these paintings; they're wonderful. I love his portraits.

GB: Castiglione showed the emperor pictures of famous buildings and palaces in Europe. Qianlong wanted the same things as his Western counterparts—imposing marble edifices with lots of fussy fountains and ponds. Castiglione and his fellow missionaries were housed in a special part of the

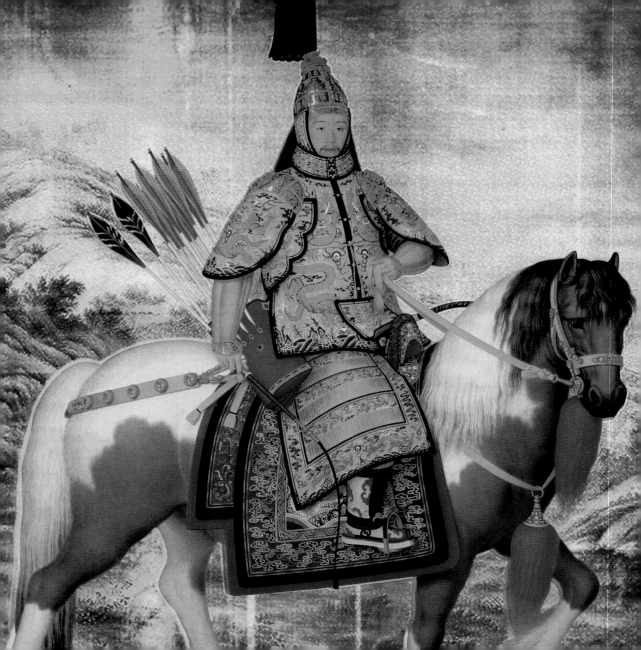

Yuanmingyuan gardens, the Ruyi Guan, or Pavilion of Hearts' Wishes, and that's where they designed the bizarre Western palaces built in the 1740s, including a maze, a banquet hall, galleries, a perspective hill, and an outdoor theater where live tableaux could be performed. The palaces had a Chinese accent, though—each building with a roof made of different-colored Chinese tiles.

VT: When I look at the marble carving, it amazes me that this kind of architecture traveled so far. You'd need special skills to do it. Did they import builders from Europe?

GB: No, palace architects and builders worked according to the Jesuits' designs. By then they'd had a lot of practice. The gardens began evolving from the time of the Kangxi emperor in the late 1600s. By the time of his son Yongzheng's reign, the place had expanded to accommodate most of the palace bureaucracy because the emperor preferred to live and work there instead of in the Forbidden City. The gardens were expanded—with elaborate waterways, imperial barges, and dragon-headed boats. Fake hills, valleys, and mountains were made from the earth, and dug from the marshes; pavilions and scenes were based on the emperor's favorite lines of poetry and prose.

VT: What happened to Yuanmingyuan? Hasn't it become a tourist site?

GB: For almost a century and a half it was the center of the Qing empire. When the power of the Qing began to fall apart, so did the garden. The Western palaces were neglected, the fountains broke down and weren't repaired, and the pavilion walls began to crumble. In 1860, following the second Opium War, British troops sacked and burned Yuanmingyuan as a lesson to the Qing court.

The broken marble columns and overturned stone slabs of the half-dozen European pavilions became the most concrete symbol of what China sees as a humiliating past. It's ironic, because they also symbolize an early blending of the best of two worlds, the Qing dynasty's attempt to possess the West today.

A tourist park with a zoo and theme rides has been built around the site. Farming villages nearby rent out huts to college students and artists. In the early 1990s, there was a large bohemian artists' colony exactly where Castiglione had worked two hundred and fifty years ago. They called it the West Village, after the one in New York City.

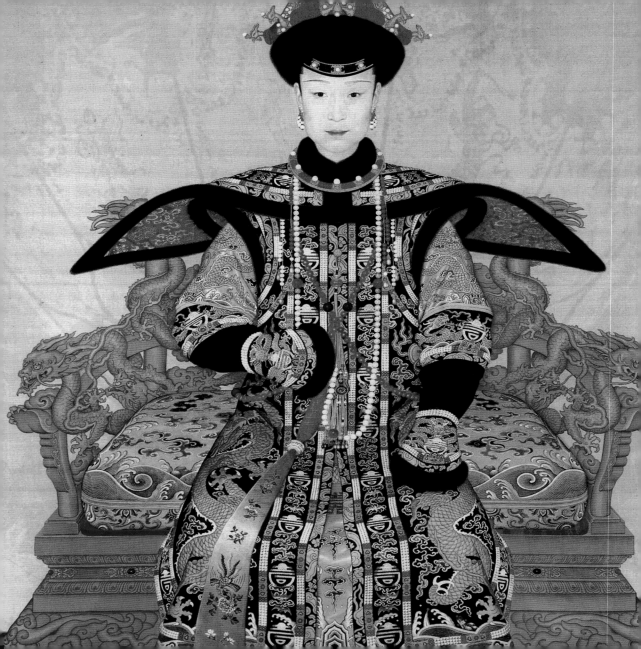

QING GIRL

Giuseppe Castiglione ran a studio at the Qing palace where imperial artists learned Western painting techniques. I love the portraits of imperial concubines they did. They have such a strong sense of the modern in them. At the time, the Qing weren't very comfortable with shading used in face portraiture—for them, only a clear, shadowless face showed a morally pure soul. But there was nothing to stop the artists from using perspective and lighting to bring out the textures and colors of the clothing or the mad carving of the furniture. So much attention has been paid to detail that it's almost scientific. The elaborate headpiece, the fur trim, the long string of pearls, and the kingfisher feathers all create a luxurious sensuousness. The gown is rich with color, and its writhing dragons and geometric patterns generate energy and power.

Still, the face is classic—those fine, arched eyebrows, those rouged lips, that beauty spot. She could be a 1920s calendar girl, a real dragon lady! I love the winged shoulders and the hoofed cuffs. She's like a winged horse.

The end of the Qing dynasty in 1911 didn't mean the end of Qing style or chinoiserie. It meant that the Qing aesthetic was now shared with the people—for instance, the Forbidden City was opened immediately and turned into a public park. In Shanghai, rich layers of Qing palace style combined with the streamlined shapes of Art Deco to create sleek skyscrapers trimmed with pagoda roofs and Forbidden City balustrades.

For me, the designs of the Ming are timeless, their elegance remains always contemporary and modern. The aesthetic of the Qing is something else. Tied to its time and its history, somewhere at the end of the nineteenth century—no matter where you find it, Qing design always looks a bit old-fashioned, even when it's mixed with revolution.

When the People's Republic of China was established in 1949, the new rulers gave their speeches from atop the Gate of Heavenly Peace. Mao was in his new suit, but his backdrop was still the Qing grandeur of the Last Emperor.

市

CITYLIGHTS

CITY LIGHTS 市 *(shi)*

The city starts out as a market *(shi)* where things are taken for trade or barter. In the past, urban life consisted of a market *(shi)* and a well *(jing)*: food, clothing, and water, the basic needs of any community.

YITNAU

The light of the city illuminates the soul. The sunlight bouncing off glass and chrome, its heat reflecting off the hot pavement, or cool-colored neon at night. The Chinese have a word *renao,* or *yitnau* in Cantonese, which literally means warm and noisy. This is the essence of city light: the heat of the crowd and excitement, noisy to the senses. The streets are passionate, full of the crowd's mixed emotions. That's *yitnau,* the sound of people bargaining over vegetables or jade, the rumble of the street tram down Central, or the sounding of the horn on the Star Ferry. It's the smell of fresh roast pork at a street stall, or an herbal whiff from the open door of a drug-store. Street hawkers, electronic stores, piped music, and the clatter of mah-jongg through an air-conditioned doorway, as gamblers "dry-swim," shuffling the tiles over cardboard tables, and swear at their bad luck. The landscape of a Chinese city isn't so much botanical as human. The ghost of old Mao hovers over the futuristic skyline, and the sun shines through thick yellow-gray air. Too many cars and trucks spewing exhaust, so many people drawing breath, each following his own story, and forming the stream of *yitnau* that flows through the city.

国
第几
品牌
···

买房 到建行

上 海
五 香 豆 商 店

五香豆大王

兼营各类糖货 蜜饯

正宗

树牌椰汁

日白嫩嫩

椰树
天然椰子汁

椰树集团(海口罐头厂)电话:(0898)6784293 传真:0898 6784264
总经销 北京迪文区副食品公司东大街经理部 电话:010 65123245

红星牌

红星二锅

北京红星酿酒
(北京酿酒

7up

圣
达

Goldlion
金利来

馒

幸运城 ⒼLUCKY CITY 大酒店
上海城市建设学院设计所 设计
上海新世纪艺术装潢有限公司装潢
一九九三年八月

国人的喜酒

善临门

联系电话:(010) 6815

走支现代化国际经济中心
城市而努力奋斗!!

林器店

中国邮政
CHINA POST

LUNAR NEW YEAR FESTIVAL

When we were little, we lived with two separate calendars—the Western year and the lunar year. The Western calendar was for school and work, the lunar calendar was designed to follow the seasons, the holidays a little different each year. We celebrated everything together.

For us, Christmas and Chinese New Year melted into one long celebration. By mid-December the Christmas lights would go up on Tsim Sha Tsui and along Hong Kong Harbor. Then there were the lights for New Year, and after that the Lunar New Year lights would go up, all through downtown Hong Kong and Kowloon. On Chinese New Year's Eve, everybody went to the harbor to look at the lights and to watch the fireworks display. There was the mix of Western holiday greetings with Chinese sayings like *Kong hei fat choy,* "May you have peace and prosper." Santa Claus and his reindeer pranced alongside dragons, pandas, the god of wealth, and of course one of the twelve celestial animals—maybe a rat, or a monkey, a rabbit, or a dog.

Preparations began weeks before Chinese New Year: the house was cleaned from top to bottom, and decorated with lucky fruits like golden mandarin oranges or kumquats, and lucky flowers like paperwhite narcissus. I can still remember that mix of fragrances. On the walls we pasted sheets of lucky writing, called *huichun,* or "welcoming spring" that we bought from the street calligrapher. Every year he set up a stall and covered red paper in gold ink with words like "fortune," or auspicious four-character phrases like "may you have the spirit of the horse and dragon," "may you be safe whenever you leave home," "as you like it," or, my favorite, a combination of four characters—wealth, health, good fortune, and longevity—all combined into one big beautiful word that meant everything good.

We prepared "eight treasure" boxes of sweets, filled with an assortment of dried fruit and nuts for guests. Melon seeds were also important—you can't really have a good New Year's conversation unless you're munching on melon seeds. Some people pick them up one by one, crack them between the teeth, and then pick out the seed to eat. The most skillful can shell a seed, or a bunch of seeds, with only their tongue and teeth and then spit out the empty husks. Not finding a seed inside the husk was very bad luck, so my mother taught us how to look for red and black seeds that weren't too dry and had the right shape for easy cracking.

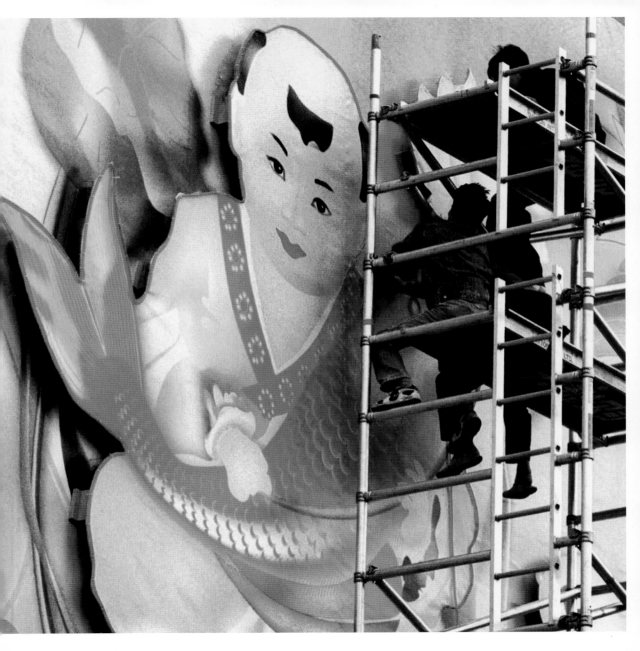

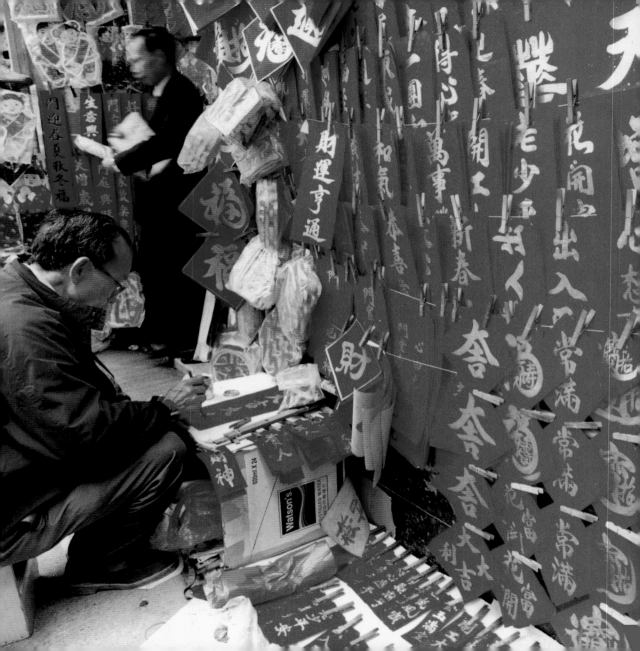

On the first day of the New Year, no one is supposed to use scissors or knives, because that might "cut short" the good luck that's just arrived. All the food must be prepared beforehand. My mother made my favorite special deep-fried *jiaozi,* or dumplings, filled with coconut, sesame, peanuts, and sugar. My sister and I learned how to prepare the filling and to roll the dough very thin and cut it with a cup. My mom taught us to pinch and twist the edges together tightly because it was bad luck if the filling fell out. We worked hard to get it right.

Of course, we had to greet the New Year wearing a whole new outfit: new clothes, new shoes, everything. My mother and I did most of the sewing, and I always tried to do something special for myself. Once I didn't finish my dress in time—it still needed a hem—but my parents said I should just wear it anyway, because I couldn't use scissors and needles after midnight. I argued, but in the end I gave in.

On New Year's Eve we started with a big dinner. Everyone was careful not to drop his or her chopsticks because that was bad luck. Then we each took our last bath of the year to wash away our old luck. After that, it was out to the flower stands in the park to buy plum and persimmon branches. We stayed up all night, wandering through the night markets looking for last-minute bargains and going to family parties. Finally, we went home and decorated the house with the flowers bought in the last hours of the old year when the prices were lowest: branches of pussy willow were so graceful, and pots of persimmon and kumquat trees symbolized gold growing on trees.

Early the next morning, the New Year, we got our first packets of lucky money from our parents, and then we went to the temple. Afterward, we could rest, but we couldn't wash our hair, bathe, clean the house, or even sweep the floor, because the new good luck might be washed away. The second day we did the housekeeping and made visits. For children, the best part was waiting to see how much *laisee,* or "lucky money," we'd get from friends and relatives. It was the seed money for our piggybanks, and by the end of the year the savings added up pretty well.

MID-AUTUMN MOON FESTIVAL

We looked forward to the Mid-Autumn Moon Festival, when the moon was huge and red in the autumn sky, the way children look forward to Halloween. Preparations began very early. Because of the cost, my parents ordered the mooncakes on an installment plan almost a year in advance. They bought dozens of boxes with different fillings—red bean paste, single yolk or double yolk centers, sugared ham, lotus paste, sesame seeds and walnut—and gave them as gifts to friends and relatives.

During the weeks before the festival, we had colored-paper lantern competitions at school. We went to the stationery and incense shops, where special lantern makers hung their beautiful samples of wire and colored tissue paper—rabbits, fish, peaches, Chinese fairy-tale characters—or modern airplanes and rockets. At home we made lanterns out of pomelos, a fruit like a giant grapefruit. We hollowed them out, cut different shapes into the skin, and stuck a candle inside. The scent was delicious. The peel of the pomelo is great stewed with mushrooms and oyster sauce.

All of us kids knew the story of Chang E, the moon goddess. Back when the earth was young, it almost died from the heat of ten suns. A famous hunter shot down all but one with his bow and arrow, and the gods gave him two immortality pills as a reward. He refused to take them, not wanting to live without his beautiful wife, Chang E. But she wanted to live forever, and one day she stole the pills and swallowed them. She immediately flew up to the moon, left with only a white rabbit and a cassia tree for company. The image of her flying through the sky, ribbons, sleeves, and robes streaming around her, stays with me. We looked up and tried to make out the tree branches and her beautiful face, thinking how lonely she must be. I loved Chang E's picture on the mooncake tin; it made a great stationery box.

On the big night, we carried our lanterns to the nearest public park to watch the moon. A place was already staked out, because friends would go the morning before to hold the spot with a blanket. We put our lanterns around us in the dark and ate our mooncakes with cups of hot tea—mooncake is very rich and heavy, you only need a bite or two. Every family did the same thing. Back home, on the late-night news, they would show the parks from the sky, with hundreds of lights like an ocean, and my brothers and I would try to guess which lights were ours.

CITY FOOD

A huge part of city *yitnau* is the food. In Hong Kong on the street are *dai pai dong*, food carts with *cheung fen*—steamed rice-powder dough sprinkled with shrimp or pork; fishballs and sausage on a stick, squid on a stick; fried tofu stuffed with fish; deep-fried fermented tofu; green pepper with meat; and steamed dumplings with so many different fillings. There is also the wooden bucket filled with sweet tofu pudding, sliced really thin and sprinkled with brown sugar or sugarcane juice, my favorite dessert. My factory in Kowloon is very close to a street-food area, so I go there quite often.

For street breakfast, there are *youtiao*, deep-fried sticks of dough, steamed buns freshly filled with sweet bean paste or meats, and hot soybean milk, sometimes with an egg dropped in it. Huge thin omelets are wrapped around chopped greens, chili spices, and a square of deep-fried egg white.

In the Chinese tradition, food is not just about feeding the body, but about completing it and satisfying the spirit. In terms of the city, it's part of *yitnau*, nourishing the spirit of the street.

I grew up with Cantonese cooking, which is relatively plain compared to spicy Hunan or Sichuan cuisine. The food is stir-fried or steamed, with light sauces, usually just salt, soy, scallion, ginger, and garlic. Freshness was crucial for my mother, and she didn't like to use the refrigerator. Fresh vegetables bought daily were left at room temperature until it was time to cook. Shopping in the food market was an art. She taught me how to tell when vegetables were at their ripest, and fish had to be swimming when she picked them out of the vendor's fish tank.

In the kitchen or on the street, preparing food is like a meditation. You have to feel the surface of what you're cutting, and move the knife in accordance with the texture of the meat and vegetables. The way you slice and shape the food affects not just the appearance but the flavor. Nothing should be overcooked; a plate of beautiful jade cooked vegetables is a work of art.

Even the simplest dishes combine color, flavor, and preparation with cosmology. Take a bowl of noodles, the most common type of street food. There is the yellow of the noodles (earth), the green of the scallion (wood), the white of the sliced turnip (metal), the red of the meat (fire), and the *qing*, or clear color, of the meat broth (water). All five cosmic elements are represented, dropped into the pot according to their cooking time, so the textures and flavors are mixed in a perfect balance. It's fast food, but a complete world.

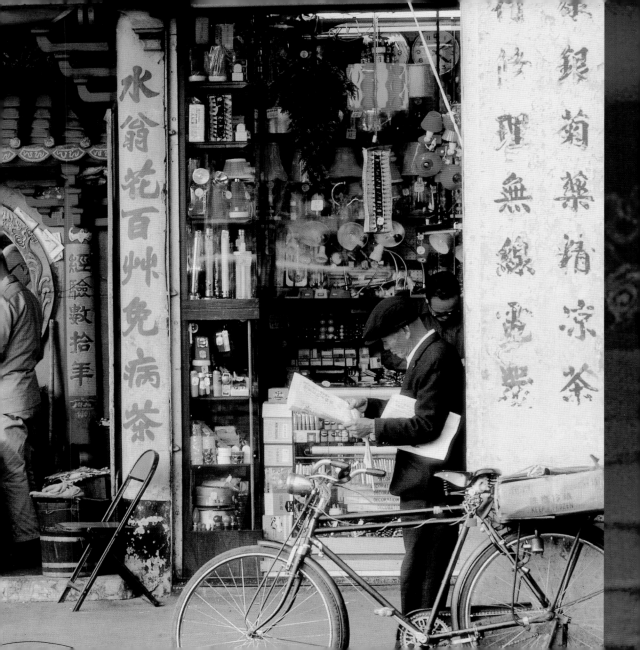

DIM SUM

The characters for *dim sum* literally mean "dot" and "heart." You write the character for heart with two strokes and two dots. If you leave out the last dot, the word means "nothing." Having dim sum is about completing the heart and its meaning.

Food occupies such a central position in Chinese culture that when you say you're going to a restaurant, you actually say you're "going to worship at the temple of the five entrails." Restaurants can be enormous, almost like food factories, filled with hundreds of round tables. Even so, there are long lines to get in, because dim sum restaurants don't take reservations. I get impatient, but it's part of the ritual. You take a number and get in line.

Dim sum for Sunday brunch is always a family experience for me. Chinese families work very hard, so Sunday is when they can relax and catch up with one another and the hot gossip from the week. You tell stories and read the Sunday papers. In between, there are shrimp dumplings, stuffed winter melon rounds, steamed barbecue pork buns, turnip cakes, flash-fried squid, steamed bean-sheet rolls filled with mushrooms and dried tofu, phoenix-claw chicken feet stewed with black beans and chili, jeweled sticky rice with salty ham and water chestnut steamed in lotus leaves that you have to cut open with scissors. For dessert there's chilled mango pudding or coconut sago. In Hong Kong, new dim sum are constantly being invented, partly because more regional cuisines are being adapted to dim sum. In New York City, Chinese restaurants stick with the old standards, but once in a while they might add something new like "Mexican buns."

Now you're ready to order. Dim sum ladies circle the room with their food carts, each holding a variety of tiny and scrumptious dishes. They invite you to inspect their specialties, lifting woven bamboo lids off stacks of steamers. If you say you don't want it, they look disappointed. You want to tell them not to take it so personally. If there's something special you want, you have to wait until the cart comes by your table—people are always looking around to find their favorites.

The dim sum ladies come from all over China, so you hear many dialects, and if you don't understand them, you can read the signs on their carts or ask to see a sample. Clouds of steam rise everywhere; the little trays smell of wet bamboo. There is the clatter of plates being

stacked, the sizzle of oil as the turnip cake and stuffed green pepper hits the grill on the cooking trolley. People pour tea for one another, and you hear people knocking on the table with their knuckles. It means "thank you," and when they stop that's when you should stop pouring the tea. When you run out, you lift the lid of the teapot and leave it dangling from the top. Tradition has it that long ago a waiter once refilled a teapot and parboiled a small bird nesting inside the pot. The customer had put his pet in there to keep it warm. So today, to avoid this happening again, the waiter waits until you remove the lid.

Grandparents teach children how to use chopsticks. I've seen kids as young as one or two years old learning. The chopsticks are too big for their hands, and they have to swivel them around very slowly, like a big crane, to get a bite off the end. But by the time they're in kindergarten, kids are very skillful. Watching them reminds me of my mother instructing me and my siblings; if we held them too near the top, she said, we would marry far away from home. If we left any rice in our bowls, she said our spouses would have pockmarks, so we had a lot of practice picking up those last grains. Most of her warnings were about getting married and what our future spouses might be like.

Chopsticks in your hands should become part of your body. The simplicity of their design is so elegant, and very linear. Forks and knives are extensions of the hand, but chopsticks are extensions of the fingers themselves—long, graceful, and very precise. The Chinese word for them is *kuaizi*; *kuai* is the character for "quick" or "happy" under the sign for bamboo, and *zi* can mean "child" or "son"—newlyweds often get chopsticks as gifts in hopes for a son. Chopsticks can be made of wood, silver, or gold, and my mother had a family set made in ivory—we each had a pair, with our names engraved on the top end—for special dinners. Before and after she rinsed them with boiling water—never soap because that yellows the ivory—and returned each pair to its special holder: red velvet lined with white cotton stitched into pockets.

The key to eating dim sum is that you should never do it alone. You need other people to share with, so that you can order a lot. This way you never get full, but you can try everything, all the flavors—sweet, salty, sour, bitter, and hot. A dot here, a dot there, and the heart is filled.

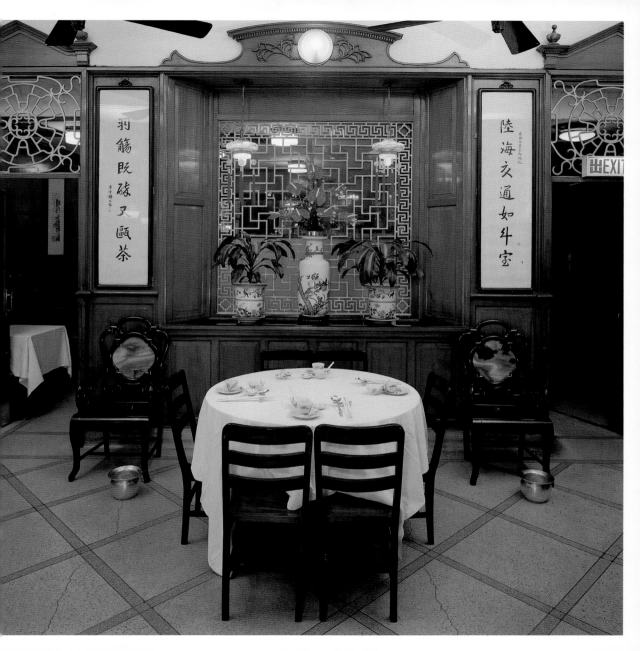

HONG KONG

The first time you fly into Hong Kong at night, you see the city below strung with jeweled lights, truly the Pearl of the Orient. As the plane skims over the islands, you might see a lone high-rise, thirty or forty stories high, outside the city and built into the side of the rocky slope. It reminds me how Hong Kong first began, and it helps me imagine the energy and stubbornness it takes to make something like that happen.

When you look at the buildings clinging to the side of the mountain, you realize that the people in Hong Kong have always had to fight the elements. The building foundations have to be sunk into the ground like the roots of a tree, holding the side of the mountain in place, keeping it from being washed into the sea. It's a constant battle to keep the slopes in place.

In Hong Kong, miles of bamboo scaffolding envelop the city, wrapping meters of green netting in wonderful designs around new, growing buildings. The art of lashing bamboo trunks into scaffolding is an old one, dating from the earliest days of Hong Kong's history. Strong and lighter than steel, bamboo is still being used to scaffold the highest skyscrapers and even the new airport. Bamboo rods are also used for hanging laundry out the windows. The multicolored lines of clothing draped over the buildings make a wonderful, organic kind of decoration, like lichen on a tree, more environmentally friendly than a clothes dryer. Old women lean out the window to arrange their drying rods and the different fashion shapes hanging from them.

At night on Nathan Road, the main shopping street in Kowloon, the sky is cut by the verticality of red and yellow neon signs, lit with huge Chinese characters. They are like weeping willow branches, hanging down so low that the double-decker buses always seem to be on the verge of running into them.

On Temple Street, there's a night market famous for counterfeit copies, everything from T-shirts, watches, and jewelry, to handbags and CDs. There are also rows and rows of fortune-tellers, with their red banners and face- and hand-reading maps. It's quite difficult to know which one to choose—you have to look at the person's face. One night, right after I graduated from high school, I finally picked one and he read my palm for HK$20. He said, You will go abroad to further your work. At the time, I thought he was being ridiculous, but after I graduated from college I left.

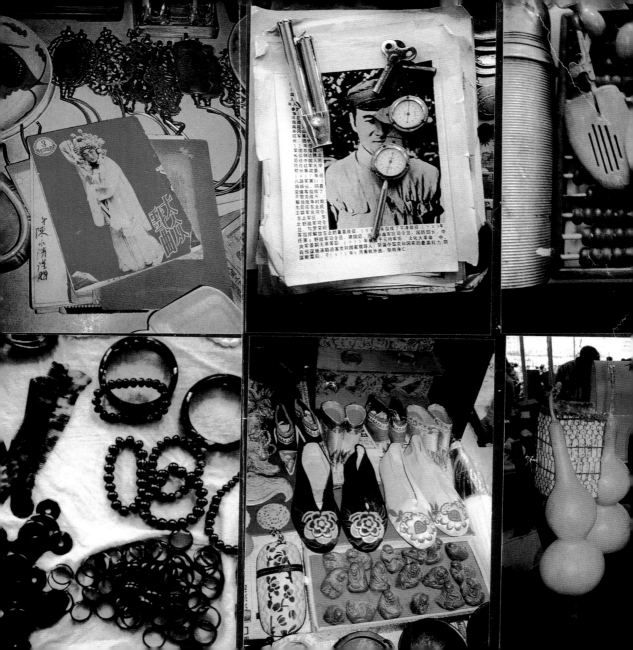

CITY BAMBOO Interview with Chan Do Ping

When I'm in Hong Kong, I look up at the tall buildings covered in bamboo scaffolding and green net and wonder what it would feel like to be up there in that huge urban jungle. Chan Do Ping has been in the scaffolding business since he was seventeen years old. Now forty-three, he was introduced to the profession by his brother-in-law, who looked after him and taught him everything.

VT: Mr. Chan, how did you learn your job?

CDP: I followed my brother-in-law into the profession. I learned by looking and doing on the job. You start at ground level and slowly work your way up the floors. From the fourth floor to the fortieth, the work is basically the same.

VT: How high can bamboo scaffolders go?

CDP: My colleagues have worked as high as the seventieth floor. We have to use safety belts now, the government requires it.

VT: What's the origin of the bamboo scaffolding technique?

CDP: We date back to prehistory, supposedly. People lived in thatched bamboo and straw huts, and some tribes lived in trees. So the technique comes from that, all over China.

VT: What's the advantage of bamboo over steel scaffolding?

CDP: Working with bamboo is fast and light. With steel scaffolding you need to screw and unscrew—with bamboo you just use a quick fastener. The structure goes up quickly and comes down even more quickly. Bamboo is pliable, flexible, and very strong. After a typhoon, if the side of a building's scaffolding is blown down, we just hoist it up again, good as new. You don't get this with a steel frame. If it's warped in a storm you can't bend it back.

248

VT: What's the normal training period?

CDP: The government rules say three years, but one and a half is enough, really. Usually there are about two thousand workers on-site in Hong Kong daily, and the daily rate there is about a hundred U.S. dollars a day.

VT: What's your day like?

CDP: We start at about eight or nine in the morning and work until noon. Then we take a nice hour-and-a-half lunch, usually in a teahouse. We start again around one-thirty. Three o'clock is teatime, which can last anywhere from fifteen minutes to an hour—we make our own schedule—and then we finish at five. We're all gamblers, people in the construction trade, so we lose our wages at the gambling table after work.

VT: Your work is so dangerous. Do you follow any rituals? Do you have any gods or masters that you pray to?

CDP: Yes, we worship three masters: Wah Kwang on January 19, Lu Ben on June 13, and another one—I don't remember now. Usually we have a banquet, and at the front there is a picture of the master. Lu Ben is the god of the opera, I think. Actually, we just enjoy the food. Older workers used to have a lot of superstition. For instance, seeing a Buddhist priest in the morning means you can forget about working that day. You should never sing a song in the morning, never cross in front of a funeral parlor, never go to work if you see someone washing their hair in the morning because it will be a wet and sticky day.

融

CHINGLISH

蕭芳芳
丁慧

CHINGLISH融 *(rong)*

Things blend with one another to create a hybrid of qualities and essences. The composite elements retain their original natures, yet by coalescing they gain a richness and variety previously impossible.

"THAT'S CHINGLISH!"

Hong Kong calls itself the Pearl of the Orient. A pearl starts out as an irritant, a piece of grit or a grain of sand. Then the oyster starts to coat it with nacre, trying to ease the discomfort, and an amazing sea jewel is the result. Hong Kong is like that—the irritant was its status as a colony under the British government. The mixture of Eastern and Western cultures provides the iridescent layers. In the end, you have a dynamic, creative, ever-changing city unlike any other, a true pearl.

Living in a colony meant that at home we spoke Chinese, but we went to school in English. I wouldn't say we were bilingual; we were always more comfortable with Chinese. Talking with friends, we used a mix of the two, and if we got stuck, one of us would say, "That's Chinglish!" and we would laugh. Chinglish started out as a joke.

In Chinglish, new terms are constantly invented. In the sixties, the Chinese characters for miniskirt could be translated as "a skirt to dazzle you." Something "undingable" meant unsurpassed, because *ding* means the top. Almost all the pop music we listened to was a mix of Chinese and English; even the disc jockeys on the radio switched back and forth constantly.

But Chinglish is more than language, it's a lifestyle.

In fact, we celebrated all the Western and Chinese holidays, one after another. For the Angel Dance at the Christmas pageant, we wore white robes and wings but did a Chinese dance. We balanced a candle in each hand, twisting our arms over and around our waists. My costume caught fire, and there was a lot of panic. I was only six. After that I wasn't particularly interested in going onstage.

English always sounded very musical to me, even when I didn't understand it. In high school, we had a ceramics teacher from Scotland and a dressmaking instructor from Ireland.

They had very heavy accents, and none of us could make out what they were saying. We just watched their hands and tried to follow them. I'm not sure they ever knew.

Preparing for classes, we had to think in two languages, but there was no question that English was more important in the outside world. Most of our classes and textbooks were in English, and we knew that once we got to college all the instruction would be in English. At the end of high school, we had to take citywide exams. If we failed English, we failed everything, and there was no way to go on to college or get a decent job. It's difficult if you don't speak English well in Hong Kong—mistakes are embarrassing. I made much more progress in English after I left Hong Kong. A friend once told me that even in Paris it's easier to speak English than in Hong Kong.

The architecture is also a mix—the tiled roof of the Governor's Mansion, the arched verandas of the Legislative Council, and the striped awnings of the Peninsula Hotel. Turbaned Sikhs still stand guard outside the polished wood front of the famous Luk Yu Teahouse.

After class, we bought sweets at the bakery—dried plums, candied orange peel, and English peppermints, baked pastries filled with sweet bean paste or curried beef. Today, fancy bakeries in Hong Kong carry a luxurious mix of Chinglish pastries—flaky napoleons garnished with cream and strawberries sit in their fluted paper cups next to purple-frosted yam cakes. We'd get drinks like cold sweet soybean milk, or hot, thick, strong black tea with sweetened condensed milk, in a glass instead of a mug. On Sundays at dim sum, we could order shrimp toast—deep-fried triangles of shrimp on white bread. These foods have a mixed heritage unique to Hong Kong.

Our culture was not just a combination of British and Chinese, it was something new. If you grow up hearing two languages, you know from the start that there's more than one. Some things are best said in one language, or avoided in another. Only with a mix of both can you say what is truly in your heart.

Pidgin English was created by Chinese middlemen to do business in the treaty ports along China's eastern coast. It had a dynamic energy and rhythm that got things done whether it was building Hong Kong—or building the railways in America. But Chinglish touches every part of Hong Kong's culture. When I see a Chinese person in a wig and the robes of the British courts, I see the first tradition of the rule of law in China. When I see Chinese men dressed in tartan and marching down the street in a bagpipe regiment, I see discipline and training. When I hear that sound, it reminds me of Chinese opera, and it gives me goose bumps.

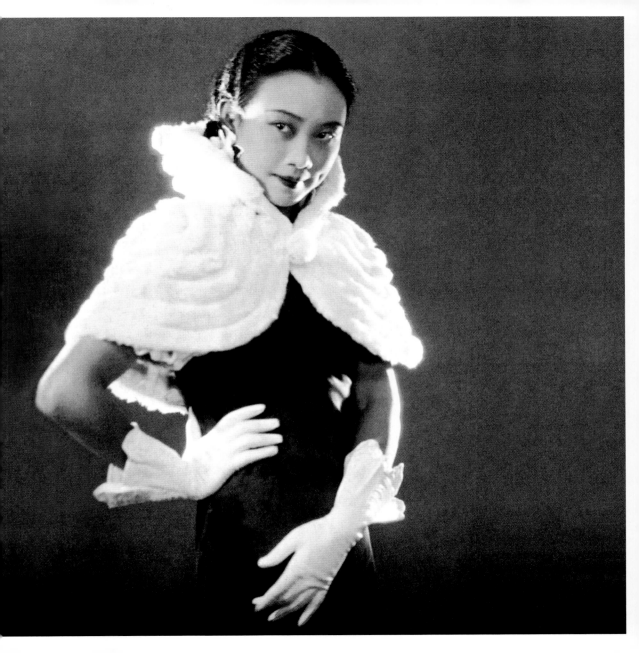

红雙喜

DOUBLE HAPPINESS

FINDING FASHION

When it came time to choose a college, I applied to Hong Kong Polytechnic because it was the best school for graphic design. After the first year of basic training, the administration decided to open a fashion design section, so I was very lucky. Suddenly, what I loved to do best could be my work. At Polytechnic, my teacher, Valerie Garrett, was in charge of the fashion program. She later became a renowned expert on the history of Chinese clothing.

I was curious about ways of dressing and fascinated with secondhand clothing. I used to sit in the library looking at old magazines to get a sense of past times, but nothing compared to handling or wearing the clothes. In those days there wasn't much around—only a few used clothing shops in the old flower district, Lan Kwai Fong, near central Hong Kong.

I loved trying on old shoes. I have very big feet—long and fat. My mother always said they were peasant feet, which meant that it was my fate to work hard and labor. She was right. Even if they were a couple of sizes too small, I was determined to wear the shoes. Fashion is suffering, what can you say? I had high heels, at least two and a half or three inches high; spike heels—we called them five-cent heels, because they were the diameter of a Hong Kong nickel—really tiny. I'd never seen anything like them before and collected over sixty pairs because they were so inexpensive. That was the beginning of my own fashion resource collection.

After graduation, I went to work in the fashion division of the Hong Kong Trade Development Council, promoting products made in Hong Kong. I worked under Hilary Alexander, now the fashion editor at the *Daily Telegraph* in London. Hong Kong was just developing its own fashion scene, and the job gave me an opportunity to travel—that's when I made my first trips abroad.

I looked at clothes, not just in fashion shops, but also in the street, especially in flea markets where I could see fashion from all periods, and from all around the world. I bought everything I could afford. My favorite was a knee-length red taffeta gown with a lot of tulle underneath. It was cut in an hourglass shape with a big bust. Since I was much smaller, I wore it with a T-shirt underneath. It was a big hit at the disco.

I brought bags and bags of vintage clothing back to Hong Kong. I was used to making new

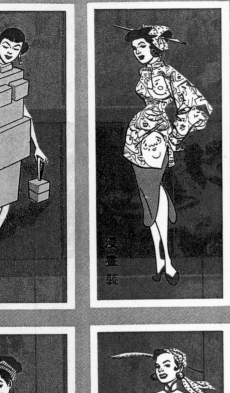

漫畫裝

橋牌裝

玩具裝

立體裝

鷄尾裝

肉彈裝

音樂裝

接吻裝

clothes with no history. Now each dress had its own story. I could imagine the woman who wore it and the details of her life. When I looked at the dress to study its construction, I could almost see her skin inside. It made me aware of the past.

It was important to experience every period of fashion—the dress, shoes, accessories, fabrics, prints, line, and style, the thinking behind the construction. My mother was horrified that I was willing to wear dead people's clothes. According to tradition, secondhand clothing, especially shoes, carries its wearer's karma. She said, "Aren't you afraid of ghosts? They will haunt you!"

In the eighties, I left Hong Kong. This was a big step. At the time, people in Hong Kong were becoming more aware of fashion, but they were only interested in buying Western designs. I felt there was no room to do what I wanted to do, and I needed to get out and see more.

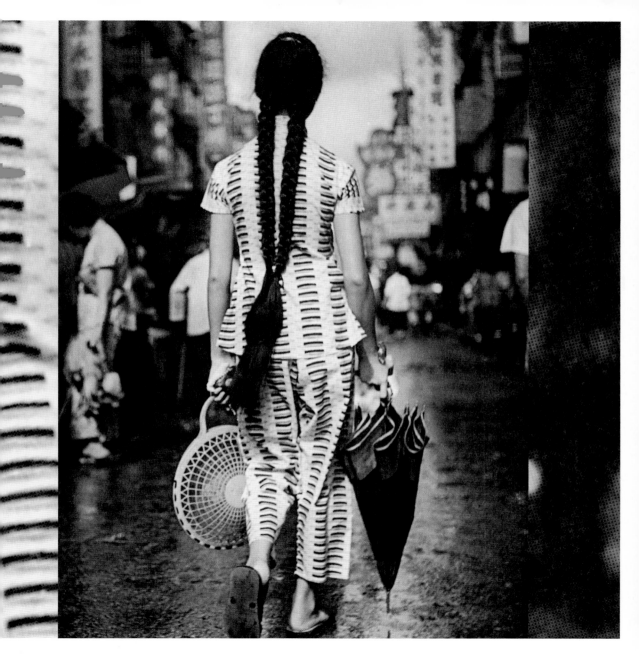

ANNA MAY WONG

Anna May Wong personified Chinese elegance in Hollywood. Born in Los Angeles in 1905, she got her first bit part, in a silent film, at age fourteen, and her first billing at seventeen. For most of her life, she played supporting roles—always the Asian femme-fatale. It made her crazy that when the script called for an Asian leading lady, the studio would always cast a white actress—Myrna Loy, for example, or Luise Rainer in *The Good Earth*. Anna May hated playing nothing but prostitutes. But even so, she was good enough to steal scenes from the best. When she went to London in the late1920s, she starred opposite Laurence Olivier in the West End. Her most famous part came in 1932, in Josef von Sternberg's *Shanghai Express*, as Hui Fei, a Chinese playgirl who saves the lives of hostages by stabbing the villain. She played opposite Marlene Dietrich's Shanghai Lily. Marlene had great lines—"It took more than one man to turn me into Shanghai Lily!" but Anna May did a slow smolder that was even more powerful.

The first time I saw Anna May on film, I was very moved to see her, a strong Asian woman, moving across an American movie screen. She was a true pioneer. The look in her eyes, her distinctive style, were all very inspiring to me. I loved the way she turned all the dragon-lady clichés on their heads. She was limited in her roles, but she transcended them. I like to think that all of us have a dragon lady inside us—she represents our power to be ourselves.

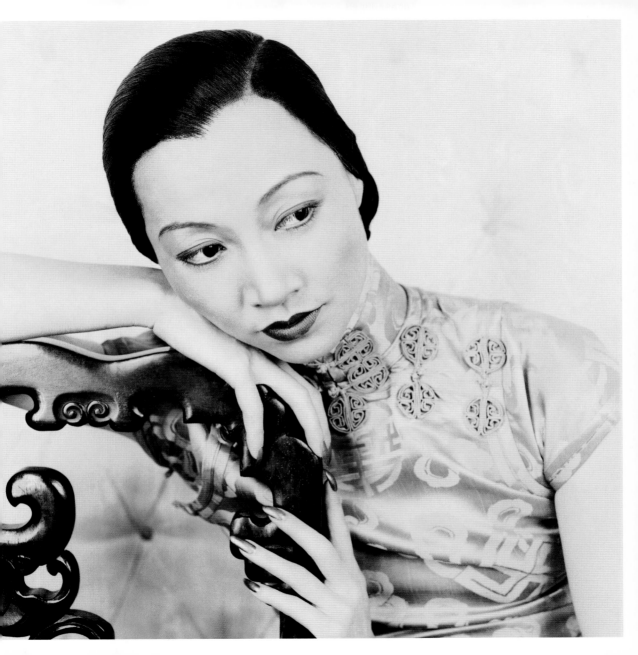

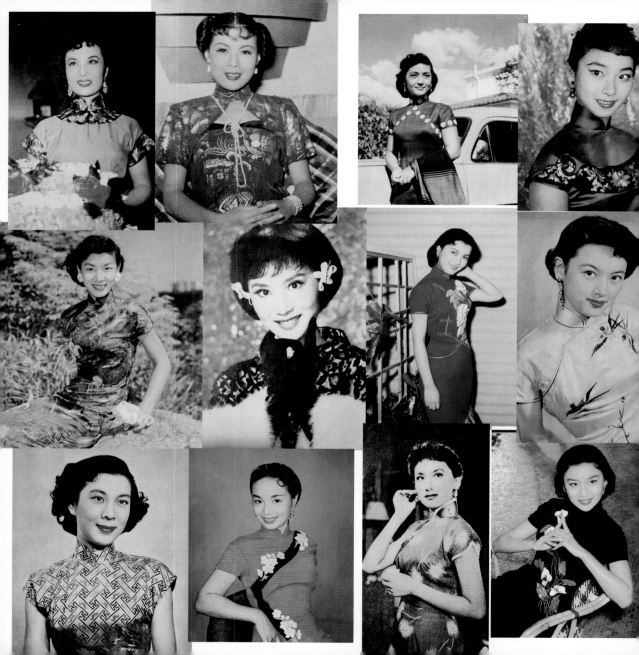

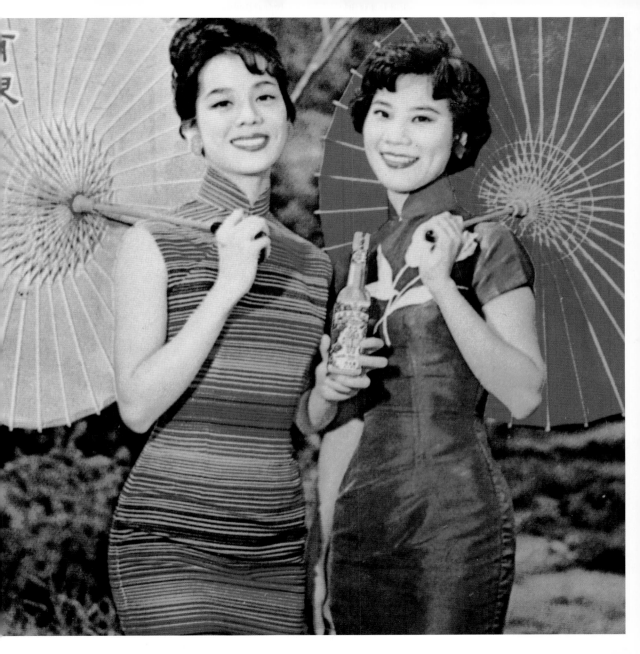

CHEONGSAM EVOLUTION

The cheongsam goes back almost to the beginning of the century, when young girls expressed their advanced ideas by dressing in a man's long gown. It's always been an experiment combining Chinese beauty with Western lifestyle. The way the cheongsam began to hug the contours of a woman's body was a combination of brave risk-taking and social strictness, of liberation and confinement.

Old magazines, calendar art, and movie posters reveal how the cheongsam changed. As a fashion student, I studied the evolution of the cheongsam; it was a great way of understanding how clothing could reflect changing times in the West but still be true to its basic nature. Like the rest of China back then, the cheongsam was always learning from the West, but usually a few years behind.

What interested me was that through the changing of Western fashion shapes, new fabric technologies, and new ways of understanding color combinations and patterns, the basic essence of the dress—the high collar, crossover and side fastening, and the slit in the skirt—remained. Body shape, hairstyle, accessories, and makeup all changed but the cheongsam remained, and it was still Chinese.

Hollywood was a major influence on modern Chinese fashion. American movie stars were always popular, and so were their clothes, hair, and makeup. The tailors and their clients came up with hybrid fashion, a great blend of Chinese-Western fabric, cut, and style. In the twenties and thirties the unisex gown slimmed down to the lines of the Western flapper. The silhouette was slinkier, copying the bias cuts of Chanel; the sleeves got shorter, the slit higher. Hair was straight and bobbed, skin was pale and lips, red. By the mid-thirties, the dress was long and light, skimming the body. Hems dropped to the ankle, sleeves were cut to reveal the underarm. Hair was permed, eyebrows drawn thin and arched like Greta Garbo's, but the faces were still demure. Then in the forties, women added jackets with padded shoulders and platform shoes like Joan Crawford's. The women began to look stronger, more assertive, their shoulders back and their chests out. I love it.

After 1949, the dress became more shapeless on the mainland until it was replaced by the trouser suit, but it continued to be popular in Hong Kong. Many Shanghai tailors emi-

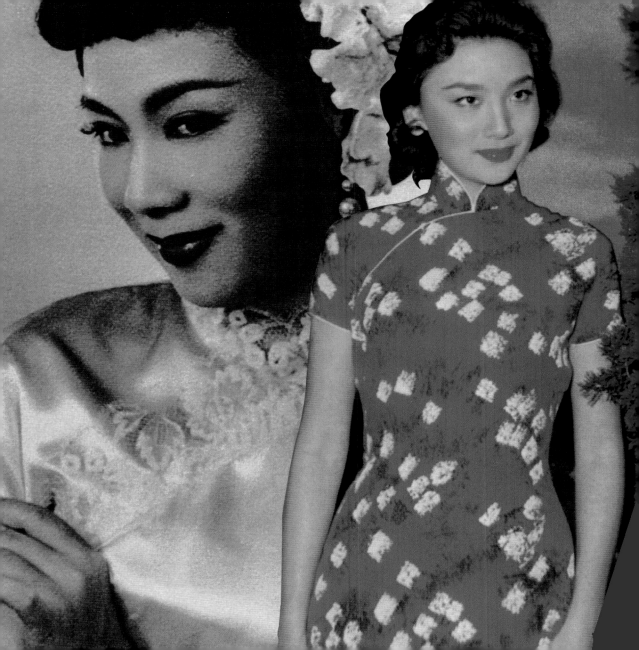

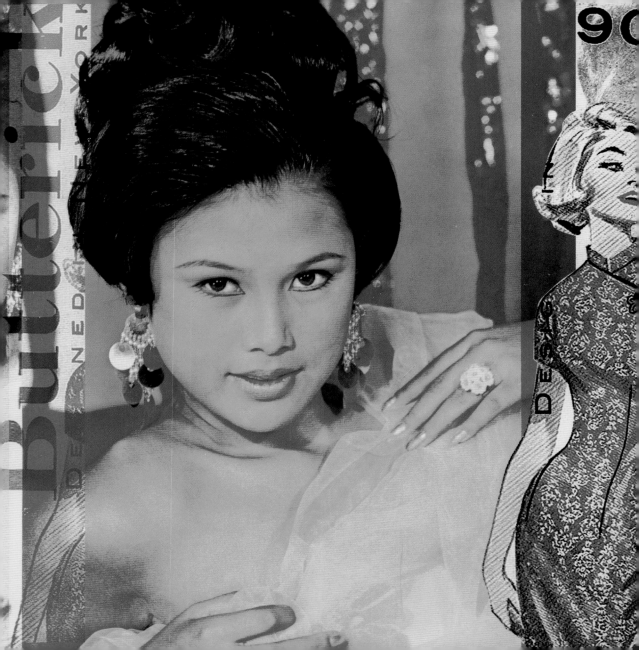

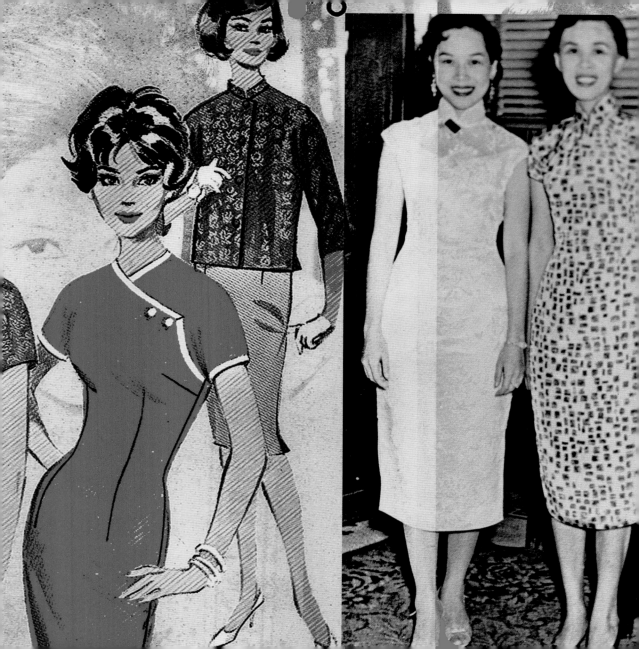

grated to Hong Kong, following their well-to-do customers. The fifties and early sixties were really another golden age for the cheongsam, because the new Hong Kong movies were a stage for the latest designs and all the socialites and stars in Hong Kong wanted to wear cheongsams. The hair was brushed into sleek rolls, eyebrows were stronger, fierce. The face was strong and the gaze began to smolder, like Bacall's or Gardner's. The body, too, was rounder, more structured, a Chinese hourglass.

In the late sixties the cheongsam got shorter and more boxy, the hemline tapered so that even with a slit in the skirt it was hard to walk. Hair was teased up into the "omega"—that's what we called the beehive hairdo! Patterns and prints were much bolder in the sixties, and by the seventies they were psychedelic, and the cheongsam was paired as a tunic with bell bottoms. The eighties gave us the power cheongsam with a more padded shoulder.

When I design a cheongsam, I want it to be a clean translation of the dress's essence—almost an abstraction—beautiful, but without restriction. I've made it in stretch fabric, unconstructed, hugging the body with no darts. The collar is still there, but it doesn't have to stand stiff upright against the neck; it can be folded down into points or it can stretch. It's fun to experiment with the basic elements—to make a new slit where the side closure would be, use a zipper instead of frog fastenings, find ways of liberating the shape.

Different fabrics and textures can be manipulated to find their secret potential. Bed linens and bedspreads can be distressed, shaved, dyed, bleached, or washed to wrinkle and shrink. Polka dots and stripes can be pleated to create a 3D optical illusion; embroidery, appliqué, and jacquard patterns can be turned inside out and something unexpected happens.

In this new version, anybody can wear the cheongsam—and you can climb on a bus or take a plane in it. You can walk fast in a modern way. It's cheongsam liberation. In Hong Kong, young women today combine Chinese mass-produced cheongsams with white T-shirts, jeans or leggings, and platform sneakers. The look is totally different, more casual, more street. The same cheongsam can go from day to night and back again; anything goes. Fashion is always changing, so you have to travel light.

SUZIE WONG

Most of my Western friends have at least one cheongsam. They usually start out with a really traditional piece, purchased from an Asian emporium like Pearl River or China Products Department Store in New York City's Chinatown, or sometimes tailor-made in Hong Kong or America.

When I ask them why they like it, they answer that the cheongsam is sexy, or classic, or just really Chinese. If they have a second or third cheongsam, then the syles start to get funkier and more personalized, maybe a micro-mini or something in denim. But when I ask them about the first time they saw a cheongsam, they almost always say "Suzie Wong."

The World of Suzie Wong introduced the cheongsam as a dress that Western women could integrate into their own style arsenal. The first time you see Suzie Wong in a cheongsam, she is poured into red silk, slit up to the thigh, curves everywhere. She pouts and a light goes on in poor William Holden's brain, the guy doesn't have a chance. The story of the hooker with a heart of gold was classic, and Nancy Kwan played her with a mixture of mischief and dignity that was irresistible. Near the end of the film Bill takes her to a fancy restaurant, where Suzie wears a formal white cheongsam, with a collar so high she can barely turn her head. The higher the collar, she tells him, the higher class the woman. And she *is* high class in that dress, like a princess—her features made perfect by that long collar, like a trivet stand for a precious piece of porcelain. Suddenly, she's an Eastern ice maiden.

For most of the movie, Suzie combined the cheongsam with the street. She was a sixties girl. She looks just as good in pedal pushers and a trench coat. She pulled her hair into a ponytail and scrubbed her face. The look is less glamorous and more working girl. That was important, too. Suzie showed that a woman didn't have to be limited to just one look.

Women tell me that they always feel different when they wear a cheongsam—more poised, cultured, elegant, or more sensuous and body-conscious. If she's Chinese, she feels more so; if she's Western, she feels exotic, with a different quality of sexiness. No matter who she is, a woman feels different when she puts on a cheongsam. For me, that transformation is the essence of the cheongsam, and that's what makes it a fashion classic.

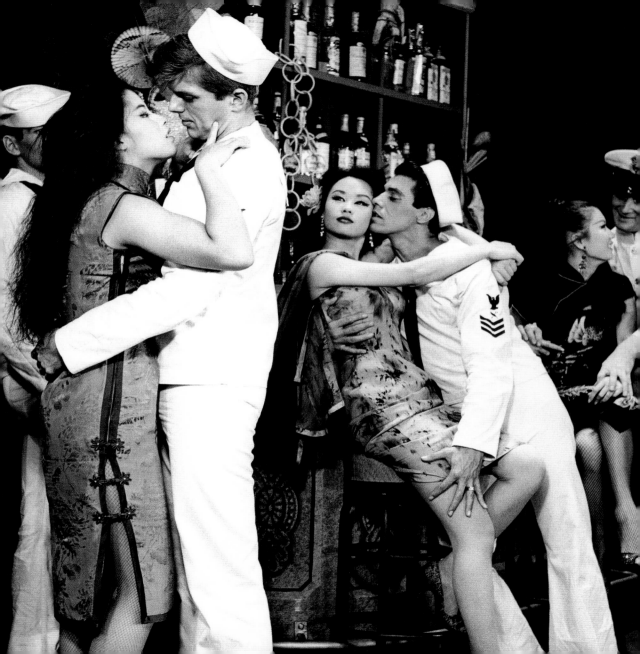

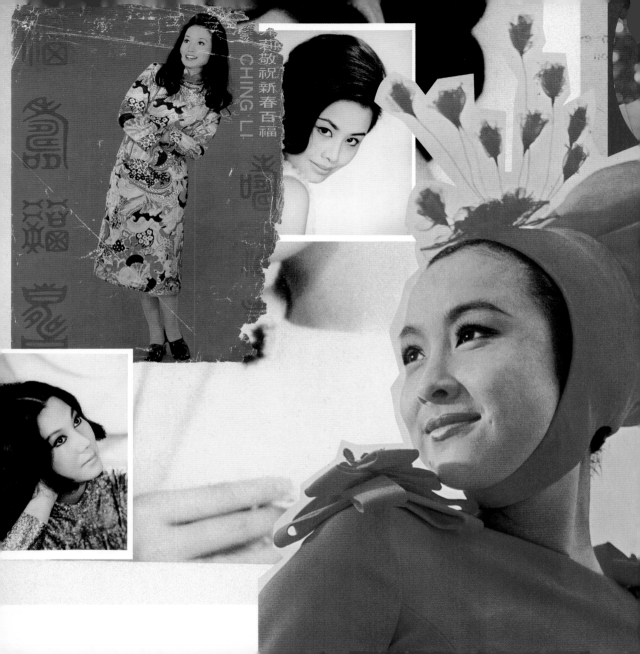

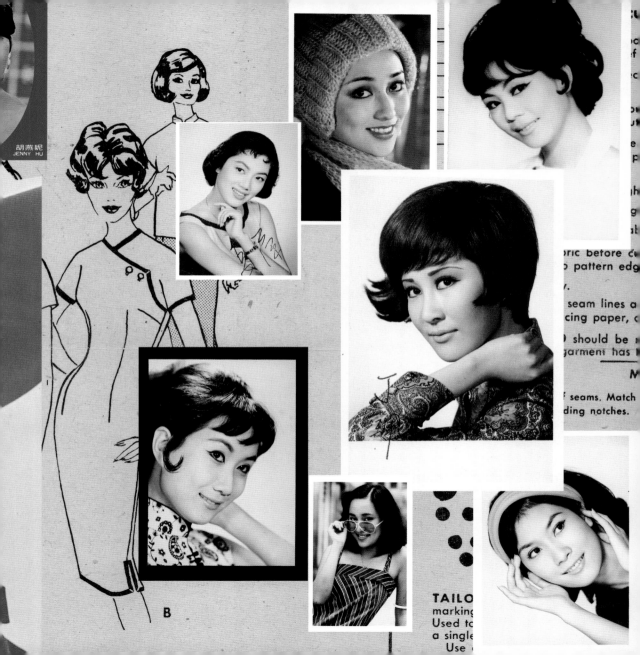

B

bric before c
o pattern edg

seam lines a
cing paper, c

should be
garment has

f seams. Match
ding notches.

TAILO
marking
Used to
a single
Use

SHADOW BOXING

When I was a little girl, although we were taught a few traditional Chinese stories, I can't say that we received strong formal training about our own heritage. Instead, we got a lot of our ideas about family, moral behavior, justice, and righteousness from our parents and from a very rich street culture—especially the martial-arts novels, comic books, television shows, and movies that were popular in Hong Kong.

The characters in martial-arts stories embodied the essence of the three great teachings in China—Confucianism, Buddhism, and Taoism. One person might have the morals of Confucius, but also the vision of a bodhisattva and the humor of a Taoist sage. Who couldn't be seduced by this combination? The hero would swagger down the street, afraid of no one, ready to enjoy a good meal with rice wine, but also ready to deliver a swift kung fu kick in the pants to anyone who behaved badly to those around him. Then he'd turn around and bow his head to a passing monk and vow to protect those weaker than himself. Loyalty, family, brotherhood, equality, obedience to a spiritual master, quick thinking when trapped—and of course, incredible martial-arts skill—these were every Chinese kid's hallmarks of a true hero.

These kung fu romances were everywhere. Lending libraries in the street had shelves of pocket comic books with covers drenched in color and supernatural fantasies. The newspapers ran daily installments of kung fu fiction—the great martial-arts novelist Louis Cha serialized his stories in his own newspaper, *Mingbao*. People clipped out those chapters every day and pasted them in notebooks until they had the whole novel to enjoy again and again. Children hid the comic books inside their school books during study period so they could catch up on the latest episodes.

When I'm in Hong Kong, I still watch late-night reruns of the movies and television serials made from these stories. I love the early special effects. The hero pulls out his sword, and a flowing arc of lightning flashes from the blade. The thunderbolt looks like a child's cardboard cutout, but the whimsy and naïveté can be more effective than some of today's cybertechniques.

The love stories in these movies are the best. The girls in them study kung fu with the boys under the same master and call each other brother and sister. When the enemy comes, they fight together. I love the grace and strength of these women. At the end, when the hero and heroine discover that they've fallen in love, they're equals. It's so different from Western love stories!

FILMING CHINGLISH Interview with Tsui Hark

Tsui Hark is an undisputed master of modern kung fu film. I've always loved his work, especially his version of the Butterfly Lovers, and of course his famous Wong Feihong series about a Chinese Robin Hood character who travels through Chinese history fighting injustice.

Born in China, and raised in Vietnam and Hong Kong, Tsui Hark attended university in Texas. He returned to Hong Kong to begin his film career.

VT: You've set the trend in special effects for kung fu movies. Why did you choose to make films in Hong Kong?

TH: I think of Hong Kong as extremely commercial. Change is fast and vibrant—like a window display that changes every week. What attracts you will always be what is shown. You don't mind the confusion. The most vital thing in Hong Kong is to make a living. That promotes flexibility and fast thinking, because prosperity comes from speed.

VT: You reflect this speed in your films. They're fast, lively, humorous.

TH: Hong Kong people are about everything fast, they know everything practical—East and West—everything.We say we're used to Hong Kong but we're not. It's always changing, information is everywhere. Everybody reads Hong Kong like a special magazine—it has everything and it communicates easily. Everybody knows everybody . . . it's a big melting pot.

VT: You do a lot of period films, and the costumes and sets are so beautiful. Kung fu movie actors have to get used to wearing historical clothing on a daily basis. What's that like?

TH: Actually, I once got wet on a movie set and had to wear the costumes, kung fu pants and top, and I found them very comfortable. I used to laugh at older people who wore them, but now I know they're not backward at all.

Wide-waisted Chinese pants—you just fold and wrap and they're fixed, they never fall

down. In the movie fight scenes, we always add a sash. The kung fu belt is very long. You twist it several times around the waist and it supports you well—it never comes loose, and there aren't any belts or buckles. But I can't find any Chinese clothes that look good on me; I look like a waiter.

VT: So many of your movies are about Chinese history and culture. Why?

TH: When we were kids, we grew up with a lot of fantasies—that men could do fantastic things. Acupuncture, New Year's dancing, kung fu, iron fists, herbal medicine. We live with these things in everyday life. Actually they're very special. They don't exist anywhere else. In Chinese history and culture, there are so many interesting things we take for granted. It's a great culture that doesn't need to be formally studied—I love it, and of course, I've put it in my movies.

VT: What appeals to you about kung fu?

TH: I love the romantic idea of action. In theory, kung fu is exercise, motion with no fixed point. It's all about balance. There's a universe inside the body, and action kung fu is like a symphony of life. It's more than action—it's also great to watch.

Take taiqi. I find taiqi to be the most graceful of all the martial arts. It contains great history, thought, and spirit. The movements are simple, but they weren't easy to develop. Every action has been done by thousands of people, refined, perfected through the generations, simplified to its present form. When we watch someone do taiqi, we begin to have an idea of how our culture thinks, what it's made of. For that moment, it's as if the world has no more problems.

VT: What drew you to moviemaking?

TH: I'm in the movie industry because I went to the movies in the sixties. The process was fun—you go with your peer group, eating, talking, a kind of play process. I was in my twenties, Cantonese movies were fading out, and Mandarin was coming in.

VT: Do you remember the black-and-white Cantonese movies—those kung fu films with special effects drawn in, with thunderbolts and flashes from swords and palms? They were so exciting.

TH: Yes, we participated with our own imagination and sense of fantasy. It was a creative process. It didn't take place just on the screen, but through our own associations. The soundtrack and music were funny, especially the sound effects. They used a lot of dubbing from Hollywood UFO and monster movies. That's unique—the very funny marriage of the two fantasy genres—kung fu action and space fantasy soundtracks. Chinese futurism begins with fantasy kung fu—there were no UFOs in Chinese culture, so we invented flying swords.

VT: In the films of the sixties there were flying objects—swords, dishes, etc. But in your films it's the people who are flying. That's the strongest impression I have.

TH: Yes, a lot of people say that. My feeling is that flying is an elevation of a person's character. In the caves at Dunhuang, I saw a lot of flying figures in the Buddhist cave paintings there. They are all U-shaped, with their heads and feet pointing upwards. This arch of the body has not appeared before or after, nor anywhere else in China.

In China, there's the Northern School and the Southern School. In the South the stance is steady because the landscape is water, and fighters must stand in water, on a bridge, or on a boat. In the North the stance is jumping, because the terrain is all desert, and you need to move around to win. But nobody can explain the Dunhuang flying figures to me. I've inquired about this at many museums but with no answer. I do the flying figures because of the romantic idea that man can be freed from life's restrictions by physical levitation. By working against formal logic, I free myself. In Western filmmaking, there is always the unstated question of how these people can fly. Flying people in the West must have scientific power or actual wings. In the East it's not necessary.

VT: It's true—when I visited the Royal Pavilion in Brighton, England, the chinoiserie dragons had wings. This was so interesting to me, because in China dragons fly, but without wings.

TH: Exactly—in Chinese imagery, man's flight isn't just physical, it's also spiritual. Wings emphasize the physical—when you look at Western angels, their wings are really big, really heavy.

VT: Wong Feihung is a well-loved traditional kung fu hero. In your movies, he's romantic—he even has his feminine side, unlike before, in the films of the fifties, when he was all macho.

TH: In the Wong Feihung series, the action is always restricted to main street—in teahouses and shops. The fight is always against bad people. But if the settings are simple, the historical context is huge. The hero is always of his time; we shouldn't take him out of his context. If we do, then he becomes stubborn, distant, and not very secure. He will have no sense that the world is changing, so he'll do the wrong things.

VT: How have kung fu movies influenced Hollywood? I felt there was a lot of kung fu influence in the Star Wars movies.

TH: Actually the influence is mutual—we're also influenced by Hollywood filmmakers. I've been deeply influenced by Hitchcock, John Ford, and Spielberg. We grew up with Western film, and we see the work of these masters as products of a ripe maturity. We dig our own stuff out of our subconscious and imagination—it's another world. We have things in common with Western filmmakers, but we find what we like in our hidden selves.

VT: Do you like working in Hollywood?

TH: Yes, but I also find it fun here in Hong Kong. Both places are fun to play in, but the ways of playing are different. It's refreshing to go from one place to another. I like viewing both places from a distance.

It's funny—sometimes I go to a foreign restaurant and order the most interesting item. Then it turns out to be something familiar like wonton soup. The more you see foreign things, the more you want to dig into your own culture—that's how it works for me.

扣　西　今
虍　陷　南
虒　闡　崔

WRITING CHINGLISH INTERVIEW WITH XU BING

Xu Bing experiments with inventing new Chinese characters. I thought that it might be interesting to work together on something for fashion, so I visited him in his basement apartment in New York's East Village. The room was covered in pages of paper stamped with seal calligraphy, and his "Sky Book," a long banner of fabric covered with incredibly beautiful writing, draped from the ceiling.

The words in his new performance/art project, New English Calligraphy, didn't make any sense to me—the characters looked Chinese, and some strokes resembled letters of the alphabet, but more like talismans, magical and powerful. I'd always thought of Chinglish as a mix of language that was very aural, a special hybrid of tones and rhythm. But Xu Bing's work made me realize that Chinglish could exist as a written language as well.

Xu Bing was born in Sichuan province in 1955 and grew up in Beijing. He studied calligraphy and traditional bookbinding at the Beijing Academy of Fine Arts, left China in 1989, and is now based in New York City. He was awarded a MacArthur Prize in fine arts in 1999.

VT: How does your project New English Calligraphy relate to the Chinese square?

XB: I think the "square word" is really important for Chinese people. Everything begins with the square. It affects all aspects of Chinese culture, even its ideas of beauty. And because each word is a square, I would say the square has the greatest capacity to manifest the spirit of Chinese art. Because the square is the key to the structure of each character, it's very strong.

VT: I remember practicing calligraphy as a child. I was very conscious of fitting every word into a square; you always have to think about space and structure.

XB: Yes, I had the same experience. My father made me do a page of calligraphy a day. At the time, I thought he just wanted me to have beautiful calligraphy, but now I know that kind of training and method was a kind of cultural control—it inspires young people with a culture, about being square, very tight, following the rules.

Because of my background, I'm interested in words. My father worked for Beijing

University, in the history department, and my mother was a librarian. I just read a lot, and the books and words made me feel warm.

VT: It sounds like you had a good training in traditional culture.

XB: Actually, my own generation of artists—I think maybe yours too—our cultural background is really confused. On the mainland, we were introduced to a so-called Chinese cultural background, but there wasn't a direct connection to traditional Chinese culture because Mao had already changed that tradition. The culture we received was Mao culture, not really traditional, and not Western, since Mao was also against foreign ideas. He wanted to make a totally new culture. In the eighties, the great doors of China opened, and suddenly there was a mix of cultures, including capitalism.

I moved to the States in 1990—a totally modern culture. My cultural background was really confused, with different levels of culture mixed together. Right now, I feel like I'm living on the border between two different cultures. Actually that's the area where there will be a lot of possibilities, where there's really a future.

VT: New English Calligraphy is from this border area too. It looks Chinese, but it isn't. How do you read it?

XB: Each character is made up of letters from the English alphabet. And each of the letters has its own Chinese strokes. Take the word "ink," made from the letters I, N, and K, and combine them in the way you would write the strokes in a Chinese character, inside a square, following the usual stroke order inside the character—from left to right, top to bottom, outside to inside.

VT: So you're literally mixing Chinese and English together. What was the reaction?

XB: The first time people saw the words, they assumed it was Chinese. To them Chinese is a total secret—the language is really difficult, the culture is so different. Then when they began to do the calligraphy, they discovered, Oh, we can read this, it's actually English. So they experienced this transformation—part familiar, part strange.

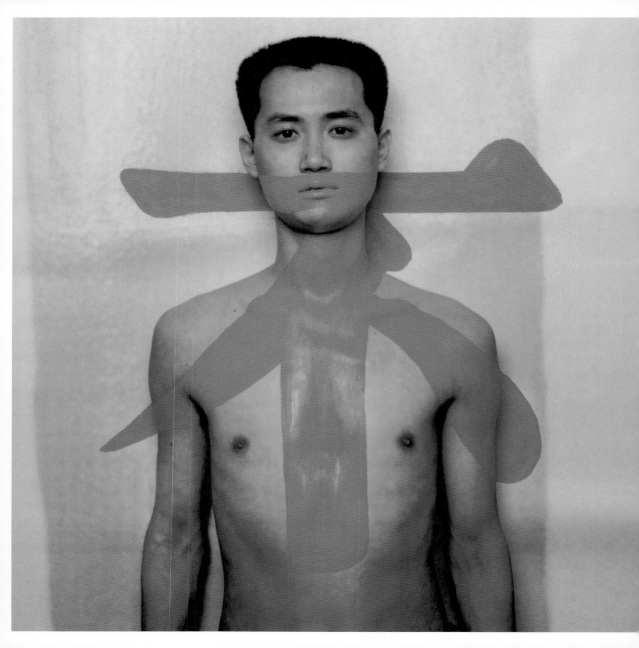

The image overpowers the reading at first, because everyone has fixed notions. You think Chinese must be Chinese, English must be English.

VT: So you make people rethink—and also reread. I might think in a sentence, but see it in squares instead of a straight line.

XB: Yes, that's what I want: to make people break their fixed notions. You can see how the audience fights in their minds when they start to write these kinds of words. They're very confused, and they don't know whether they're writing Chinese or English. Now people are actually practicing at home, and they send me documents—articles and poems, student work, all in this New English Calligraphy.

VT: Your work has always been about mixing East and West and language. Before New English Calligraphy you did a performance piece using pigs.

XB: Yes, pigs and language. The pigs were covered with cultural marks—sometimes a male pig painted with English letters, and a female painted with Chinese characters or the other way around. They mated.

VT: What did you want to express?

XB: I wanted to make a special space, to make people reflect about humanity's self. Some people wanted to read special meanings into it—the male pig is English, raping the female pig who is Chinese. But from the pigs' point of view, they are equal beings, tattooed with culture. It's human beings who want to compare cultures and create a hierarchy—one better than the other. I wanted to make people think about what is made by nature and what is made by culture.

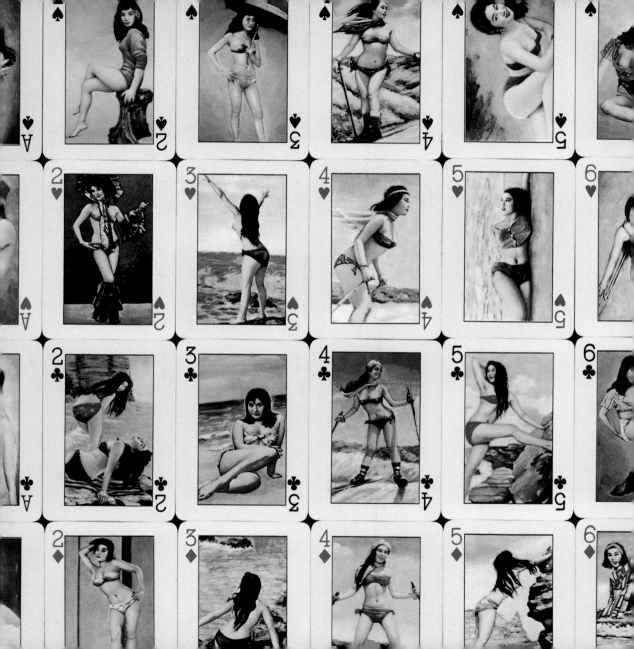

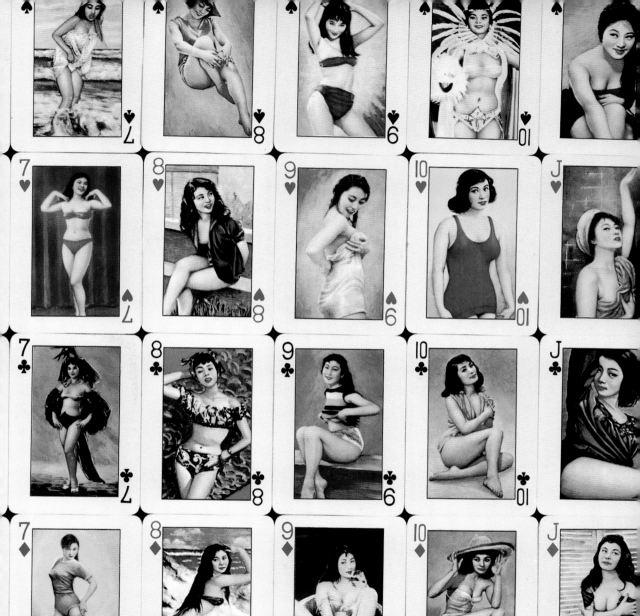

PERFORMING CHINLISH Interview with Danny Yung

I met Danny Yung when I was a student at the Polytechnic. He had just returned from the States and was starting to do experimental work in visual arts, film, and theater. He is one of the founders of the Hong Kong art collective Zuni Icosahedron, and has been its artistic director since 1985. He is also head of the Center for the Arts at the Hong Kong University of Science and Technology and artistic director of the Hong Kong Institute of Contemporary Culture. Danny has always believed art is a collective process, and over the years he has invited many friends and artists to take part in his creative projects. He even managed to get me onstage once. The play, *Broken Record No. 1*, was performed in the Hong Kong Arts Center. I stood by myself downstage in a white lace dress, facing the audience behind a table filled with sunglasses from my own collection. I had been telling him how much I loved my sunglasses, so Danny asked me to share that "love" experience with the audience. All I had to do was try on each pair, one after another, very slowly, recapturing and enjoying my relationship with these sunglasses, one by one.

Danny returned to Hong Kong just as I was leaving. He was rediscovering Hong Kong after years of education abroad, and his fresh eye helped open up space and prepare me for a new journey. He has really been a life teacher to me, and has always provided new perspectives and encouragement.

Chronicle of Women is an ongoing series of avant-garde theater pieces. Of all of Danny's work, this one fascinates me the most. The work explores the identity and place of women in Hong Kong and China, but in the process the women express themselves more personally— they are women, but they are also just themselves. I wanted to know more about the play and also about what it's like to do theater in Hong Kong.

VT: What is Chronicle of Women about?

DY: The title comes from a Chinese classical work of women's biographies. The text was traditionally read to young girls to teach them how to behave. In the process of making the play, we explored the connection between women and minority issues; in addition, we looked at the connection between theater and society, among Hong Kong, China, Asia, and the rest of the world.

VT: How did the women feel when they performed? I remember they wore cheongsams during the entire production.

DY: I think it was a stimulating and provocative experience. For instance, in one of the workshops, we took up the topic of costume. We tried to recapitulate how Chinese women have been treated through time, how they were constrained by the dress they wore. We practiced walking on Qing peg shoes, and we talked about how these shoes molded our way of moving and behaving. We had a choreographer come in—she taught us how to avoid injuries while walking in those shoes—the way to be a Qing lady.

When it came to wearing the cheongsam, some of the artists had never worn it before and hated it. Again, it constrained the way they moved and how they related to their bodies. The dress also reminded us about behavior codes—for instance, if you don't button the collar all the way up, you're viewed as a tramp and your family is seen as lower class. One performer who teaches physical education in a secondary school hated the dress so much—one day she brought in a basketball and started dribbling it around the rehearsal room. She was still in costume, so the effect was totally unladylike but also very provocative. In the end we used that action throughout the performance, and the sound of the basketball became a kind of counterpoint to the words and images.

VT: What role do you think theater can play in Hong Kong?

DY: Theater becomes a live laboratory for redefining the performing arts, performer, and audience relationships, and art and public relations. It's democracy in practice.

At Zuni we've experimented with shifting the roles of audience and performer. We've tried to insert discussion into performance. We've used questionnaires to trigger two-way communication. At one point, the program notes were literally in the form of a questionnaire. We also did record covers, a little red book, postcards, and even a deck of cards. People have started collecting them!

Theater making can be a process that makes room for more voices. It has the potential to be a platform for minorities; to consolidate, clarify, and organize. We can explore issues of

minority, the connections between theater and society, between Hong Kong, China, Asia, and the rest of the world.

VT: Have you used techniques from Chinese theater?

DY: As practitioners, we are always developing and contributing new techniques. We learn from both China and the West. Chinese theater has a rich body of information on communication art. The liang xian technique of Peking opera, for instance, is about "making the entrance" onstage. It's amazing how much knowledge exists on ways to prepare oneself to make a first impression and project onstage. Then there is the bang chang technique from Sichuan opera, which means "helping to sing," using an additional voice to help the performer express himself. For instance, when a character is weeping, someone else backstage speaks the lines for the performer onstage.

I am also very interested in the form of nuoxi, a traditional shamanistic practice from the countryside of the rural area of southern and southwestern China. This is one of the most interesting and avant-garde forms of audience participation. The classic story of Meng Jiangnui is about a young woman who follows her husband after he has been conscripted by the imperial army to work on building the Great Wall. She travels thousands of miles looking for him, only to find him already dead, buried beneath the stones of the Great Wall. To do this story in nuoxi theater, the director arrives in a village and goes to every household, inviting the men to accompany him to the temple. The women follow to see the men perform. In the process, the women experience being left behind and having to follow men. They are not just an audience but also participants.

VT: What about influences from the West?

DY: I really do not know what you mean by "the West." What is the West? Europe? North America? The East and West coasts are completely different. The same thing applies to the term "Asia." I never delineate things. To me, nuoxi and off-off-Broadway can be parallel. I must admit my time in the West, studying and working at Berkeley and Columbia, was important. It

was the height of the student movement, a time of quest. In New York City, being involved in Asian-American activities was very important—it made me understand Hong Kong better. I like New York, it's an energetic, multifaceted place with a concentrated intellectual discourse.

VT: Is Hong Kong like that now?

DY: Less than before, but it still has the potential to be one of the most dynamic cities in the world. In the late seventies and early eighties, Hong Kong seemed to be in cultural ferment. We had film festivals from all corners of the world, access to all sorts of books and publications. Then came 1984, when Britain and China decided on the hand-over—the focus shifted to politics.

As a vibrant immigrant city, Hong Kong has the strength and sensitivity to be flexible, to detect shifts in energy, to gain new space and awareness. The city is good at dealing with the present. The big question is: Are we good in dealing with the future? Our present government has a challenging task ahead. Dealing with the present is dealing with economics and social conditions; dealing with the future is dealing with culture.

Hong Kong can start fresh. In some ways, as a colony—a borrowed place in a borrowed time—our community doesn't have a conventional perception of history; we don't need it. We can say we have no burden of the past. As a young city-state, we care less about the traditional definition of identity. We are fine with mixing English and Chinese. We create new terms. Because we live on the edge between two cultures, we are on the move, and can be flexible.

Politically, we're part of China, but culturally, we can be independent—of both China and the West. We can appreciate and be inspired by both. We have the best of both worlds and can be the best. We can be both the interpreter and speaker at the same time. We can be the bridge for cultures and at the same time a unique culture ourselves.

To be an artist is often to be on the edge. And Hong Kong is on the edge too. You always have to be on the lookout for new grazing spaces. If we are totally aware of our position on the edge, we have the potential to make our community truly pluralistic, dynamic, versatile, and above all, creative.

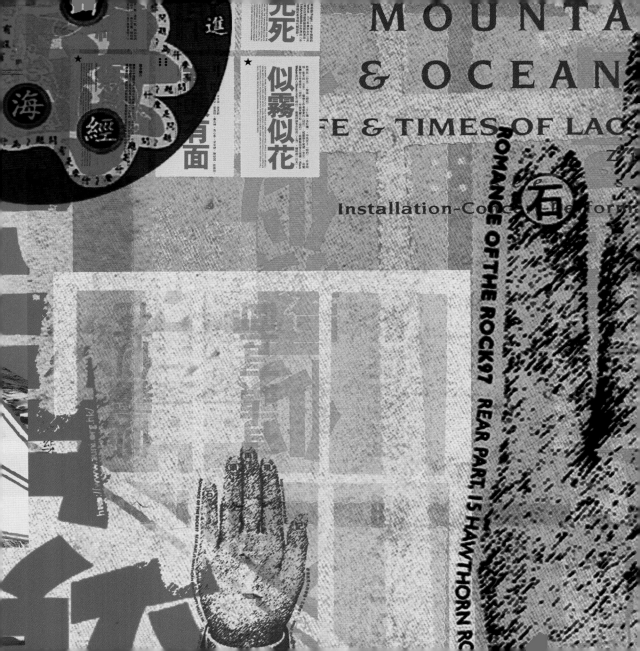

CHINGLISH REDUX

When I began this book, I knew the idea of China Chic, and of Eastern style meeting Western style, was going to go much deeper than fashion. I've been living with this mix since childhood; it's how I have learned to think and express myself. From the beginning, the idea of East meets West, for me, meant Hong Kong and its special hybrid culture.

When I chose the name for this chapter, I wanted a Hong Kong word, one that I'd grown up with—"Chinglish." It just made sense. When I told friends, their reaction was a big surprise. They gave me a list of reasons why I shouldn't use it: it was derogatory, cheap, something not Chinese, not English, but an impure mix. The response made me reconsider. I realized that these issues needed to be discussed. Instead of putting me off, their arguments turned Chinglish into more of a challenge. It was more than a cute title; it was an idea. I wanted to rethink and explore the meanings of this word.

These negative ideas of Chinglish reminded me of Xu Bing's pig installation. A mating between pigs is a natural thing. To paint their skins with two languages, English and Chinese, is to tattoo them with culture. It's the audience that sees this mating as an act of violence or sees one language as violating another. The pigs themselves, in Xu Bing's words, "are just having fun." Nature made these pigs equal, but man imposes inequality and discrimination.

I wanted to confront these negative feelings about Chinglish and argue with them—to approach them from a new angle and find a new energy in them. Any mix is by definition "impure." Why should that be a bad thing? Biologically we are all mixes, with genes from both parents. Mixing things up is necessary to sustain life—it's the basis of life.

The strongest responses were from male friends, especially those who had grown up or gone to school in the States. For them, the issue was that "Chinglish" reminds them of epithets like "Chink." Although they couldn't be clear about the exact connection, they saw "Chinglish" as somehow both an acknowledgment and an affirmation of racism. One of my closest friends suggested that using the term might be seen as self-denigrating. Obviously, I don't believe that.

In contrast, some of my women friends didn't understand what the fuss was about. They were quite puzzled by the men's objections. "This happened when we were little," they said about the name calling, "but you have to get past that." A friend who'd grown up in San

Francisco pointed out that minority women have always had it "easier" than men in the West, and have always been more easily accepted. But women told me they also responded to prejudice differently from their brothers.

For instance, one friend told me about her reaction to the name calling: "I just told my parents and they taught me not to take it too seriously and to have pity for the source." In their construction, this kind of taunting was just supposed to make us work harder. To a certain extent, this worked. On the other hand, one man I spoke to told me he never told his parents about his problems, because he didn't want to give them any worries.

I grew up in Hong Kong, where there was plenty of institutional prejudice against the Chinese, but where Chinese were the majority in the larger community. I didn't experience being different in my everyday life. And again, when we did experience prejudice, it seemed to make everyone "work harder." I think this is an important source of Hong Kong's work ethic—and its firm belief in business and financial success.

In Hong Kong, the negative responses to "Chinglish" seemed to come from a different base—not from prejudice, but from sensitivity to the issue of not having a "pure" culture. It came from insecurity and a fear of not being fluent in English or Chinese. One of my friends said that this sensitivity comes from being a colony, not a nation.

To me, "Chinglish" means choice—to be fluent in one or both languages, but always to be fluent in mixing them. In this new global millennium, this kind of command is so important, and very empowering. Chinglish grew from Hong Kong's experience as a colony, which was both good and bad. In any case, I still want to appreciate the incredibly rich, beautiful, and funny culture that it has created. It's part of who we are—who I am.

ACKNOWLEDGMENTS

First of all, I would like to thank Judith Regan of ReganBooks. In the fall of 1997 she asked me if I would be interested in creating a book about Chinese style to be called *China Chic*. "It can be about whatever you like," she said. I am grateful to her for inspiring the project and giving me the opportunity and freedom to pursue it. In the process, I've been able to express myself in words and visual images and expand beyond the world of fashion. This book has enriched my life tremendously, providing new insights, new friends, and a new awareness.

What is China chic? When I asked a taxi driver in Beijing, he said, "friendship, love, and money." To me, chic is to be stylish with a kind of ease and effortlessness. But China chic goes deeper—it incorporates a balance that's spiritual as well as visual. It's embodied in the Taoist concept *wuwei*, a kind of stillness that doesn't go against nature. To talk about chic on that level is to talk about all things Chinese, but I'm still on my own personal journey of discovering China, so that's what I'd like to share.

Growing up in the colony of Hong Kong, I had very little formal education about Chinese culture, but I felt something was missing and had a passion to learn. I looked at everything I could find about China, from Chinese art to the Chinese Emporium, a department store that specialized in PRC products. The first time I crossed the border into China, I was thrilled to see a real Chinese landscape and to walk through real Chinese streets. China is the source of inspiration in my fashion design, and now this book is an expression of that passion also.

I had great faith that things would come together the way they were meant to. That's how my shows work, too. One of the first people I contacted was my friend Geremie Barmé, an Australian scholar of Chinese literature and culture. I've always admired his work and his knowledge of China. I want to thank him for his enthusiasm, ideas, support, and expertise. We traveled to China together to meet artists and collectors, and his insights into the artistic and intellectual scene there were invaluable. My longtime friend Robert Loh became the project manager of the book. He joined us, taking beautiful photographs of our journey. I deeply value his tremendous support, ideas and research, understanding, and good company. He was an essential liaison with artists and photographers in Hong Kong and contributed great visual ideas. Danny Yung, a wise mentor to me, provided advice and guidance and a tour of avant-garde Hong Kong.

I found a graphics team and writer to work on the book in Hong Kong. My old friend Phillip Kwok, who shared in the discoveries and adventures of student days in Hong Kong, provided an introduction to Wing Shya, of Shya-la-la Workshop, who art-directed the book. I had seen Wing's work in New York and fallen in love with the energy of his beautiful, delicate montages. Wing asked me how I put my fashion collections together. I explained the process: how we started with basic ideas and improvised and evolved through stages, adding and refining until the actual show. "Great," he said, "that's how we'll do the book!" At our first meeting, we embraced the concept of the book as a square—so important in Chinese writing and culture—and selected the main colors to be used—red and gold. Wing's colleague Elaine Kwong became our designer—her patience, passion, and hard work in developing the images were invaluable.

Martha Huang, a specialist in modern Chinese literature, also has an interest in fashion and popular culture. An American who's lived in Beijing and Hong Kong, she understood my ideas and way of looking at things—we clicked. We had wonderful long conversations at all hours of the day and night from all over the world. Her patience, knowledge, and understanding helped me find the words to say what I wanted.

Special thanks to Tama Janowitz and Geremie Barmé for their wonderful preface and introduction. The combination is truly a "double

happiness." Tama and her husband, Tim, gave wonderful dinner parties and advice, and it is always special to hear their daughter, Willow, speak in Chinese. In addition, Geremie helped to pick the Chinese characters that open each chapter and provided their definitions.

The staff at Vivienne Tam in New York was tremendously supportive. Vice president Brian Hogan has been a close and treasured friend. I can always count on his true understanding and advice. Shelley Crawford, Tara McCollum, Margaret Schell, and Lisa Mercer provided administrative and public relations. I would like to thank my fashion design staff, who were so patient when the book took me away from the design studio.

Also in New York: thanks to Emily Cheng, who was instrumental in the early stages of the book. Anna Sui provided friendship and good fun. Thanks also to Lois Connor, Chalkie Davis, and Carol Starr for creative and visual advice. I am grateful to photographers Patrick McMullen, Roxanne Lowit, Peter Mauss, Frank Veronsky, Corky Lee, and Nik Wheeler. Emma Tarry, her mother, Marie Tarry, Ling, Danny Wolf, and Laurence Tam graciously gave their time and good stories. Thanks to Richard Gordon, Reed Darmon, Robert Bernell, and Jonathan Goodman for their support and help.

Sandy Leung, Patricia Cheung, and Teresa Wong provided indispensable support and assistance. Teresa tirelessly coordinated the graphic material and credits, traveled with me to China, and acted as administrative liaison in Hong Kong. Thanks to Leong Ka Tai and May Holdsworth, also to Allan Chow at Six Bugs, Edwin Leong, Mary Wong, and everybody at Chi Lin Nunnery. Marjory Yeung, Ray Chen, Kathy Yu, Professor Ng Chun Bong at Hong Kong Baptist University, and Valerie Garrett all provided expertise, teaching, and hospitality. Dorinda Elliot at *Newsweek International* gave me the chance to write about Mao and fashion. I thank them all.

In Beijing and Shanghai: thanks to Duke Erh and Lawrence Wu. And special thanks to Francesca Del Lago for introducing me to contemporary artists and collectors and for showing me her beautiful home in Beijing.

Thanks to Andrew Higgins, Dorinda Elliot, Adi Ignatius, Priscilla Huang, Jon Singer, and Stacy Mosher for hospitality, good cheer, and advice. I am grateful to Andrew Bolton and David Vincent for their support and friendship.

We did a tremendous amount of research, both for the text and the images. I would like to thank all the writers, photographers, and researchers whose work I have consulted. All the interviewees took time from their busy schedules to meet with me to add their ideas and experiences to this book. I am grateful to them for their generosity. To everyone I may have inadvertently left out, I apologize and express my deepest thanks.

Without ReganBooks, this book would never have happened. Judith Regan, who proposed this book, planted the seed. Charles Rue Woods, the former art director at ReganBooks, brought the flower to bloom. Many thanks also to Cassie Jones, Renée Iwaszkiewicz, Pamela Flint, Carl Raymond, Dana Isaacson, Amye Dyer, Chris Pavone, Lorie Young, Roni Axelrod, Maggie McMahon, Jennifer Suitor, Marta Schooler, Rebecca Farrell, Mark Landart, David Sweeney, Judy Dunbar, France Fochetta, Sharon Lyons, Robin Artz, Lucy Albanese, Heather Locascio, Julie Duquet, Paul Brown, Marcia Salo, Mark Magill, and David Wolfson.

Finally, my family has always been my main support: My parents' bravery and hard work have defined my life, and my brothers and sister have supported me in my work and been my first and truest friends. Scott Crolla, my mentor, dearest friend, and love, has given me creative inspiration, support, and patience. They all have my love and thanks.

CREDITS

i, Vivienne Tam on a Ming chair: photograph by Foreign Devil.
iii, Buddha face: "Man Shu Bodhisattva."
iv, Shanghai night scene collage: by Elaine Kwong of Shya-la-la Workshop Ltd.
v, "A Chinese Dream": courtesy of Beijing artist Wang Jin.
vi (right), back view of two women wearing cheongsams, Hong Kong, 1960: courtesy of photographer Yau Leung, Photo Pictorial Publishers Ltd.
x–xi, goldfish: courtesy of photographer Robert Loh.
xiv, modern Ming chair: courtesy of Beijing artist Shao Fan.
xv (center), "Year of the Mice": T-shirt design collaboration between Vivienne Tam and artist Zhang Hongtu.
xv (background), "Unity: The Handover Party": courtesy of Bon Kwan/The Graphis Company.
xvii, old actor playing female role, c. 1995: courtesy of artist Liu Zheng.
xx, Vivienne Tam at three years old: from the collection of the author.
xxiib–c, calendar girl posters: courtesy of Joint Publishing Co., Ltd., Hong Kong.
4–5 (left), pottery tomb figures; Sui, Tang, and Five Dynasties period: courtesy of private collection; dragon robes: from *Peking Opera Costumes and Ornaments,* courtesy of The Artbook Co., Taiwan.
7, dragon robe: courtesy of private collection.
9, Two Girls Brand calendar poster: courtesy of Joint Publishing Co., Ltd., Hong Kong.
10–11, calendar girls poster: courtesy of Joint Publishing Co., Ltd., Hong Kong.
13, Shanghai "Calendar Girls" poster: from the collection of the author.
14, Ruan Lingyu in silent movie, *The Goddess:* still photo courtesy of China Film Press.
16–17, calendar girl posters for cosmetics and cigarettes, c. 1920: from the collection of the author.
19, calendar girl poster: courtesy of Joint Publishing Co., Ltd., Hong Kong.
22–23, "Four Seasons" calendar poster series—Spring (pussy willows), Autumn (chrysanthemums), Summer (lotus), Winter (plum). The models are dressed in the height of fashion and strike Hollywood starlet poses c. 1930s: from the collection of the author.
24, "Shanghai Bride": courtesy of Formasia Books, Hong Kong.
25, "To Marry a Mule": courtesy of Beijing artist Wang Jin, photograph by Shi Xiao Bing.
27, traditional wedding couple: from *Lao Zhaopian.*
29, Vivienne Tam's parents' honeymoon photo: from the collection of the author.
30–31, Red Dragon and Ling: courtesy of photographer Scott Crolla.
32, printed peony netting dress from the Vivienne Tam Spring 1995 Collection and paper cutout of Double Happiness symbol: from the collection of the author.
33 (top), dragon boat wedding: courtesy of Ming Pao, photograph by Tam Tak Yun.
35, bride wearing sunglasses to represent "modern" marriages in the village, Shanxi province, Beijing: courtesy of photographer Richard Gordon.
36–37, wedding cake box design from Lin'Heung Tea House: from the collection of the author.
39, antique erotic drawing from *Mixitu Daguan:* courtesy of Kam Fung Publishing Co., Taiwan.
41, Chinese group wedding: courtesy of Jiang Yu Bin/Image Bank/CTP.
43, dressing up for Lunar New Year festival, Shanxi province, Beijing: courtesy of photographer Richard Gordon.
45, "Double Spring" illustration: courtesy of Hong Kong artist.
48–49, backstage at the Chinese Opera, "Homeland of Shaoxing Wine": courtesy of Feng Xue-Min, Zhejiang Photographic Press, Hangzhou.
51 (from left), Pak Shu Sin and Yim Kim Fai in "The Emperor's Daughter," c. 1960; Crown Records record cover: from the collection of the author.
54, Chinese opera star Mei Lanfang in "The Heavenly Maid Showering Flowers," c. 1920: courtesy of Mei Lanfang Memorial Museum.
55, "The Web Cave" opera performance series, c. 1997: courtesy of artist Liu Zheng.
56–57, Chinese New Year babies poster, c. 1960s to 1970s: from the collection of the author.
59, Chinese New Year good luck poster, c. 1960s to 1970s: from the collection of the author.
61, Shanghai family portrait, c. 1920, from, *The Vicissitude of Shanghai Folk Style and Features:* courtesy of Shanghai People's Art Publishing House.
65, PRC poster, "Greeting the Holidays," by Wu Zhefu, 1962: private collection.
66–67 (left), "Little Guests in the Moon Palace" (Yue Gong Xiao Keren): courtesy of

Stefan R. Landsberger; (center top small image): from the collection of the author; (center bottom) Chinese propaganda poster: from the collection of the author; (right) collage of contemporary children's photos: courtesy of photographer Robert Loh, Osbert Lam, and Alfred Ko.
68 (bottom left), children's toys package design: from the collection of the author; revolutionary toy missile: courtesy of AP/Wide World Photos.
70, Chinese school book: courtesy of Joe Chung Collection.
71, PRC poster celebrating the Lantern Festival, c. 1960: from the collection of the author.
72–73, countryside schoolchildren: courtesy of photographer Lois Conner.
75, toddler wearing ventilated trousers: courtesy of photographer Julie W. Munro.
76–77, Mao woodblock print collage: by Elaine Kwong of Shya-la-la Workshop Ltd.
78, "Long Live...!" slogan appearing in People's Pictorial c. 1960: from the collection of the author.
79, "Mao Reviews Troops": from *A Century of Chinese Photographs,* courtesy of Fujian Art Publishing House.
80, patriotic parade—Chinese calligraphy and edict slogan of Mao, "Develop sports and exercise. Increase the quality of health and stamina for the whole nation," from People's Pictorial, c. 1960: from the collection of the author.
82–83, PRC poster, "The Worker, the Farmer, the Soldier": courtesy of photographer Robert Loh.
84, wine label collage: from the collection of the author.
86–87, Mao memorabilia: courtesy of photographer Robert Loh.
89, Vivienne Tam Spring 1995 Mao Collection: collaboration between the author and artist Zhang Hongtu.
91, Tiananmen Square: courtesy of artist Wei Wei Ai.
93, "Quaker Mao": courtesy of artist Zhang Hongtu.
95, Red Chinese soldier from *A Century of Chinese Photographs:* courtesy of Fujian Art Publishing House.
96–97, airport security guard: photograph by the author; woman with gloves: courtesy of photographer Fred Fung; PRC sailors: courtesy of Magnes Bartlett, Pacific Century Publishers Ltd.; street friends: courtesy of Calvin Tsao, Tsao and McKown.
98, fashion in the park: courtesy of photographer Fred Fung.
102, Mao quote from the *Red Book,* "Our literature and art is for the People's public, but first they're created for the worker, the farmer, and the soldier for them to use and exploit": from the collection of the author.
103, street fashion: courtesy of Calvin Tsao, Tsao and McKown.
105, bicycle fashion with protective headwear: courtesy of Leong Ka Tai.
106–7 (left), Vivienne Tam Spring 1995 Mao Collection; (right), "The Great Hall of People," official souvenir print: private collection; *The Women's Cadre in Red Ballet:* from the collection of the author.
109, "Born with the Cultural Revolution": courtesy of photographer Xing Danwen.
110–11, "Last Banquet," 1989: courtesy of artist Zhang Hongtu.
114–15, revolutionary ballet: from the collection of the author.
118, Buddha net dress from Vivienne Tam Spring 1997 Collection and collage of Buddha images: from the collection of the author.
121, Buddhist temple interior: courtesy of photographer Keith McGregor, Pacific Century Publishers Ltd.
123, cat in incense store: from *Chinatown: A Personal Portfolio,* courtesy of MPH Bookstores PLE Ltd., Singapore; photograph by R. Ian Lloyd.
124–25, burning paper sequins dress from Vivienne Tam Fall 1998 Collection and Chinese ghost paper money collage: from the collection of the author.
126, Chinese almanac: from the collection of the author.
127, porcelain thousand hands Kuan Yin Buddha: courtesy of photographers Davies and Starr.
129, Sudhana wall mural of Chong Shan Monastery, Shanxi: from *The 53 Visits of Sudhana,* courtesy of the Chinese Buddhist Cultural Institute of China.
130, eye of the Buddha: from the collection of the author.
132, Kuan Yin and Buddha collage: from the collection of the author.
133, nuns, c. 1996: courtesy of artist and photographer Liu Zheng.
135, face-reading map from a Chinese almanac: from the collection of the author.
136, collage of Chi Lin Nunnery.
139, Buddha face, profile of "Buddha Siddhartha."
141, Sudhana wall mural of Chong Shan Monastery, Shanxi: from *The 53 Visits of Sudhana,* courtesy of the Chinese Buddhist Cultural Institute of China.
144–45, Chinese herbal medicine and clay pot: *Allan Amsel Publishing, 2000*

148–49, Bada Shanren calligraphy: from *Bada Shanren Art Scrolls, Book II,* courtesy of Tianjin People's Fine Arts Publishing House.
152–53, Qui Lin Mountain and rice fields, Kwangsi: courtesy of photographer Lois Conner.
154–55, Chinese garden: photographs by Professor Chung Wah Nan, Hong Kong architect.
158–59, Huangshan, Anhui Province: courtesy of photographer Lois Conner.
163, scholar rock: "Worlds Within Worlds," courtesy of the Asia Society, Greg Heins, photographer.
164–65, Chinese garden: photographs by Professor Chung Wah Nan, Hong Kong architect.
167, Chinese garden: photograph by Professor Chung Wah Nan, Hong Kong architect.
168–69, Chinese Ting Tong: photograph by Professor Chung Wah Nan, Hong Kong architect.
171, The Astor Court Exhibit, Ming Room: The Metropolitan Museum of Art, gift of the Vincent Astor Foundation, 1980. Photograph © 1982 The Metropolitan Museum of Art.
172, Ming "official's hat chair": from the collection of the author.
174, ceramic bowl: from *Imperial Kiln Porcelain of Qing Dynasty,* courtesy of Shanghai Chinese Classics Publishing House.
178, ceramic vase: from *Imperial Kiln Porcelain of Qing Dynasty,* courtesy of Shanghai Chinese Classics Publishing House.
179, lattice window: from *Chine Ting Tong,* courtesy of Shanghai Pictorial Publishing House, Hong Kong.
181, courtyard: from *Chine Ting Tong,* courtesy of Shanghai Pictorial Publishing House, Hong Kong.
182–83, Chinese screen: from *Ancient Village in Southern Yang Tze,* courtesy of Joint Publishing Co. Ltd., Hong Kong.
186, Vivienne Tam Spring 2000 Collection: from the collection of the author.
188, author's New York bedroom: courtesy of photographer Tohru Nakamura.
190, author's New York living room: courtesy of photographer Tohru Nakamura.
191, collages of author's New York apartment: courtesy of photographer Tohru Nakamura.
192, "Moon and Melon": from *Bada Shanren Art Scrolls, Book II,* courtesy of Tianjin People's Fine Arts Publishing House.
194–95, "Lotus and Birds": from *Bada Shanren Art Scrolls, Book II,* courtesy of Tianjin People's Fine Arts Publishing House.
196, gold starburst beaded dress from the Vivienne Tam Fall 2000 Collection: from the collection of the author.
197, dragon chandelier, The Royal Pavilion, Brighton: reproduced courtesy of The Royal Pavilion, Libraries and Museums, Brighton & Hove.
199, Palace of Heavenly Purity, Imperial Palace: courtesy of Alfred Ko/Getty Images Ltd., Hong Kong.
200–201, floral paintings by Giuseppe Castiglione: courtesy of National Palace Museum, Taipei, Taiwan, Republic of China.
203, screen and throne in the Palace of Eternal Spring in Yuan Ming Yuan: courtesy of the Imperial Palace Museum of Beijing; Forbidden City Publishing Co.
205, collage of interiors at The Royal Pavilion, Brighton: reproduced courtesy of The Royal Pavilion, Libraries & Museums, Brighton & Hove.
206, Music Room, The Royal Pavilion, Brighton: reproduced courtesy of The Royal Pavilion, Libraries & Museums, Brighton & Hove.
208–9, South Galleries, The Royal Pavilion, Brighton: reproduced courtesy of The Royal Pavilion, Libraries & Museums, Brighton & Hove.
210–11, Yellow Bow Rooms, The Royal Pavilion, Brighton: reproduced courtesy of The Royal Pavilion, Libraries & Museums, Brighton & Hove.
213, Music Room, The Royal Pavilion: reproduced courtesy of The Royal Pavilion, Libraries & Museums, Brighton & Hove.
214–15, copper engraving of Haiyan Hall in the Garden of Eternal Spring in Yuan Ming Yuan: courtesy of the Palace Museum of Beijing; Forbidden City Publishing Co.
216, "Emperor Qian Long in Armour Reviewing His Troops": from *Daily Life in the Forbidden City,* courtesy of the Palace Museum of Beijing; Forbidden City Publishing Co.
218, "Portrait of Empress Xiao Xian Chun in Court Dress": courtesy of the Palace Museum of Beijing; Forbidden City Publishing Co.
220–21, collage of Shanghai TV tower, Mao statue, and bamboo scaffolding: courtesy of private collection.
222, Shanghai street collage: by Elaine Kwong of Shya-la-la Workshop Ltd.
224–25, collage of light boxes and shop signs: courtesy of photographer Robert Loh and the author.
227, preparing street decorations for Chinese New Year: courtesy of Ming Pao; photograph by Lee Siu Cheung.

228–29, Chinese New Year lucky writing (huichun): courtesy of Ming Pao; (left) photograph by Fung Kong Yui; (right) photograph by Lee Suen Yee.
230, flea market: courtesy of photographer Robert Loh.
233, Mid-Autumn Moon Festival: courtesy of photographer Keith MacGregor, Pacific Century Publishers Ltd.
234, street food in Beijing: courtesy of photographer Robert Loh.
236–37, Healthy Tea Shop: courtesy of photographer Keith MacGregor, Pacific Century Publishers, Ltd.
240, "Feng" performance series: by artist Ma Liuming, courtesy of photographer Xing Danwen.
241, collage of market fruits and vegetables: courtesy of photographer Robert Loh.
242, collage of dried seafood: courtesy of photographers Robert Loh and Jolans Fung.
243, Luk Yu Tea House interior: courtesy of Formasia Books, Hong Kong.
245, stone fu dog at the entrance to the Bank of China, Hong Kong: courtesy of photographer Jolans Fung.
246–47, Shanghai flea market: courtesy of photographer Robert Loh.
249, bamboo scaffolding: courtesy of photographer Keith MacGregor, Pacific Century Publishers, Ltd.
251, bamboo pole with clothing: courtesy of Formasia Books, Hong Kong.
252–53, Chinese New Year fireworks celebration: courtesy of the Hong Kong Tourist Association.
254–55, Cantonese movie posters: from *Silver Light: A Pictorial History of Hong Kong Cinema, 1920–1970,* courtesy of Paul Fonoroff.
257, 1997, Year of the Ox T-shirt design: collaboration between the author and the artist, Zhang Hongtu; (background) "Boy with Hong Kong Flag": courtesy of Hong Kong Artist.
259, Butterfly Wu, 1940s Chinese movie star: courtesy of Edwin Loui.
260, Hong Kong neon signs at night: courtesy of photographer Robert Loh.
261, Double Happiness cigarette advertising on double-decker bus: courtesy of photographer Robert Loh.
263, cheongsam cartoons: courtesy of Joe Chung Collection.
265, "Market 1963": courtesy of photographer Chung Man Lork.
267, portrait of Anna May Wong: courtesy of Photofest.
268, 1960s Hong Kong movie stars: courtesy of Edwin Loui.
269, 1960s Hong Kong movie stars: courtesy of Robert Loh.
271, 1950s Hong Kong movie stars: courtesy of private collection.
272–73, cover of pattern book: courtesy of *Butterick* and *Vogue Patterns* magazines, from the collection of Marie Tarry.
272–73, 1960s and 1970s Hong Kong movie stars: from the collection of the author.
275, 1960s and 1970s Cantonese movie stars and posters: courtesy of Edwin Loui.
277, stage production of *The World of Suzie Wong:* courtesy of Photofest.
278–79, 1970s Mandarin movie stars: courtesy of Joint Publishing Co., Ltd., Hong Kong.
281 (left), Bruce Lee artwork: by Romain Slocombe © *Tofu* magazine; (right) Bruce Lee artwork: by Loulou Picasso © *Tofu* magazine.
282–83, collage of Hong Kong movies, 1960s to 1990s: courtesy of Media Asia © Star TV Films Entertainment.
286–87, poster for *A Chinese Ghost Story,* a movie by Tsui Hark: courtesy of Media Asia © Star TV Films Entertainment.
290–91, *Zu Mountain,* a movie by Tsui Hark: courtesy of Media Asia © Star TV Films Entertainment.
292, "Cultured Pigs": courtesy of artist Xu Bing; Xing Danwen, photographer.
293, New English Calligraphy: courtesy of artist Xu Bing.
296, "Tattoo I": courtesy of artist Qiu Zhijie.
298–99, "Oriental Girlie" series playing cards: courtesy of Joe Chung Collection.
302, "Chronicle of Woman," an ongoing avant-garde theater series: courtesy of Zuni Isosahedron; directed by Danny Yung.
303, cartoon drawing of a woman wearing cheongsam: courtesy of Matthew Turner.
306–7, avant-garde performance series: from *Book of Mountain and Ocean: Life and Times of Lao Tze,* Freeman Lau, graphic designer; courtesy of Zuni Isosahedron.

VIVIENNE TAM was born in Canton, China, but moved to Hong Kong when she was three years old. Her bicultural upbringing in the then-British colony was the first stage in the development of her signature East-meets-West style. One of the world's most celebrated fashion designers, she has cultivated a strong international following.

As a designer of clothing that "suggests tolerance, global acumen, and a Fourth-of-July faith in individual expression," Tam, in the words of fashion critic and curator Richard Martin, possesses an "idealistic globalism that transcends politics and offers a more enchanted, peaceful world."

Tam's clothes have been collected for the permanent archives of the Museum at the Fashion Institute of Technology and the Costume Institute at the Metropolitan Museum of Art in New York, the Andy Warhol Museum in Pittsburgh, and the Victoria and Albert Museum in London. In 1998 she was a nominee for the CFDA Perry Ellis Award for Womenswear. Chosen by *People* magazine as one of the world's "50 Most Beautiful People," Tam has also designed a car for General Motors and was one of the first graduates to be honored as Outstanding Alumnus of the Hong Kong Polytechnic.

Tam has boutiques in New York, Tokyo, and Hong Kong, and her fashions are sold in prestigious stores, including Neiman Marcus, Saks Fifth Avenue, Barneys New York, Nordstrom, and Bloomingdale's. She has been featured in prominent publications such as *W, Harper's Bazaar, Vogue,* the *New York Times, Elle, In Style, Mademoiselle, Jane, Allure, Cosmopolitan, Glamour, Marie Claire, US, People, Talk, Surface, Newsweek, Time Out, New York,* the *Herald-Tribune, Elle Décor,* and *Interior Design.*